PREHISTORIC
ROCK ART
IN BRITAIN

PREHISTORIC
ROCK ART
IN BRITAIN

STAN BECKENSALL

AMBERLEY

As one of the first students at the University College of North Staffordshire in 1950 (now the University of Keele), I wish to dedicate this book to the founders, especially 'The Master and the Vicar' – Lord Lindsay of Birker and Alderman the Reverend Thomas Horwood. They dared to be different.

First published 2009

Amberley Publishing
Cirencester Road, Chalford,
Stroud, Gloucestershire, GL6 8PE

www.amberley-books.com

British Library Cataloguing in Publication Data.
A catalogue record for this book is available from the British Library.

ISBN 978 1 84868 626 7

Typesetting and Origination by Amberley Publishing.
Printed in Great Britain.

CONTENTS

	Acknowledgements	6
	Preface	8
	Introduction	9
1	Elements in rock-art	11
2	Places where rock-art is found	33
3	The search for meaning	58
4	Artistic responses to prehistoric rock-art	77
5	A history of the study of rock-art in Britain	86
6	Finding, recording, preserving and displaying rock-art	103
	Appendices:	
I	Terminology	126
II	Timescales	128
III	Regions	130
IV	A world perspective	135
V	Recording	141
VI	Creating a website	143
VII	The Creswell Caves rock-art	147
VIII	Shamanism: A dead end in rock-art studies	150
	Bibliography	154
	Index	159

ACKNOWLEDGEMENTS

I owe a great debt to so many people who have helped with this work. The major task at the end fell to Paul Frodsham whose editing skills again came to my rescue; he seems to miss nothing, though any mistakes will be mine. I was also helped to ensure that the text is accessible to a wide audience, and for this I thank Matthew Hutchinson and Gordon Tinsley.

I was determined to make this book a shared effort and to include people whose photographic skills I admire – those who have travelled hundreds of miles to make discoveries and to record them, and who have contributed their work to this book: Keith Boughey, Jan Brouwer, Barbara Brown, Paul Brown, George Currie, Graeme Chappell, Paul Frodsham, Ian Hewitt, Ian Hobson, Brian Kerr, Aron Mazel, the late Ronald Morris and Gus van Veen. Most of them do this for the love of the quest and are unpaid for what they do.

In the text photographs are acknowledged under full names or initials.

Scales are essential to archive recording, but for aesthetic reasons photographers prefer pictures with no scales in a book like this.

The cover was chosen from the work of Brian Kerr, whose photographs recently commanded a large national newspaper audience.

I am grateful to Birtley Aris and Gordon Highmoor for their splendid artwork, to the staff and pupils of the Greenfield Community School, Newton Aycliffe, for theirs, and to those American teachers who so long ago responded to our rock-art.

I have stressed the contribution of independent researchers throughout, named them, and outlined their contributions. There is a strong fellow-feeling among them which has been delightful and stimulating to share. Professional archaeologists who have given most to the study of rock-art and have had strong links with me include Paul Bahn, Richard Bradley, John Coles, Christopher Chippindale, Paul Frodsham, George Nash, Aron Mazel and Clive Waddington.

English Heritage has brought resources and new people to the study of rock-art, and this organisation should be able to continue to develop

it. I have been happy to help with some of their work and through them to establish more contacts with other countries who share this interest. I am grateful to UNESCO for inviting me to share international thinking on rock-art. The Kilmartin House Trust has always been helpful. All these contacts have helped in the writing of this book.

Marc Johnstone has again produced a splendid map for me; he is another professional archaeologist who has been involved in rock-art, especially with his part in the University of Newcastle website. The work for this site has been one of the defining moments of my life, and working with the team there, especially with Aron Mazel, has been an unprecedented opportunity to bring to the general work the specifically important rock-art of Northumberland. This work was essentially research in the field before it was ready for presentation to the world – the right way round.

Representing a wider and older world of rock-art is Paul Bahn who has not only contributed the Preface but also shared his expertise in the appendices. So too have Paul and Barbara Brown and Aron Mazel. Thanks to all of them. These appendices flesh-out many ideas raised in the book.

So I have seen what value independents, professional archaeologists and organisations have given to what used to be a fringe activity. I hope that by acknowledging the contribution of all, we continue to work amicably together.

I am again most grateful to the commissioning editor, Tom Vivian, who has throughout worked splendidly to publish this book.

And this our life, exempt from public haunt,
Finds tongues in trees, books in the running brooks,
Sermons in stones, and good in everything.

Shakespeare, *As You Like It*

PREFACE

BY DR PAUL BAHN

It is both a pleasure and an honour to contribute a preface to this book by Stan Beckensall, doyen of rock-art researchers in Britain. He is one of the greatest in a long list of distinguished specialists in this field who have often been dismissed as 'amateurs' but who, as I have argued elsewhere (Bahn 2006), are the very backbone of the subject. Stan worked for decades, in his own time and at his own expense, to compile an unrivalled database which will be of incalculable importance to future generations of researchers. I am delighted that he was eventually rewarded with an honorary doctorate from Newcastle, since most 'amateurs' or 'independent researchers' in his position never receive any kind of award, and are often actively denigrated, belittled or ignored by the so-called 'professionals', many of whom cannot hold a candle to them in terms of knowledge, experience and dedication. But Stan's many contributions are not limited simply to the recording of rock-art sites. His numerous fine publications have brought them to the attention of a wide public, while his skills in teaching have ignited an interest in rock markings in the younger generation, as he shows so vividly in this volume. In addition he has been a breath of fresh air in his insistence on clarity of language and of thought processes, his determination to shun trendy interpretations for which there is no supporting evidence, and for his humility and modesty in being able to accept that there are many things we shall never know or understand in prehistoric rock-art. These are all hallmarks of a truly objective and scholarly mind. Not surprisingly, therefore, what he so rightly calls 'pretentious nonsense', dangerous generalisations and 'weird and silly speculations' are given short shrift in this concise but highly informative volume. After a survey of the main motifs to be found in British rock-art and their interpretations, we are given some examples of ways in which he has triggered the interest of youngsters in the subject, a very valuable and detailed account of the history of research in this country, and of recording techniques, and finally a timely assessment of the many threats, both natural and man-made, to the survival of this precious and irreplaceable resource.

This book, therefore, forms a fine addition to the already remarkable series of works that have flowed from Stan's pen, and further ensures his place in the roll-call of all-time greats in the field of rock-art research.

INTRODUCTION

Until a few years ago the study of British prehistoric rock-art was in the hands of a few enthusiastic, unpaid researchers who pursued it, mainly outdoors, discovering and recording new sites. They also researched written records and illustrations to find out what exactly was known about it.

People who lived in the countryside close to the sites mostly took them for granted, knowing that they were there, wanting sometimes to know more, but not necessarily being too bothered about them. There were a few exceptions who were so proud of 'owning' them that they guarded them jealously. Occasionally a speaker might wander into the community and mention them during a talk. Often myths were exchanged rather than researched information, and these could take on the authority of fact when there was no alternative theory to explain rock-art. There was literature about the motifs, but this tended to be in articles mostly hidden from all but those interested in, and with access to, research. Such literature shows that awareness of rock-art goes back about 200 years, but again the study was in the hands of gifted and often well-off people who saw it as one element of the past, perhaps important, perhaps not, but certainly a challenge to understand, rather in the same way that code-breakers approach their subject.

A rather spasmodic approach may have stemmed from the idea that markings on rock might never be explained. The growth of modern archaeology provided other more certain and lucrative outlets for historians' energies but the emphasis on southern England, where there is little or no rock-art, meant that it took some time for professional archaeology to catch up with a powerful, intriguing aspect of our development, as almost all British rock-art belongs to the North.

So what has changed? Thanks to an accumulation of records of panels and single rocks, an outpouring of literature, and to an extensive international interest in rock-art, British professionals at last began to catch up. However, with the expansion of resources made available for further research from the taxpayers, there has been an emphasis on re-recording sites already known and attempts to re-interpret what has been

found without actually being able to make much progress in interpretation. More is known, but this has not led to answers to questions that are still being asked, and Britain is not alone in this. Perhaps the greatest progress has been made in making people aware of what we have, what threats there are to this 'heritage' and how to preserve and display some of it. But that does not answer the questions about what rock-art was for, how long it has been around, why it is where it is, and how it was used by our remote ancestors. Some of us think that many questions will not be answered, but a mystery is not a bad thing to contemplate in the face of so much arrogant assumption that we can know everything. Meanwhile committees continue to be set up, volunteers are trained and encouraged to join groups to record sites, universities establish niches within their structures to further the study of rock-art, and technology becomes more sophisticated and unthinkable compared with what antiquarians had available to them in the past. All this is good without moving us very far in our understanding, although our recording systems may have improved.

The greatest benefit of the awakening interest in rock-art is to the people who have discovered a whole new way of looking at landscape and who have explored parts of the countryside previously unknown to them. Such discoveries can bring joy and companionship in the search, something that has always been a vital part of archaeology. Vital, at least until the production of turgid, dreadfully invented language in which many reports and articles are written and which has distanced the study from its roots. Sadly, archaeology has gone the same way as many government agencies in making language as ghastly as possible. (Are we at this moment in time being ring-fenced so that our rafts of ideas are not taken on board so that we are not delivering … see what I mean?)

One feels that the people who hammered their motifs on the rocks thousands of years ago would be chuckling if they knew what has been proposed to explain them. What to them may have been a straight-forward response to these images, a recognition of what they meant as part of their inheritance, the reasons why the marks were sited in those particular places are now regarded as 'enigmatic' and 'mysterious' by us.

What I want to do in this book is to show readers what rock-art is visually, what we know about it, and why there are so many questions remaining. I want to cut through some of the pretentious nonsense written about it and to suggest some ways of studying it so that people may continue to be fascinated and enjoy it.

I

ELEMENTS IN ROCK-ART

Like many terms, 'rock-art' is only partially satisfactory to many and unacceptable to some. A few cupped depressions hammered into a rock with a hard stone pick hardly qualify as 'art', but when we see some of the more elaborate panels we can hardly fail to be moved by the skill with which the motif-makers used their material – rock surfaces with all the natural indentations, slopes and cracks that rock is heir to.

We look first at one surface that has been treated in this way; it is at Ketley Crag, Northumberland, on the floor of a sandstone rock-overhang.

Look very carefully at the way in which the circular patterns follow the rock surface, and how they run into each other and down the slope to suggest mobility and life.

Now we move to Argyll in southern Scotland, to the Kilmartin valley to an almost-level outcrop of metamorphic rock at Cairnbaan, set on a hill.

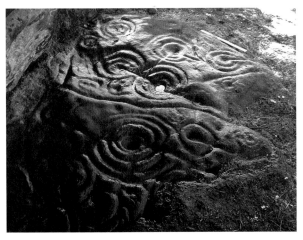 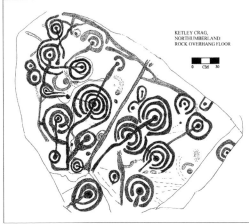

KETLEY CRAG,
NORTHUMBERLAND:
ROCK OVERHANG FLOOR

0 CM 30

1a & b Ketley Crag

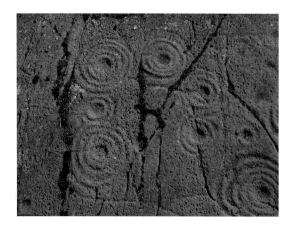

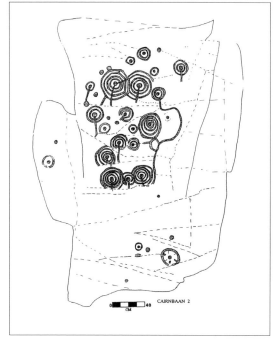

2a & b Cairnbaan

The rock is different from sandstone in that it has been formed under great pressure and heat, transforming it, and has been scoured by ice to give it its more even surface that is, however, pitted with gas bubbles ('vesicles').

It has much in common with Ketley Crag, though over 200 miles away, in that the same use is made of concentric rings, the natural form of the rock, particularly the spacing created by cracks, and the idea of running shapes into one another to create a flow and togetherness.

Even further north, overlooking Loch Tay, is this small isolated slab of sandy-coloured rock, probably carried there and dumped by ice sheets. Although smaller than the other two that we have seen, the whole surface is covered in the same way with circles and grooves.

In all three locations, we can see a similar sensitivity to rock, a common use of concentric rings and great skill in pecking the marks on the surface. Even as images they are impressive, but set them in the landscapes where they belong, where they have survived for thousands of years, where the land surface may have been affected by human activity above the geological 'natural' base, and we get a fuller picture. Draw them, photograph them, laser-scan them as a record, but that record does not convey a full sense of the power of Place. In a sense the images become sanitised, even further abstracted, and a vital element in their existence has been lost. Some laser images can look like dough.

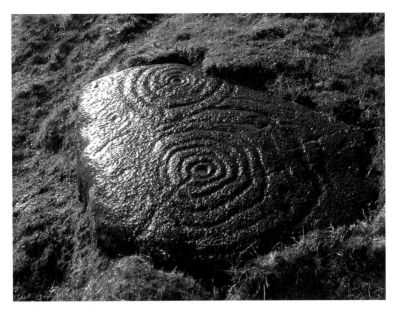

3a & b Loch Tay

BEN LAWERS. SITE 2. NN69051 42652.
Visited by P and B Brown and S Beckensall in May 2003.
Drawing from rubbing: S. Beckensall

BEN LAWERS. SITE 1. NN 69039 42750 1(b) is NN690272 42478
Visited by P and B Brown and S. Beckensall in May 2003. Drawing from
rubbing
S. Beckensall

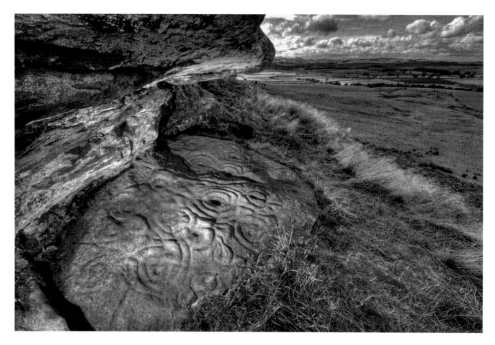

4 Ketley landscape (Brian Kerr)

5 Cairnbaan. People stand by the site

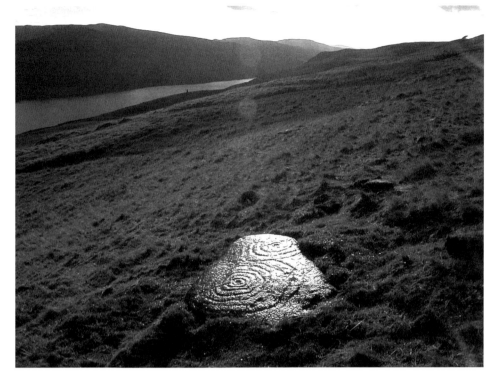

6 Tayside from rock-art to loch

People tend to concentrate on the big pictures, the elaborate workmanship, but that is only a small part of the total picture. The simplest motif in the whole repertoire is a 'cup' – a small depression like an inverted cone cut into a rock with a hard stone shaped to a point or chisel-edge. These cups are not obvious in the wide countryside among all the other unmarked rocks, and can easily be dismissed as 'natural'. Indeed there are natural cup-shaped depressions caused, for example, by dripping water or by erosion working on a weakness in the rock, but when each little pick-mark is visible inside the cup, there is no doubt that they were deliberately made. We can even gauge the size of the 'cutting edge' of the tool, whether it is nail-shaped or chisel-shaped.

These pictures show the marks made by the picks clearly, and with different widths of the pecking tool; others in the book show the same features. The fact that these can be seen clearly today is because the rock has been covered over for centuries or the minerals are particularly resistant to weathering, or a bit of both.

To move these simple cups from the record in favour of the more elaborate designs would be to deny their importance. They were made for a reason, and the fact that some were incorporated in the structure of some

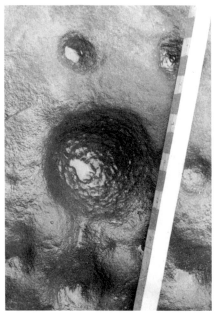

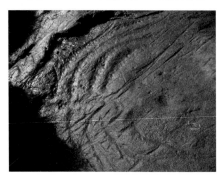

7a, b & c Peck markings; these images are from Eel Hill, Fowberry and Glentarf (George Currie)

cairns strengthens their importance. A Christian who makes a small scratched cross may be no less devout than one who produces an elaborate cross-based design in precious stones and metals. You would not place cup-marked cobbles in a burial cairn unless they were of great significance to the practice of the burial of the dead. Of additional interest is the fact that a mound of stones was often placed over a burial so that it would be seen, but that some cup-marked stones were deliberately placed face-down; this makes it a far more private matter between the living and the dead. More will be said of this practice when I come to discuss the link between rock-art, burials and monuments.

It would not be of great interest to fill a book such as this with thousands of examples of cup-marks on outcrop rock, standing stones or cobbles, but they must be recorded somewhere; usually this is where an archive is important as a complete record of everything found. As the act of making a cup was important, all must be recorded. It can be counter-productive to overdo this in a general work – it would become like those pages of bits of pottery, flint and quartz necessary for full recording but boring in the extreme for most people to read. The skill is how to handle all this material, to select from the detail what are the most significant finds, and explain why. It is an exercise of perception and intelligence. Information is essential to understanding, but is not the same as understanding.

MORE ABOUT CUPS

As there are more cups in rock-art than anything else, I shall now examine some rock surfaces where they occur in different parts of Britain. It is now time to look at multiple cups, combinations of which can produce patterns that we may still find satisfying.

They can occur in random clusters in small or very large numbers.

The Greenrigg example places cups between natural cracks and faults that have been enhanced in the massive sloping outcrop rock.

At Eggleston this embedded boulder has unusually well-made cups. The rock at Finduie Wood has cups of different sizes packed into a space, covering the whole surface in profusion.

On many sites only part of the rock is cup-marked, possibly because some of it was not showing at the time the motifs were made.

We have to accept that it is difficult to know why people should cover a surface with random cups. It is not easy either to understand the significance of cups arranged into patterns. Of particular interest is the way in which cups can follow the edges of rocks as though to define such edges further.

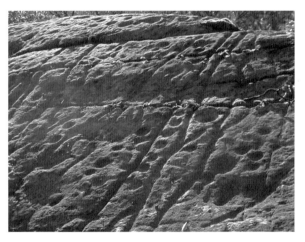

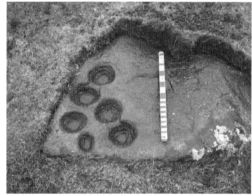

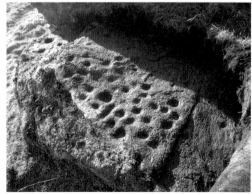

8a, b & c Cups from Greenrigg, Eggleston and Finduie Wood (George Currie)

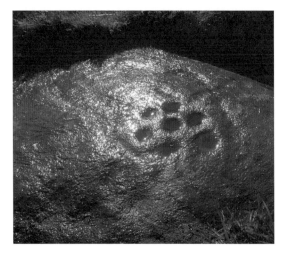

9a & b Rosettes: Goathland and Corrody Burn (George Currie)

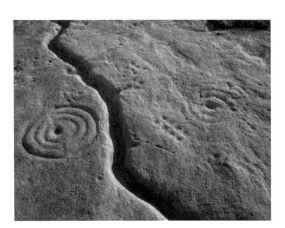

10a & b Dominoes: Chatton Park Hill and Lamp Hill (Aron Mazel)

A rare pattern of cup-marks is known as a rosette, where a central cup is surrounded by a circle of cups.

Further on you will see how these rosettes may be enclosed by circular grooves.

When cups are paired, we call them dominoes. Such arrangements can involve two or many cups.

Whereas cup-marks are very numerous in rock-art, the arrangements described above are not, so it is unwise to use such exceptions to prove conjectural alignments or anything else until there is concrete evidence, as some have recently tried to do. Ultimately we have to say that the art of making cup-shaped depressions was a common practice in the

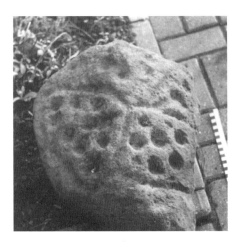

11a & b Zoning: Witton Gilbert and Creagantairbh

tradition, that cup-marks are integrated into more complex designs by using grooves with them, but that complex designs involving only cups are very rare.

An example from Witton Gilbert, near Durham, shows how a boulder has been zoned with grooves that follow the slope of the rock and enclose patterns of cups in differently-shaped enclosures. The example from Kilmartin, at the constricted north end of the glen, has the tail end of the rock divided by grooves.

That brings me to other uses of grooves that make designs more interesting, without in any way diminishing the importance of single or random cups.

GROOVES

As we saw at the beginning, grooves are what make rock-art designs so satisfying, at least to modern eyes. Cups can be joined closely together, touching, to make curved or straight grooves, or grooves can be made more usually by chipping away rock in a continuous line or curve and can form circles, ovals and occasionally pear-shapes.

In some cases it is possible that a ring of cups may have been intended to be linked to form a circle, but were not joined.

The most common link between cup and groove is when a groove leads out of a cup, usually at the centre of a circle, following the downward slope of the rock or sometimes radiating from it. It is very rare for the groove to run up the slope. It is more usual for a circle to be centred on a cup than to enclose a blank space.

12a & b Linked cups, pecked grooves and cups: Whitehill Head (Ian Hewitt) and Chatton Park Hill

Grooves link motifs in a kind of flow-pattern, as we see at Buttony and Achnabreck. The latter was revealed in 2008 when a tree was uprooted in high winds; it is like others on the outcrop further down the slope, often illustrated in many publications, that have been exposed for over a hundred years.

There may be one circle or penannular around a cup (the term 'penannular' meaning a gapped circle), or without the central cup. The circles or penannulars can be multiple, forming an impressive design. In some designs extra grooves can lead from the central cup as radii, giving a spoked wheel effect; they vary in size, with some regions specialising in these motifs.

Multiple rings continue to come to light, as we see in these recent examples from Scotland and Cumbria, both found by independent field workers.

It is rare for a rock to have just one set of multiple concentric circles; a notable design element is that they are linked to other figures. We have seen this at Ketley Crag.

At Blairbuie (*16a*), Kilmartin, almost hidden in dense planted forest, the flow of design comes from the slope of rock, natural cracks and the links between the concentric motifs.

At Old Bewick (*16b*), Northumberland, concentric rings are linked forming a figure-of-eight. Rings or penannulars without a cupped centre are not so common.

An unusual variation is when lines radiate from outside or inside the circle. These examples are from the largest rock-art panel in England, where there are many variations in design, and from a newly-discovered Scottish site at Ballochraggan (*17b*).

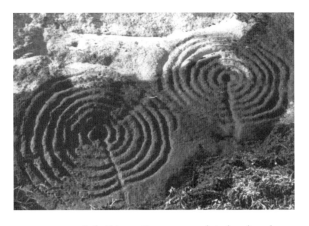

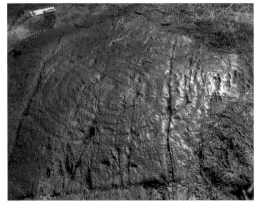

13a & b Rings: Buttony and Achnabreck

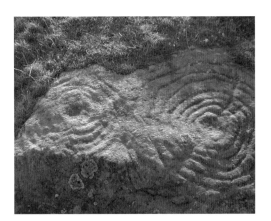

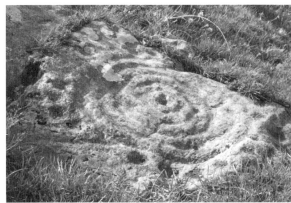

14a & b Rings: Gled Law and Galloway (Jan Brouwer)

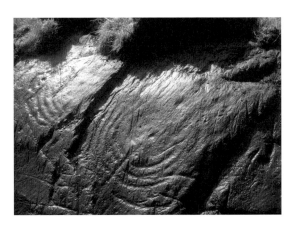

15a & b Rings: Glentarf (George Currie) and Chapel Stile/Copt Howe

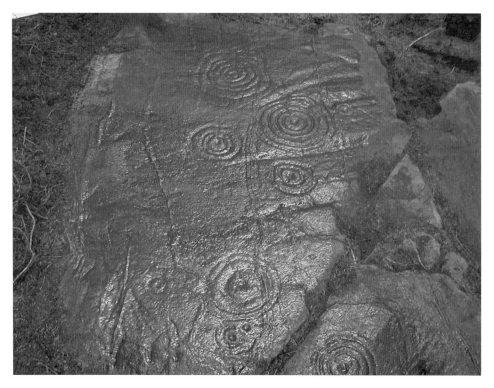

16a & b Rings: Blairbuie and Old Bewick

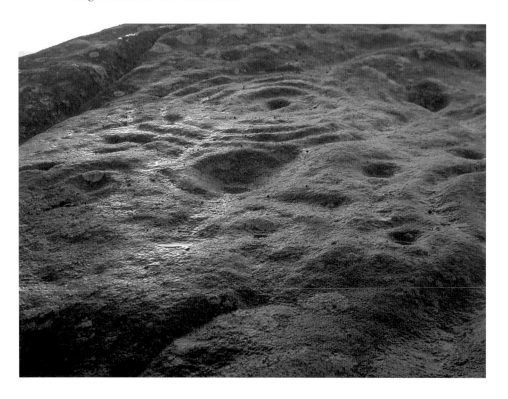

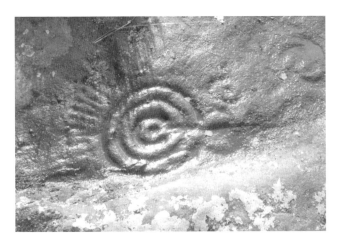

17a & b Radiates: Roughting Linn and Ballochraggan (George Currie)

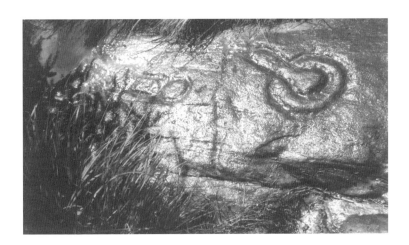

18a & b Keyholes: Stronach and Gayles Moor

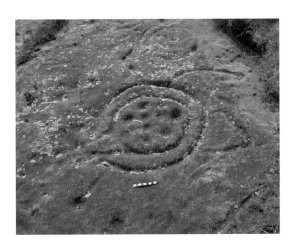
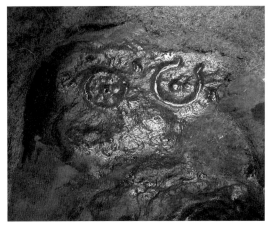

19a & b Rosettes: The Ringses and Buttony

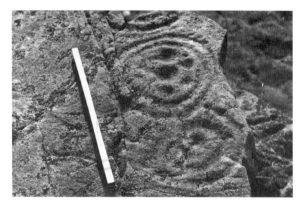 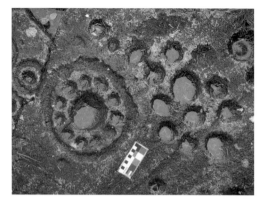

20a & b Rosettes: Harelaw and Ormaig

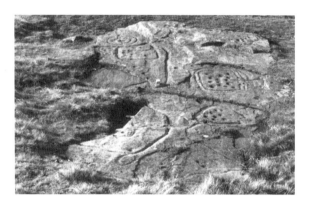 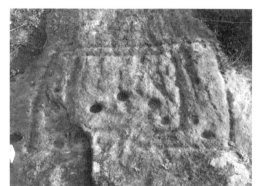

21a & b Rectangles: Dod Law and Amerside Law

The variety of approach continues when we see the 'keyhole' patterns at Stronach (*18a*), Brodick on the Isle of Arran, on a large sheet of outcrop sloping to the sea, or at Gayles Moor (*18b*) on the army ranges in County Durham.

Rosettes of cups that are enclosed by rings are limited to parts of Scotland and Northumberland. Here are two examples from Northumberland (*19a & 19b*).

Hare Law, Northumberland, is a line of outcrop rock that has been partly quarried. Ormaig, Kilmartin, has extensive sloping sheets of outcrop with a commanding view of the sea from a gap in planted forest.

When we encounter exceptional or unique designs, they might be regarded as variations produced by some individual mind getting away from the commonplace to leave his or her mark. Rarities like this make it even more dangerous to generalise about what some patterns 'mean' in rock-art. 'Hey, I've never seen anyone do that' may have been the admiring friends' reaction!

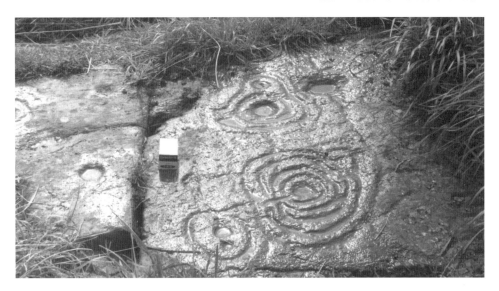

22 Complex and unusual designs: Townhead, Galloway

There are some rectangular patterns and near-square enclosures that enclose cups, with dramatic results. Both sites are in Northumberland.

One of the finest is at Dod Law, which has led people who look in them for plans of houses, settlements and defences to think of it as the plan of a Roman fort, ignoring the fact that the Romans came well over 2000 years later. On Dod Law, excavations have revealed that circular hut foundations of Iron Age or Romano-British date overlie the rock-art, the latter thus being earlier. This kind of analogy is not unusual among shallow thinkers, for in the same way circular patterns have been held to be plans of Iron Age houses. More of that later.

But look again at the Dod Law example. What we see there is a line of cups at the top of the enclosure, an arc of cups below that, three cups below that, and grooves leading out of a gap in the concentric rectangles. Someone had a sense of number-relationships within a panel that had been divided by grooves and which included a heart-shaped groove around cups and the more usual cup-and-ring design. It also had parts of the surface removed so that these unique motifs could be added. We do not know precisely when these things happened. The whole surface has been 'zoned' with curved and straight grooves, and the unique design of this emphasises that this was a special place. Further examples from the county of rectangular and square grooves are to be seen at Amerside Law, on a continuation of the sandstone scarp that carries so much rock-art, also showing that there are some designs which are purely regional. That, of course, is an important consideration when we are balancing the general and the particular.

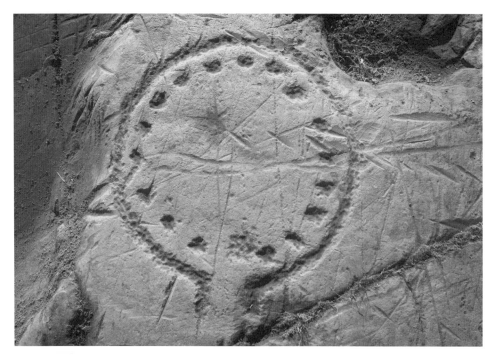

23 Cups in a ring in a ring: Galloway (Brian Kerr)

24 Ilkley: Hanging Stones: unique and endangered motifs. These are on the same outcrop that overlooks the town (Ronald Morris)

The more rocks that are discovered, the more variations on common themes appear. We are constantly surprised to find a pattern we have not seen before. This is a good example in Galloway (22).

Although circles of cups are not unusual, the motif above (23) manages to produce something different, henge-like in structure.

Further examples follow that reinforce the variety achieved. No further comment is necessary.

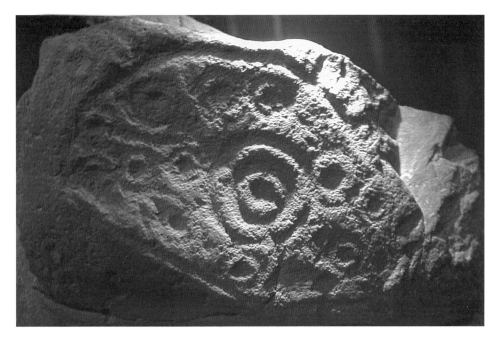

25 Honeypots Farm stone at Tullie House Museum

Above, the large stone removed to safety is, unusually, made of very hard whinstone.

With earthfast rocks there may be less material to work on than outcrop rocks, which may account for the use of the many surfaces that they show; considerable variety in design can be achieved.

SPIRALS

Although the spiral is a common motif produced in many cultures throughout time, it occurs only rarely in British rock-art, and attracts much attention, out of proportion to its frequency.

Irish passage-graves exhibit several kinds of spiral both inside the tombs and on the kerb stones that hold in the mound material.

The spiral (*26*) on a large, fairly rough kerbstone slab has peck marks visible.

Galloway has many spirals out in the open, scattered widely. This example is pecked out on a small flat piece of outcrop rock (*27*).

Morwick, Northumberland, has a great variety of spirals on a vertical sandstone cliff face overlooking the River Coquet, and only one other occurs in the same county (buried in a grave). Another similar site on a vertical face is at Hawthornden, near Edinburgh (*28a & 28b*).

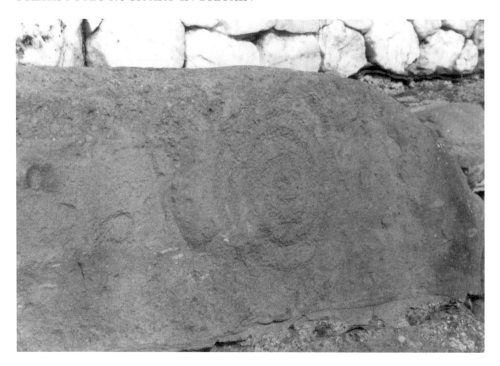

26 Spirals: Newgrange, Ireland

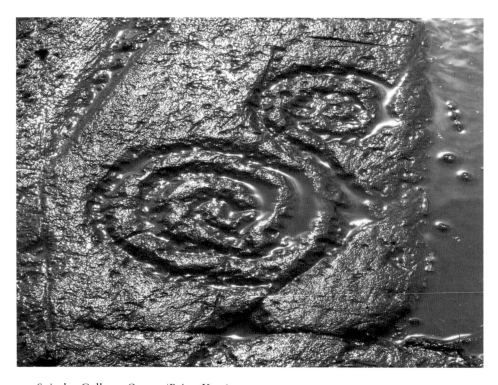

27 Spirals: Gallows Outon (Brian Kerr)

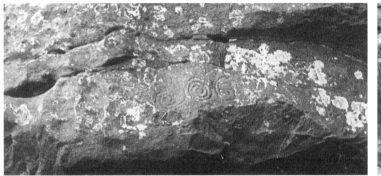
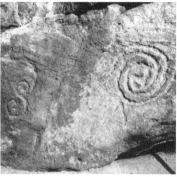

28a & b Spirals on cliff faces: Morwick and Hawthornden (Ronald Morris)

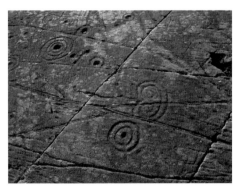
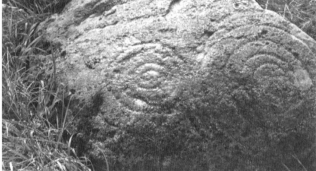

29a & b Spirals: Achnabreck and Little Meg

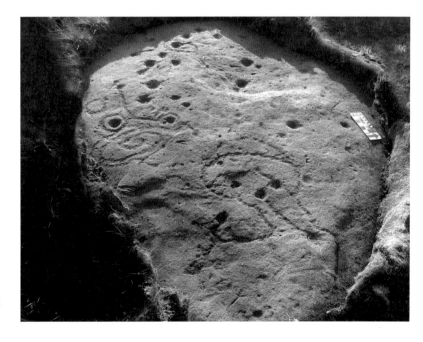

30 The
Barningham spiral
(Paul Brown)

Achnabreck (29a) has a horned spiral and three linked spirals at the top of a long sloping outcrop sheet. Little Meg (29b), Cumbria, links a spiral to concentric rings on an igneous boulder that forms part of a cairn kerb, enclosing a burial that included cup-and-ring marked stones.

Spirals occur in North Wales and Anglesey, but are missing from Yorkshire, Derbyshire and most of northern Scotland.

A spiral has been discovered recently on Barningham Moor, County Durham, by Paul and Barbara Brown, pecked out among other symbols, the first of its kind here. Some of the motifs appear to be rough-outs rather than completed carvings (30).

On Long Meg stone circle, Cumbria, there are strong spirals on the large sandstone monolith, and faint ones on fallen standing stones to the north (see 70a & 70b).

This section ends with a round-up in drawing of these basic motifs and the ways in which they can be combined. The drawings are taken from a wide range of sites across the British Isles and show what variety has been achieved.

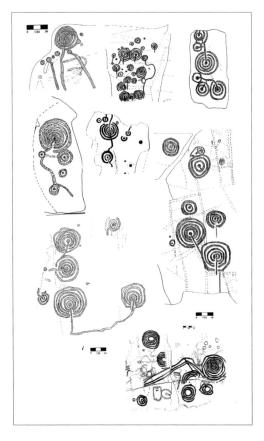
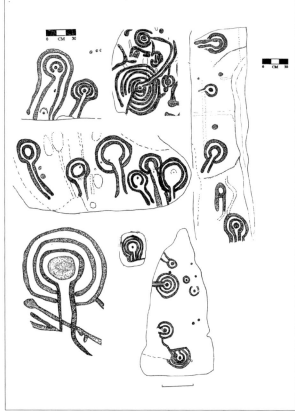

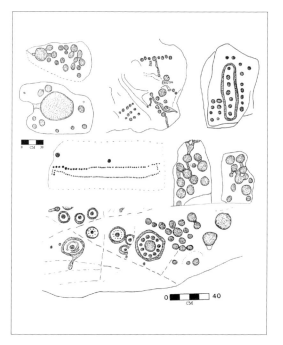

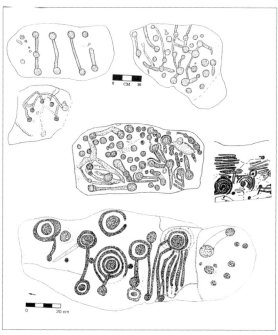

Opposite, above, below & overleaf:
31a, b, c, d, e, f, g & h A round-up of rock-art motifs

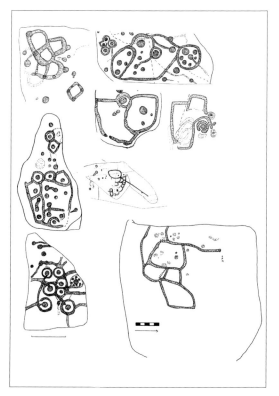

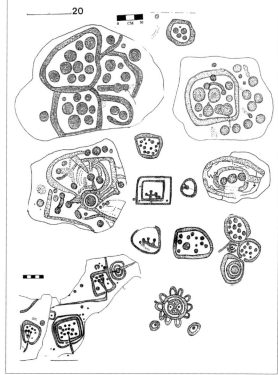

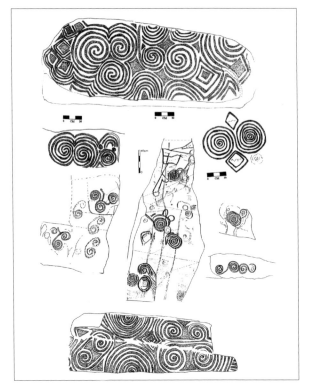

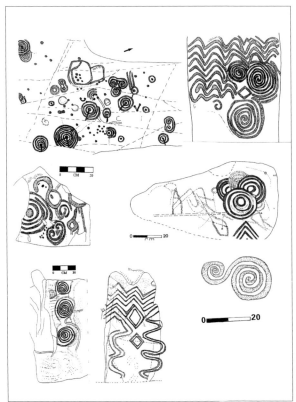

2

PLACES WHERE
ROCK-ART IS FOUND

If I were to go on producing hundreds of pictures of what is on the rocks this may well show how many common elements there are and how many variations are possible, but it does not begin to try to answer who put them there and why. The next step is to look carefully at where the marked rocks are and what else there is of prehistory in the same area, if anything, and to ask questions about why they appear in these 'contexts'.

There is a slight complication in that some have been removed from their original places.

Quarrying, for example, has moved many, as we see in these pictures. At Lordenshaw, Northumberland, an outcrop has been cut through, with wedge marks visible (32). At Gayles Moor, Durham, the sharp edge shows where a slab has been removed.

Some marked rocks find their way into people's gardens and houses as curios, some are housed in museums, and examples can be seen as 'recycled stones' at the end of this chapter.

Some have been reused in burial mounds, as we shall see.

However, there are hundreds left in their original places, and a careful examination of where they are located may hold the key to why they are there and how they were used.

Outcrop rocks with horizontal or near-horizontal surfaces were favoured. A slope, as we have seen, could direct the pattern of grooves to follow it. In areas like Northumberland and Durham the rocks used were almost always sandstones. The same applies to north-west Yorkshire, including the coarser Millstone Grits. Many of the Scottish sites are on metamorphic rocks, tougher and more durable. Given a choice, the motif-makers would favour those easiest to chip into. A condition of rock-art of course is that there must be suitable rock surfaces available, and in many parts of Britain there are none. Elsewhere there are many such surfaces, but only a few were used.

In the absence of good outcrop, people used the surfaces of rocks of all shapes and sizes that had been carried on ice sheets and left when the ice melted. These became embedded in the ground surface and are known as 'earthfasts'. Like outcrop rock, some were targeted by quarrymen. The

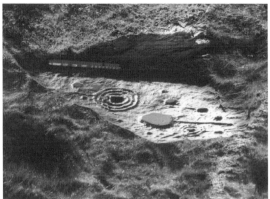

32 Partly quarried motifs at Lordenshaw and Gayles Moor

shapes vary, and as the bedding planes could be tilted, erosion got to work on the tops and fluted some of them into grooves like organ pipes.

A rare place to find rock-art is on the floors or overhangs of rock-shelters, where massive deposits of rock may be faulted and protrude sideways.

The last 'category' is of rocks already marked on outcrop or earthfasts, or about to be marked, which have been deliberately moved to special places, often involving considerable physical effort, and erected as standing stones or incorporated in other monuments.

So, what determines which rocks should be singled out for special treatment? It is clear that in many areas where there are markings some rocks were preferred not because we think they have the best surfaces for carving, but because the slope, indentations and cracks already suggested a design. Otherwise, there may be other considerations of which we know nothing.

One thing that we can say is that decorated rocks are overwhelmingly found in intermediate areas: not necessarily at the highest places or the valleys, but somewhere in between. Another term for these areas is 'marginal', where the land was not the best for cereal growth. Available outcrops are usually found where the surfaces are visible or just below the surface, in areas of thin, sour soil that would not be so good for growing crops, but ideal for rough grazing areas, light woodland where edible and other useful plants could be harvested, and where game could be hunted. In lowland areas where the soil was richer, people established their more permanent farms, defined by hedges and walls. They would have cleared timber away and used it in building houses and fences and for fires. The uplands remained a source of hunting and pasture, a vital part of their economy.

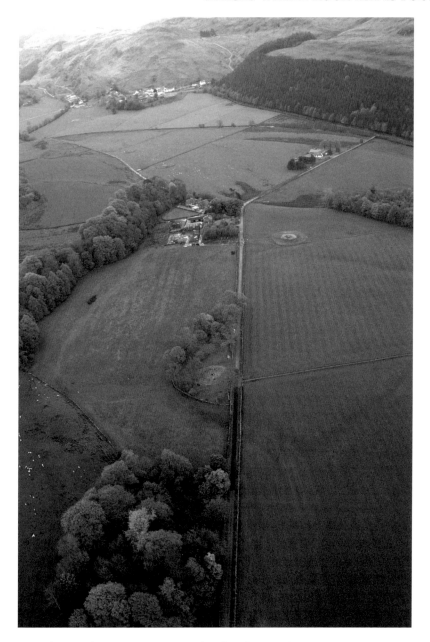

33 Kilmartin linear cemetery, on the glen floor (Kilmartin House Trust)

Although the major monuments lie on the glen floor at Kilmartin, revealed when peat was taken out in the nineteenth century, the rock-art there is generally simple, mostly cups. The complex designs occupy the higher ground above the glen, although to the right there is a line of recently-discovered simple cup-marked stones above the forest.

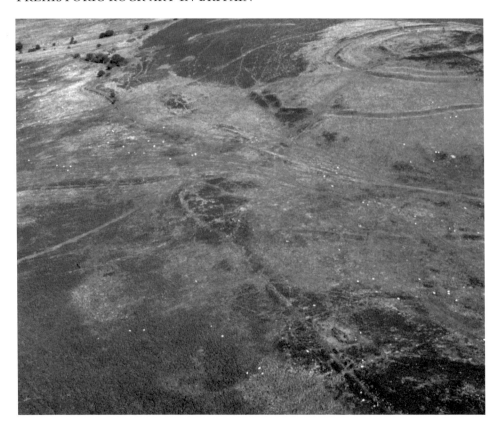

34 Lordenshaw: the rock-art lies in a rich prehistoric and later landscape, featuring cairns and a modified later prehistoric enclosure

It is difficult to know whether the decorated outcrops were at the best viewpoints then; they may be today, and very often are, but there may have been trees in the way. Perhaps decorated outcrop that we can easily see today was hidden in forest clearings. Until we know more about ancient buried soils around the rocks we may not have the answers, and modern archaeology is in some places concentrating on precisely that: what was growing there at the time the markings were made, and what else is now buried in the area surrounding such rocks to make the rock the focus of such treatment.

Many decorated rocks seem to be in places where trails may have existed. Again, we cannot be certain about this, but if we walk from one decorated rock to another from the pattern suggested by maps of their distribution, and if we remember that movement through a landscape would have relied on local knowledge and some more or less permanent features such as cliffs, rivers, streams and of temporary things such as trees, it is possible that they may have acted as waymarkers. This is by

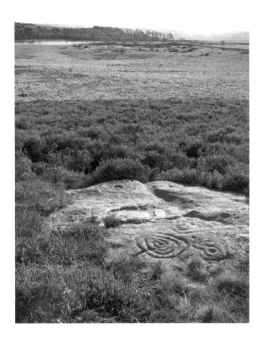

35 Coldmartin: a sandstone scarp site in Northumberland

no means certain, though; it depends also to some extent on what the markings meant. If they pinpointed places in this ancient landscape where acts of bravery, foolishness or death had happened, these could be reasons for making a mark. There is always an urge to commemorate events in all societies, to capture the moment and the place. Thus, for example, a wayside cross may mark a pilgrimage route or the place beside the road where someone has recently been killed and remembered with a bunch of flowers there. People may mark in different ways in different times, but there is the same human response. The strength of feeling about some events brings with it a special 'sense of place', but when many people claim to feel the horror at Glencoe it is because they have been told what happened there. We can colour our reactions to places through knowledge. We can understand, though, that rock-art could mark places where special events have taken place. Could a cup-mark be put on a rock as a 'thank-you' for something? The possibilities are so many that we can only surmise.

So we are brought back to the search for concrete information, something that can be proved, but that leaves us at times with precious little.

Apart from these numerous 'high places', there are other signs that rock-art marked special places. The connection between the distribution of marked rocks and the presence of springs and other water-sources

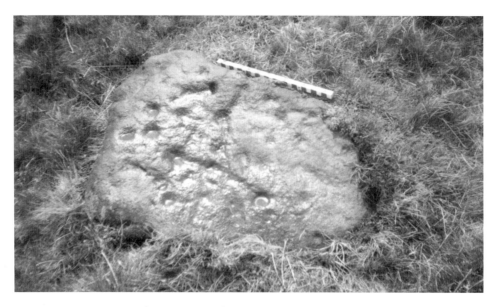

36 A spring source: Gayles Moor (Paul Brown)

is reasonably strong. We take into account the fact that climate has changed over thousands of years, and that the uplands may have been warmer in prehistoric times. Because animals provided food, shelter and clothing, their survival was crucial. For that a guaranteed water supply was essential.

One of the best examples of this is at Coldmartin (*35*), where two natural small lakes are overlooked by decorated sloping outcrop. Among the outcrops there is one major marked rock that overlooks that water supply, a less prominent one and a cup-marked standing stone from two other directions.

At Gayles Moor the grooves seem to echo the flow of water here, as the horizontal decorated slab lies in a hollow where a spring rises.

I now turn to another, less common place where rock-art is found: the rock-shelter. Here are pictures of a site newly-recorded by George Currie (*37*).

'Fixed' places in the landscape include rock overhangs; whereas in some parts of the world overhangs and caves are famous for their rock-art, there are very few known in Britain (which makes the popular blanket-term of 'cave men' for all prehistoric people in the Press so irritating). Northumberland has most of the decorated overhangs, two of which covered excavated cremation burials of the Early Bronze Age and another at Ketley Crag (already illustrated) which has a very elaborately-decorated floor. Another known example near Rothbury was blown up during quarrying. Rock overhangs would provide temporary shelter from

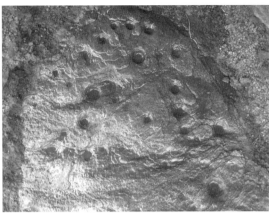

37 Rock shelter/overhang: Gleann Da Eigg floor and landscape (George Currie)

earliest times, but the discovery of a different art form at Creswell Crags caves is the first of the Palaeolithic period, where rare animal forms are depicted, something which does not occur in the period we are examining (the animal forms in the Goatscrag shelter cannot be dated, although many want to claim them for prehistory).

A site that I excavated at Corby's Crag, Northumberland, had an Early Bronze Age upright food vessel full of cremated bone; on top of the overhang was a large basin, ring and groove, and the overhang had been used from Mesolithic to modern times.

Being in the open air creates a different feeling from being in a rock shelter, cave or a chambered tomb. Caves and rock shelters have an atmosphere of mystery, containment, something hidden and perhaps sinister, a feeling carried into the structure of chambered tombs in Ireland, where the tomb-builders actually created caves of a sort, in some cases profusely decorated with images that must have profoundly moved the people who made them, for that is where their ancestors lay, and with them a whole way of life and claim to the land.

To gain access to such places would not have been easy; there must have been rules about when people could enter, why, and what they did there. This restriction would not necessarily have applied to open-air sites, especially as they must have been part of everyday life and movement.

There is a problem, though, which not many people have faced. We know how soon a rock surface may disappear from view with leaves falling on the rocks and soil blowing over, with vegetation taking over. The question is, were the patterns on the rocks visible for any length of time? That alters the whole complexion of how we view them. Did people undertake some kind of caretaking role, brushing off the detritus to keep the pattern visible? These are commonsense questions that are rarely asked.

If, as we assume, the motifs appeared on the rocks over 4000 years ago, for them to remain visible and uneroded until now means that for at least part of their lives they were covered up, protected. Yet with a rock like the great block at Old Bewick this stood so high above the ground that it is unlikely that anything would have grown over it – unlike so many others that have only been discovered by removing the vegetation cover. When we have discovered 'new' rocks and removed this covering, many have every pick-mark visible. Obviously the hardness of the rock and other factors must be taken into consideration; it is clear that rock easiest to mark was chosen, as in Northumberland, for example, where there is almost nothing on anything other than sandstone. Another point to make is that in the same county the sandstone scarps, which provided high viewpoints and trails, not rich in settlements, but used for burial mounds and, much later, fortifications, were favoured in many cases.

We cannot assume that all rock-art has been discovered; far from it. Determined searches have revealed so many in the past few years, and more rocks continue to be found as this is written. Hundreds are now known and records have been refined. Yet a multiplication of known marked rocks does not necessarily solve the problem of understanding them. Particularly fascinating is what determines the choice of rock, when so many 'good' surfaces were ignored, and this makes it important for recording to include all outcrop and earthfasts, marked and unmarked. For a while researchers became interested in 'intervisibility' – how many sites could be seen from another one, but this has an inherent flaw because even if a site can be seen from another, the rock-art is only visible very close to, particularly those which lie horizontally.

It has also been interesting to see how much of a rock surface carries motifs, but this too is problematical because we don't know how much of the surface was visible when the rock was decorated. Thus a border, and other parts of a rock that are left, may not have been a deliberate design element but a matter of necessity or convenience.

It remains now to look at another kind of decorated rock surface; on a vertical or near-vertical surface. Leaving aside the examples on ice-deposited rocks, such as that at Old Bewick where a horizontal line of cups runs round two vertical surfaces, or the many others in Yorkshire and County Durham, we find the most dramatic on cliff faces. At Morwick a sandstone cliff above the River Coquet is covered with spirals, and the same occurs to a lesser degree at Hawthornden, near Edinburgh

This spectacular rock-art is liberally spread on the cliff at Ballochmyle, Ayrshire, overlooking the river (see *colour plate 7a*).

Spectacularly, a massive block of volcanic tuff which fell off a mountain to the valley slope below in sight of the great prehistoric quarries for high-

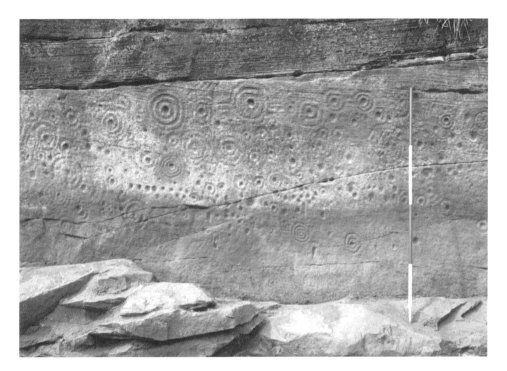

38 Cliff face: Ballochmyle (Ronald Morris Archive)

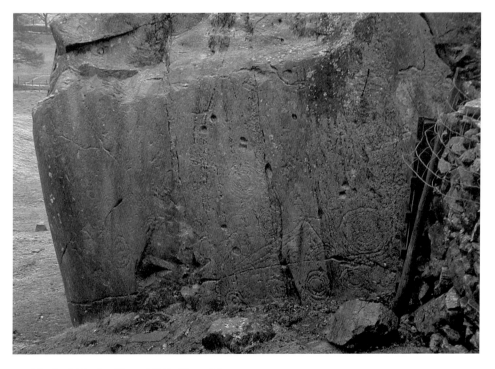

39 Vertical block: Chapel Stile/Copt Howe

40a & b Greenrigg, Patterdale

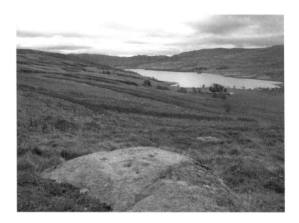

42 Crummock Water

43 Turrerich (George Currie)

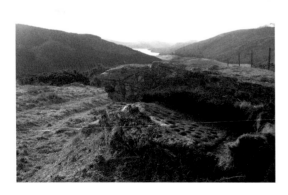

44 Finduie Wood (George Currie)

45 Ilkley: from the Hanging Stones

46 Barningham Moor: from Eel Hill

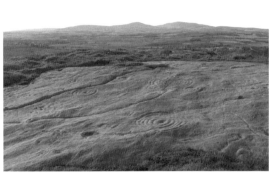

47 Chatton Park Hill west to the Cheviot Hills

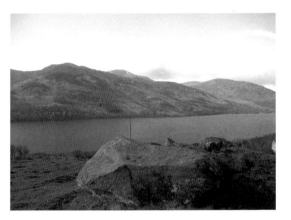

48 Wester Glen, Tarken (George Currie)

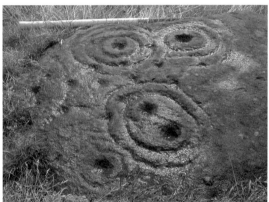

49 Gallow Hill, Tealing (George Currie)

quality axes on Langdale Pikes was decorated with skill and difficulty on its vertical face.

The discovery is recent, and others show that the Lake District has extensive outcrop rock surfaces covered with cups mainly, chosen where routeways take advantage of lower ground and passes. Excellent examples are at Patterdale (Ullswater) and at Crummock Water.

To end this section, here are more pictures that show how many decorated rocks command extensive views.

The next group of photographs adds a little more information on the kinds of earthfasts that have been decorated, and with what designs.

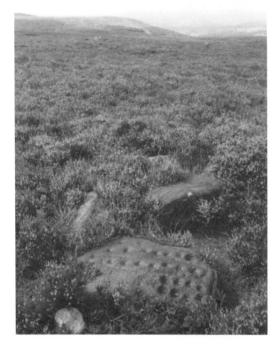

50 The Idol Stone

51 Fylingdales Moor (North York Moors)

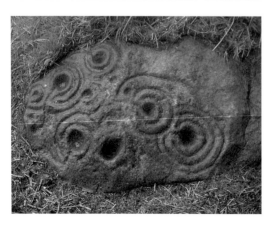

52 West Horton

STANDING STONES

Britain has, or has had, hundreds of standing stones. Many that have been recorded have disappeared, targeted as building stone and gateposts. The remainder continue to excite great interest and speculation, many have been adopted to fit a theory that bears no relation to evidence because, like rock-art, what we do know is not good enough. A site like Stonehenge has produced thousands of words and many theories, but even this well-researched site still provokes arguments and contradictions.

I am concerned in this book with standing stones that have markings on them, either put there before they were erected or added later. It is not easy to know which. They are a very small minority of stones, and this in itself makes us ask many questions about why this should be. Stonehenge's axe motifs were such a late discovery, despite the enormous attention given to that site, that it makes us look carefully at all standing stones in case we have missed something. That means that they have to be viewed at different times of the year and in different light conditions; low slanting light can reveal all kinds of markings that have been overlooked, some natural and some artificial.

Although the south of England has two of the greatest stone circles, at Stonehenge and Avebury, and others of note, northern Britain is the area where most are found. The Lake District, for example, has the well-visited Long Meg and Castlerigg, and the number multiplies as we move into Scotland.

In addition to the circles there are stone alignments, including avenues, groups that are not in circles, and isolated stones. More will be said about their significance, but for now we can look at some with markings on them.

I begin with Long Meg and her daughters. Here a large pillar of red sandstone, probably brought from the cliffs that flank the River Eden, is covered with concentric circles, lines and spirals. It stands outside a circle which is made up of volcanic 'erratics', stones which have been brought in by ice, moved by people with enormous skill and effort, and arranged in a near-circle which respects at its northern edge a huge near-circular ditch which is of a far greater diameter than the stone circle, and is one of three enclosures now invisible except from the air with infra-red film. Two of these northern fallen stones have markings, some of them rough spirals.

Why should the largest standing stone have such elaborate decoration? The sandstone was easier to work, the decoration may already have been on it when it was brought to the site, and it may have been erected before the circle, or after, or at the same time. Lots of questions again, but no definite answers.

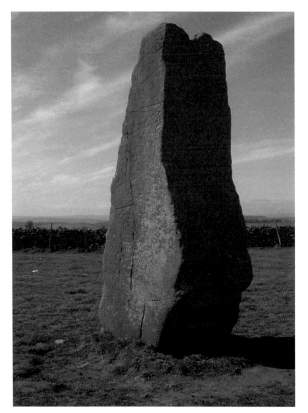
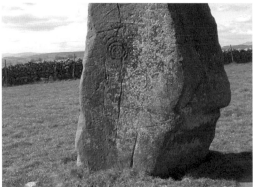

53a, b & c Long Meg and her daughters

From the many examples of marked standing stones, I shall picture a few, with little comment, as the way the decoration has been applied is clear. Just as the outcrop and earthfast rocks exhibit many different motifs, so do these standing stones, but most carry simple cup-marks.

Also included are the Scottish 'recumbent' stone circles, where cup-marks appear on some of the most significantly-sited stones.

There are some fine examples of more complex markings, such as these:

The Croft Moraig stone circle, Tayside, has a cup-marked stone at its centre and cups and rings on outer stones. Sir James Simpson illustrates some in his work, including Moonbutts in Perthshire, and many have been recorded in Ireland. For example, in County Donegal, five of the standing stones have cup-marks out of 65, and one has a cup-and-ring. In the same county there are five other decorated standing stones, three of which are decorated on two faces.

One now-destroyed avenue at Shap in Cumbria, which ran for a

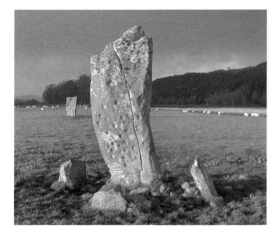

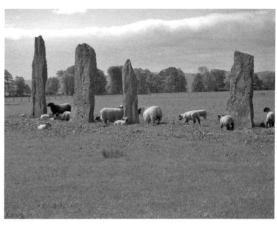

54 Nether Largie standing stones, Kilmartin

55 Ballymeanoch standing stones, Kilmartin

considerable distance, still has two stones left with decoration.

Only a few are illustrated here as examples, but there are two points to consider: the first being their rarity and the second that they were deliberately placed on monuments that everywhere suggest that they were important meeting places.

BURIALS

If we assume that rock-art of the cup-and-ring type belongs to a period 5000-4000 years ago (Late Neolithic to Early Bronze Age), to a time when settled farms were established, rather than hunter-gatherers having to move around much of the time for their food, this period roughly coincides also with the time when the burial of the dead was an elaborate ritual. There were some 'long barrows' and thousands of round mounds built to cover burials, where they could be seen. Rock-art is not usual in either, but there are many sites of round mounds where the burial included cup-and-ring marked stones.

The practice was to dig a pit into which the body or cremation was lowered and then to cover it over. Another common practice was to insert slabs of stone into the pit to contain the remains, and then put a slab of rock over it before sealing the whole thing with small stones gathered from the surrounding fields or river/stream beds. It depended on what was available locally. Many of these mounds have been dug into by people either looking for treasure or to find the body and 'grave goods' for more scientific purposes. Enough of these mounds have

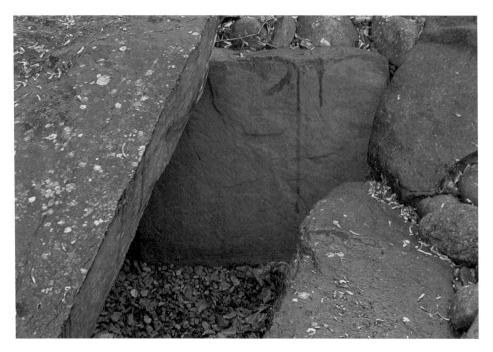

56 Axe motifs at Ri Cruin

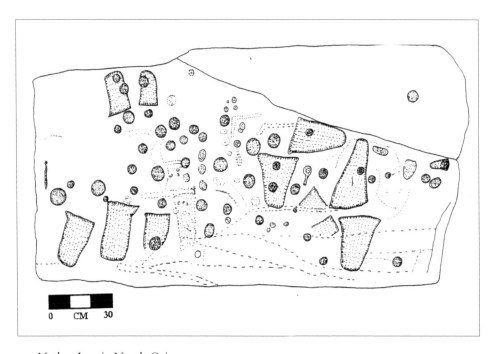

57 Nether Largie North Cairn

been excavated in more enlightened times, with a range of new dating techniques available, that it has been possible to date the contents of the burial. When a type of pottery has been dated, for example, in sufficient numbers, it then becomes possible to say what the date of the burial was without necessarily having to radiocarbon date it. If we find a marked stone within the burial this is not necessarily the same date as the burial, because it could have been broken off a rock carved much earlier and brought in because it was important. That is why some of those recorded are found to have pieces missing from the design. However, they were chosen carefully to include more than simple cup-marks. It is very likely that if a slab or cobble inserted in a burial has unweathered markings on it and is complete, it was made especially for the burial. We have examples of both things.

Decorated cist slabs were reported by antiquarians from the time that interest began to grow in rock-art, with a tendency to date them all to the Early Bronze Age, so that was the date generally thought likely for cups and rings. We now know that the tradition is earlier, and continued through the Late Neolithic/Early Bronze Age. In a way 'Late Neolithic' is more accurate, as bronze was only beginning to appear. Bronze axes carved on cists in Kilmartin Glen are unique, and obviously people were manufacturing bronze axes at that time or at least knew of them (58).

One cover from a cist in County Durham was almost certainly made for its Late Neolithic burial, as the cup-and-ring motifs on one face are not only clear with all the pick-marks showing, but the other side has simpler decoration of cup-marks only. This would have been unlikely to be taken from outcrop, and even if it had, the fact that it was decorated on the underside makes it intended as a well-fitting cist slab, with no part of the decoration removed. It can be seen in the Fulling Mill Museum, Durham. In the same cist there were two other decorated stones used to prop up the cist cover (58).

In a recent excavation at Balbirnie near Inverness a very unusual slab was found in a conventional Early Bronze Age round cairn that came from another monument, according to the excavators. It is not in the cup-and-ring tradition and is thought to be from an earlier Neolithic site nearby. However, the same grave has cup-marked stones too.

These examples of decorated cists will suffice, but of course there are more to support the general conclusion. Again, more recently, two cairns that I excavated at Fowberry and Weetwood in Northumberland demonstrate another interesting discovery about the use of rock-art: that one cairn built directly onto profusely decorated outcrop rock has marked stones in its kerb and among the cobbles that made up the mound. Not far away, there were even more marked cobbles in a partly bulldozed mound and a large rounded kerb stone had cup-and-ring motifs facing

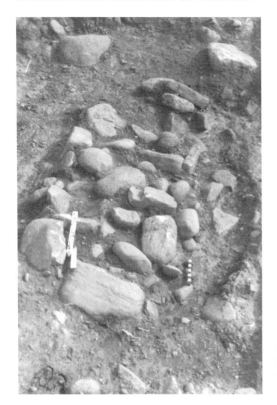

58a, b & c The Fulforth Farm cist before complete excavation (*left*), with a deposited polished stone axe blade facing upwards (by the scale); the underside of the cover (*below*); and one of the marked stones used to support it (*above*)

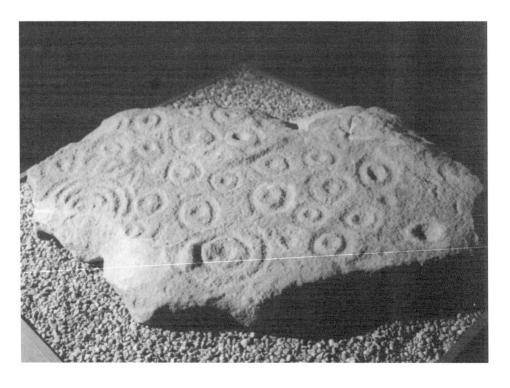

59 Loughcrew

into the mound. Those cobbles which remained in the mound were placed with their decoration face-down. In neither case was there a burial, as burials in that area had been rifled in the past, but nearby is another round mound built partly against marked outcrop with the remains of a disturbed cist lying around, one decorated slab being possibly the cap-stone, with other cup-marked stones protruding from inside the mound. The site remains unexcavated in modern times, and there is probably more to be found there. After my excavations I discovered another marked outcrop at Hunterheugh with a possible cairn built on top, disturbed by a later prehistoric wall that ran over it. This has now been scientifically excavated, but I cannot share the conclusions about the chronology of it.

The North York Moors are rich in burial sites, including the massive cairn at Hinderwell Beacon with more marked cobbles in its structure than anywhere else. Recent recording by Paul and Barbara Brown now shows that many more cairns have marked rocks in their structures than had been realised, and excavations are producing even more.

I had often wondered why the decoration on pottery was not also used on rocks, and the fire on Fylingdales Moor produced a marked kerbstone where the barrow contained usual and unusual rock-art. Here we saw lines, triangles and dots in a very integrated pattern that resembled decoration on beaker pottery. Unfortunately, at the time this was heralded as the

oldest rock-map in the world, which was, alas, purely conjectural and wrong. However, as it lay in an exposed landscape where there are many other cairns and marked earthfast rocks, after its initial discovery it was partly and competently excavated. This new discovery has emphasised that because of rocks already discovered and recorded there by independent, painstaking researchers (even before the burning of the heather made everything so much easier to find) rock-art is a complex part of a 'ritual' landscape set aside at least in part for the burial of the dead.

When we move to Ireland and Scotland to where there are 'chambered cairns' or 'passage-graves' we see rock-art used in a more dramatic way. Again, we must weigh up the examples against those cairns which have no known rock-art, and conclude that the marked ones are as yet in a small minority. However, the quality and placing of these images inside and out makes the cairns very special and helps us in some ways to understand how rock-art might work. One main group lies in the Boyne valley and the other at Loughcrew (59).

There are two positions for the art: on the outside kerbs which hold in the enormous quantity of stone which went into their construction and the decoration on the walls and roofs of the passages that form the central construction, over which the dome of cobbles was placed. The kerbs have some famous decorations, largely of spirals, zig-zags and u-shaped grooves, although there are fainter and apparently unfinished decorations too. Other major sources of these are at Newgrange and Knowth.

Inside the mounds are passageways made of large vertical and horizontal stone blocks. The passageways lead narrowly to chambers, some of which contain bones and a large decorated bowl at a central place where it was easier to stand upright. This chamber had over it a corbelled structure (stones overlapping as they narrow upwards). The interiors are like large artificial caves with a profusion of images cut into the rock which create an awesome feel. One particular feature at Newgrange has always captured people's imagination: a rectangular slot above the entrance which admits the rising sun into the passage leading to the central chamber at a significant time of the year, decorated not with circles or spirals, but, like so many other stones in the mound, with motifs that are lines, zigzags and lozenges. Outside the entrance is a huge elaborately spiral-decorated pillow-like boulder, with a division in it that seems to echo the idea of an entrance. The 'linear' decoration and spirals distinguishes some passage-grave art from the cup-and-ring type.

Some of the slabs which are built into the interior were found on excavation to be covered with different kinds of motifs, suggesting use elsewhere and a change in style.

What is so arresting is that all these passage-graves have such a wide variety of ornamentation. At Loughcrew there are further variations that

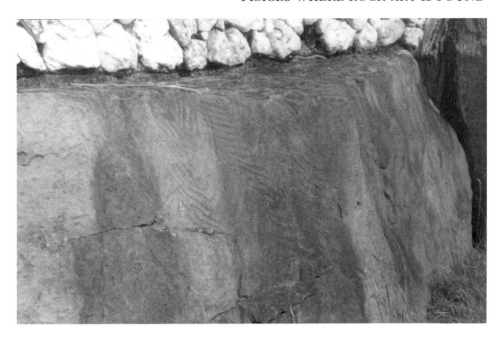

60a & b Newgrange kerbs

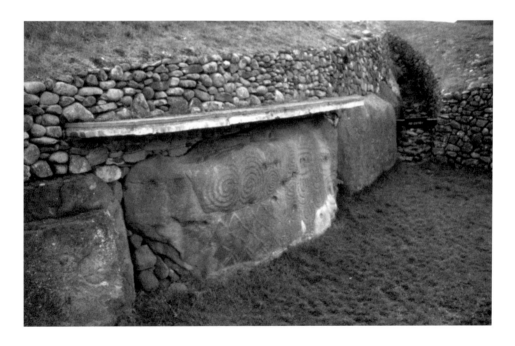

have been recorded, and pictures of these would be worthy of a book in their own right.

The rock-art in the smaller, more common and more numerous burial cairns all over Britain does not match the passage-graves, and the latter

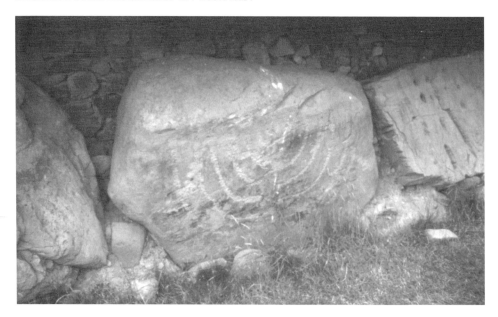

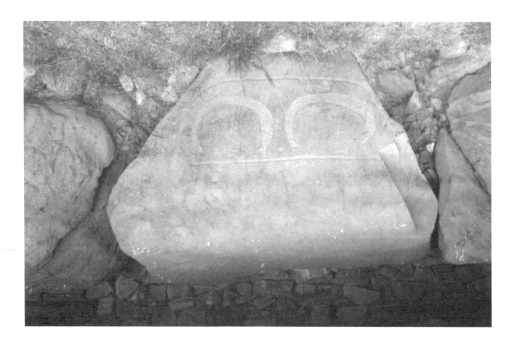

61a & b Knowth

have therefore been thought of as of a different period and culture. Other passage-graves of this type are found on Anglesey, and some of these and Orkney monuments have spiral carvings. However, we must remember that spirals are not confined to passage-graves, and those that are not do not have to be of the same age.

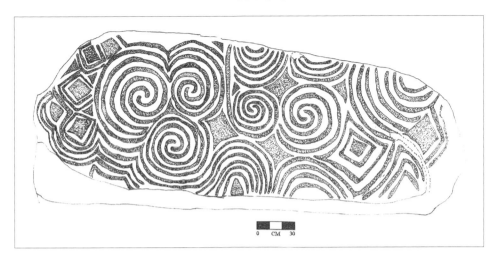

0 CM 30

Above:
62 Newgrange
entrance

Right:
63 Loughcrew art

Recent work at the Clava Cairns, Inverness, once thought to be an offshoot of Irish passage-graves and of the same date has proved them by excavation to be around 2000 BC rather than earlier Neolithic, and that all the monuments on that site are of the same date (*64*).

Burial mounds with prominent kerbs that may not be continuous like those in Ireland have in some cases rock-art on the odd stone, like Glassonby in Cumbria. Others, like Little Meg in Cumbria have decoration on the scattered kerbs and rock-art within the burial structure itself – in this case the concentric ring motif deliberately runs into a spiral (*29b*).

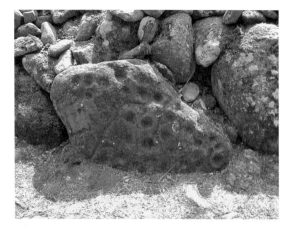

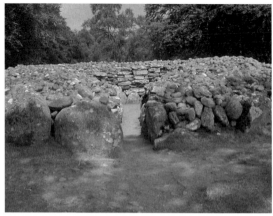

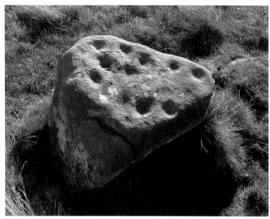

Above left and right:
64a & b Clava Cairns: rock-art on a kerb stone and a view through a passageway

Left: 65 Prominent cup-marks on the Goatstones four-poster

It is impossible for me to cover every example of rock-art in burials in Britain, but I want to add one other type of monument: the 'four-poster', where four low stones are arranged in a rough square around a centre which may have contained a burial. At least one of the tops of some of these four stones has cup-marks. Although generally four-posters belong to Scotland, there is an example at Goatstones, Northumberland, where not only the 'posts' have cup-marks, but so do many small stones in the vicinity.

'RECYCLED' STONES

Some rock-art has been recycled with no indication of where it might have come from. I choose these examples:

This shaped stone, retaining the central pattern of concentric rings, is built into the outside wall of a house near Bellingham, Northumberland.

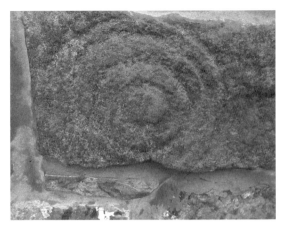

66 Recycled: Houxty house wall and Tealing souterrain

In later prehistoric time (Iron Age) this complex design was built inside the tunnel of a souterrain at Tealing, north of Dundee; this is a banana-shaped tunnel which probably served as an underground cold store. On top a flat slab covered with cups has been left.

In both cases the stones may have been regarded as curios and chosen for their decoration.

There are three other examples at Wallington, Northumberland cemented into the pier that supports an eighteenth-century bridge.

3

THE SEARCH FOR MEANING

Ronald Morris, an independent archaeologist who did an enormous amount of work to further the study of rock-art, began work in his native Scotland. He produced an archive which included a collection of over 100 possible explanations of rock-art; this became widely-known and much quoted. I am not going to go over these again, as they have served their purpose and because hardly any of them are convincing because they are unsupported by evidence, but they do show how fascinated people have become by the problem and how reason is not to the fore when speculation abounds. One that Ronald added was a reason that I cannot share: that there was some sort of 'magical' connection between rock-art and the search for metals.

To his list we can add many more recent ones, again a mixture of plausible ideas and downright silliness.

When I became interested in rock-art I was living and teaching in Malta, where the spirals carved and painted on megalithic temples above and underground posed questions which we are still struggling to answer. At that time they were thought to be associated with sculptured depictions of a fat fertility goddess, prevalent in many Mediterranean areas. It seemed a reasonable link that as all life depends particularly on the fertility of the woman, the symbols were somehow connected with that idea. Spirals may have been seen as a kind of sculptural depiction of our genetic continuation and that of all other living things on which we depend. My move to Northumberland brought me face to face with a different kind of rock-art at Old Bewick, which, unknown to me at the time, was where the serious study of British rock-art began in the 1820s. Like so many others before me, I looked upon this panel and wondered. The place was dramatic, open pasture and moorland dotted with prehistoric remains, including burial cairns and much later enclosures, with no signs of Neolithic fields or houses; the great block of stone with its decorated and horizontal surfaces is very impressive in its own right, commanding views from an exciting scarpland landscape stretching to the Cheviot Hills.

67 Malta spirals (replicas) at Tarxien temple

So what did I make of it? I was in the same position as most people, moved but ignorant, though with the helpful addition of some years of experience of excavation and research in Sussex on prehistoric sites. I brought to it my Malta experience, made the common error of trying to attribute the same motives for carving that applied in that ancient, unique civilisation, and thought that the concentric rings penetrated by grooves must in some way be connected with the fertility goddess. These were fertility symbols. But they weren't spirals; that didn't matter because I was to learn that we had spirals carved on a cliff face and placed in a burial. The total effect of circles and spirals was similar. Having got this idea, I found it difficult to shake it off because I could not find a convincing alternative. At least I did not think of them as idle doodles or purely decorative. Although my family and job absorbed most of my attention, I found time to pursue the matter further, naturally at my own expense and in my own time. I looked at maps, visited known sites, and read whatever I could find, often small articles in a variety of journals. Fortunately, as it turned out, the theory absorbed me less than the practical task not only of recording what was known, but of finding new sites as I developed a sense of where they lay in the landscape. I found too that many local people were very interested in this, so I began to include it in my talks and classes, arranging visits,

68 Old Bewick
(Birtley Aris)

and from this sharing I learned from other people. Eventually I built up an enormous collection of information, a library of slides and prints, rubbings and drawings. The University of Newcastle on Tyne, later to give me an honorary doctorate for this and to put all my work onto a website, never at that time asked me to meet them to discuss it. It is not uncommon for the 'independent' researcher, who is not paid by an institution to do the work, to be disregarded, even now. That is a grave mistake, as most sites are still found by people who are not part of any institution.

I put this experience forward because if we believe that we can understand more about the meaning of rock-art we have to collect all the available information, and most of it comes from workers in the field. Just look and see who has found what! It is all in the written record and on websites.

INTEREST IN PLACES

Contact with Richard Bradley and his Reading students with their scientific approach to research began to change the way I thought about rock-art, but what this has led to now is a confirmed reluctance to make

any emphatic declaration of what I think it means or how it originated. Much more likely is an understanding of why it is where it is and how it might have been used.

Many years ago Richard Bradley became fascinated by rock-art which he first saw in the Ilkley region of Yorkshire; he reacted to the places where he saw it, and his instincts told him that there was a pattern to its distribution. He said that he had to investigate scientifically how that original instinct came about and how it had to be pursued. The result was very important work putting everything to the test with his students from Reading University, and this had an impact on my thinking too. The results of his work are in print and work continues – all essential reading for scholar and everyone else interested in rock-art. He would be the first to admit that not all the questions about rock-art have been answered.

His emphasis was at first on where rock-art is sited; he accurately recorded it, examining places where some rocks were marked and others not, looking at whether there was a reason for this. He was not looking for more sites but using the data that others had already recorded, as there was plenty to work on in areas like Northumberland and parts of Scotland; of course all the other rock-art areas were visited to complete the picture, but not for such intense study. The result of all this I have already incorporated in my work. What was vital to me was another way of looking at what I had discovered and using a new discipline to understand it. Meanwhile all of us involved in rock-art study were comparing what we had discovered with other European sites, with Richard Bradley at the time being particularly interested in Galicia, Spain.

WHY CIRCLES?

After all these years, including the excavations on prehistoric sites, I come back time and time again to the ways in which prehistoric people loved circles! The most important 'non-domestic' structures in Britain, those with no apparent practical use, absorbed enormous energy and time. Most rock-art is circular, from individual cup-marks (most numerous) to more complex multiple concentric circles, with spirals as a kind of minority variant. I look at rock-art therefore as part of a larger landscape, not separate from it. The choice of circles for ditches which enclose areas where communal activities took place that we might call 'religious', but which also had a function of community centres or supermarkets, dominate the landscape. Circular ditches, rings of wooden posts, rings of stones enclosing other rings of stone and wood, avenues leading into them, and a wide range of circular burial cairns

– even the foundation of houses – have the same basic pattern. A circle is relatively easy to construct with a length of cord/twine/tendril and a few sticks as markers. There are, of course some variations like flattened circles and ovals.

Easy to mark out, but what else? In a life lived in the open, farming and hunting, all was seasonal – a time to plough, sow, reap, to move on to new pastures or food supplies that could be gathered. Keen observation of the heavens found its record in the way some alignments in stone and wood were set up, concentrating on phases of the moon and position of the sun. The length of day and night varied, tides rose and fell under the influence of the moon, the world became hotter and colder in turn: life was cyclic.

In the heavens all stars and planets, the moon and stars would have been more visible, brighter than our light-pollution allows us to see them. The sun was always a circular disc, the moon was only circular for part of its cycle and the stars and planets may have been seen as circular holes in the blackness. Anything else? Breasts, womb, testicles, depicted in many ancient statues, were the means of reproduction and continuation of life. It is reasonable to assume that people saw their world as circular; as individuals they were at the centre. Such a pattern too was seen also in tree rings or ripple marks in water when a stone has been thrown in. As communities they would gather at established sites to feast, to affirm their position in this universe, to ask that good fortune would attend them and to respect their ancestors.

The Late Neolithic and Early Bronze Age burial structures were mostly circular, although there was a tradition too of the long mound and the rectangular house. However, even if you accept the importance of the circle at this time in prehistory as a motif as well as a practical element in construction, there is a problem. Rock-art exists in only a few stone circles, burial cairns, standing stones, and it exists in some places where there are none. It is not found in some landscapes for the obvious reason that there is no suitable rock. It could be that people may have tattooed circular motifs on their bodies or on perishable materials such as leather, wood or cloth, but we don't know that.

'CONTEXTS': WHERE ROCK-ART IS FOUND

So we may be generalising too much when we examine these contexts for rock-art; all we can hope to do is to see if there is any rhyme or reason for including them in burials or on standing stones. The significant position of decorated outcrops and earthfasts in the open-air is, literally, firmer ground for speculation, for there are thousands of examples out there.

STANDING STONES

With that in mind, I shall look first at standing stones. Some are too scattered and too sparse to be of much help, but there are some places where they are clustered, as at Kilmartin Glen.

Standing stones have been the subject of weird and silly speculation. One theory that was taken seriously and televised at some length was that the Heel Stone at Stonehenge was the sky god's penis and the horseshoe-shaped arrangement of stones the earth mother's reception of it. The crop circle phase, despite demonstrations of how they were made, captured public attention and belief in some sort of extra-terrestrial presence for a while, and no doubt other temporary theories will take their place. There is obviously a public need for mystery and sensation. All sorts of alignments have been discovered; it is possible to align anything with anything, and it becomes tiresome to see yet another photograph of the sun setting behind some upright or supine piece of stone with some sort of claim that this is significant. Draw lines on a map that pass through prehistoric sites, ignoring some that don't fit and forgetting that some may still be buried, do the same for telephone boxes and pillar boxes and we have the believers signing up to mysterious lines of force. All this can obscure the possibility that there are valid alignments, carefully

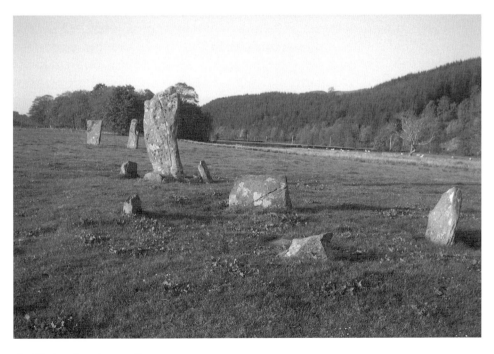

69 Nether Largie standing stones

researched and proposed. Wishful thinking and determination to prove a theory are hardly the stuff of reason.

Those alignments with movements of sun and moon emphasise how important they were to our very existence. The sun's appearance at the solstice was not only celebrated but marked out. In circles the sun and moon are brought down to earth, metaphorically.

When I am speculating and can only partially prove what I am thinking, I prefer to come clean by writing poetry. Standing stones are particularly impressive, the larger ones more than most. There is something about planting a stone in the ground that demands attention; it is unnatural, though made of natural material. There is a stillness about standing stones as though they are waiting. To people who wandered the landscape and suddenly encountered them, there must have been a sense of awe. Many stones weigh many tonnes, there were many more than now, and great effort went into shaping and transporting them. Add to those the rings of wood or circular ditches and we have a land where attention to something more than the domestic was a priority.

Of particular interest to rock-art researchers are those stones within a circle or part of a group which are marked. An outstanding example is Long Meg in Cumbria, one of many monuments in the area that includes such other outstanding sites as King Arthur's Round Table and the Mayburgh Henge. Long Meg, a different stone from all the others, being sedimentary red sandstone, commanding all-round views above the slope that houses the other stones, is unique in its decoration. Here we see not just completed spirals and concentric rings, but the beginnings of designs pecked into the naturally lined but quite flat surface. Many different kinds of motif are displayed there, including lines which follow the natural structure of the rock. Because of the difference in depth of these motifs, some may have been added and others left unfinished. It is not uncommon for designs to appear incomplete to our eyes, but the carvers may have thought that even the act of hammering out some symbols was sufficient for their purpose. It is rare to find superimpositions which indicate that marks were put on at different times, and even if they were, the new motif could have been added the next day. Here, then, is a profusely decorated stone that may have preceded the rest of the circle, lying outside it, not accurately placed outside the entrance to make it central to that entrance, possibly brought from the cliffs over the River Eden where it might already have been marked in situ like the spirals on the cliff at Morwick or Hawthornden, or the crowded images at Ballochmyle, different in material from the glacial igneous erratics that make up the rest of the circle, and dominating it by its aloofness and height. The spirals are echoed only on one fallen monolith on the north side, scarcely to be seen except in very low light. The site itself is one of four, one stone circle

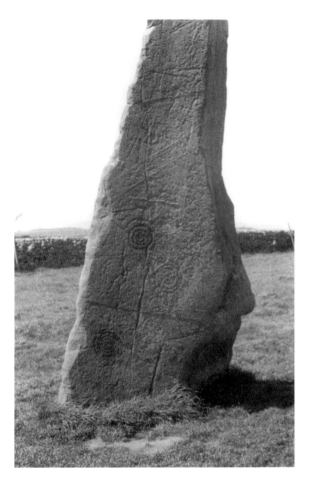
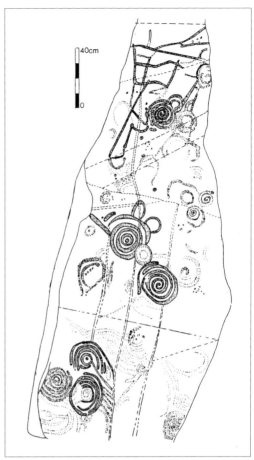

70a & b Long Meg (photograph by Paul Frodsham)

having been destroyed and the other two showing up on infra-red film from the air. The largest buried circular ditch has a flattened arc which the stone circle respects to the north and is much bigger. As no excavation has been done, we do not know what all these circles were used for, and surely this should be one of the priorities of British archaeology if we are to understand what they are all doing there, what the relationship is between them and the significance of the decorated sandstone. However we see it, the rock-art occupies a very important place in the arrangement of ditches and other standing stones. It may be earlier than everything else, the first thing to be erected on the site, perhaps having been transferred from over a mile away, either as good material or already a monument in its own right. Oddly enough, despite its fame and position, no one until quite recently has bothered to examine the profusion of decoration or to record it accurately since Sir James Simpson in the nineteenth century. I

71a & b Balkemback stone: two faces

have done this, and since then the rock surface has been laser-scanned, so we are making some progress.

There are very few stone circles with such markings, so in many ways Long Meg is a one-off. That it is the only example in its area gives us pause for thought and prevents us from generalising.

One of the finest decorated standing stones is at Balkemback, north of Dundee, which is decorated with cups and rings on one face and an arrangement of cups on the others. It is very interesting in that those who chose to decorate it put the simple cups on a flat surface and the more complex design on the rough surface, the latter example showing how the structure of the rock often directed the design. The site cries out to be examined further as a cursory tour shows that there may be hidden features. It is time for archaeology to reconsider its priorities.

Groups of standing stones are found on the floor of the Kilmartin Glen, thanks to their survival under blanket peat, along with lines of round cairns and two stone circles. One of the circles has spirals that link on two faces of spaced standing stones in a structure that has been modified for hundreds of years to accommodate cist burials and small cairns, a good example of the continuity of use of special sites. Fortunately this has been excavated using modern methods so that we know how it developed, beginning with a nearby circle of wooden posts, changed to one of stone, then abandoned in favour of a new one a few metres away. One of the spacer stones that separates one standing stone from another has cup-marks. One standing stone has two concentric rings, and another has spirals that run round two faces of a standing stone. It seems likely that these were later developments in the use of the site, but it is always difficult to know whether markings were already on a stone when it was brought in to build a monument

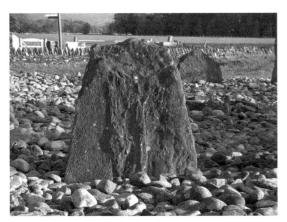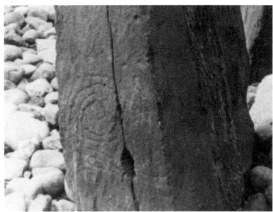

72a & b Temple Wood Circle: the site and spirals

or added later. The spiral in particular is a very unusual design and unique to this area.

Equally outstanding in this area are the standing stones in two groups, some of which are marked. One group is in lines. The other is a more complex pattern of standing stones in lines but with a central arrangement of smaller stones clustered around a large monolith decorated with cups and cups and rings.

When people look at these motifs they try to equate them, naturally, with something that they already know. Spirals: of course, Maoris paint them or tattoo them on their bodies. Concentric rings: hundreds in Australia. People doodling at meetings often produce marks similar to those in rock-art. The universal nature of some art forms can be something rooted in the human psyche, images that we all share. Children use such images when they are free to paint, draw or make marks in clay.

Unlike pictures of birds, animals, buildings, tools, weapons, chariots and boats, British art draws on 'abstract' or 'non-representational' images as an expression of what may be some fundamental idea of great importance to them. This has always been a puzzle to anyone who has given it any thought; to go to Sweden or the Italian Alps and to see a great array of representational images along with cup-marks and occasional rings means that we at least can identify some of the Continental images. After all, a boat is something we have to get into when we want to cross water to visit, trade or conquer. But is that always true? What if the boat were to depict the crossing from this world to the next, a kind of ferry across the Styx to Hades? We feel more confident with pictures of people, such as warriors wielding weapons, because we have examples of the actual thing in museums. The only tools or weapons depicted in British rock-art are the axes and daggers on Stonehenge monoliths or inside

graves at Kilmartin, and as the types depict metal axes with expanding blades, they belong to the Early Bronze Age when metal was entering the picture. These are much earlier than the weapons portrayed on the rocks in Sweden or Valcamonica; in the latter case this carving tradition comes to an abrupt end with the Roman period.

'REPRESENTATIONAL' ART

The recent discoveries in the Creswell Crag caves of pictures of animals scratched into the walls of these dark places, although thousands of years earlier than the rest of the rock-art in this book, are at least depictions of what was hunted at the time – animals that were essential to the very continuation of human life. Yet, as we are told, the cave-dwellers were not just drawing pictures to pass away the time. What was drawn, painted and etched onto walls, was fundamental to life.

NON-REPRESENTATIONAL ART

Does this mean then that our Neolithic and Early Bronze Age people were no longer concerned with animal forms? That is highly unlikely. Why choose to concentrate on what seem to be unreal things? We have to look at how people abstract or select to form a powerful kind of shorthand which sums up the 'essence' of what things matter most to them. We are surrounded by such images; some, however, are of very little importance to us. People continue to wear badges to identify an interest, such as a bowls club or football team. There are hundreds of logos to tell us where we can eat burgers or chicken, where BP sells petrol, without our having to think, as we have learnt to identify them. Football jerseys perhaps are a more serious business for some people, and announce an allegiance to a team, held very deeply by some supporters to the point of violence, anger, exuberance or triumph, even though some of the players themselves have no connection with the local area, having been bought as mercenaries from abroad. Supporters share the team's aspirations, successes and failures.

Cups and rings might have originated in the natural world, but it is difficult to discover their roots. Which group or individual decided that these particular symbols best summed up what the group believed? Why did so many people over a wide area adopt them? When did they first appear and why did they last so long? Why do we find them hammered into rocks but not etched into wet clay when most pots were being made? Could it be that the rocks themselves had a special significance as

material, a quality of endurance, perhaps, a link with something deeper and fundamental to life? Whatever the origin, people must have come to recognise them for what they meant, without necessarily knowing the origin of the symbols any more than we know or care what went into modern boardrooms to select a commercial logo. But what was there in the world on which they depended that was a strong enough image to become so revered, so repeated in so many places? Apart from what I have already said about circles, I am at a loss. An animal form, no matter how crudely it is made, manages to look like an animal of some sort. But a circle…well, it looks circular! On pottery there were dots to prick into the wet clay in lines, strokes, thumbprints, prints made with feathers and cords, chevrons, hollow circles made with cut-off stems, and many other techniques to make the pottery distinctive. Occasionally, in Ireland particularly, the chevrons, lozenges and triangles found on pottery were carved into stone in a burial context, but these are departures from the norm, a different tradition. The rock-carvers must have been happy with their basic symbols, because what must be apparent from this book is that they achieved so much variety in their work.

How much contact people had with this art form over hundreds of years, we don't know. In my novel, *Unquiet Grave*, I had two young prehistoric people walk to the place of the burials, where the view was splendid, and touch the marked rocks in deference without knowing why. In the presence of death Catholics make the sign of the cross, and they know why. What matters here is that, for whatever reason, a symbol can stand for incredibly important things. And there is no doubt in my mind that, despite what I don't know, these symbols were very important in the lives of prehistoric people. They would at once trigger a response from those who saw or touched them.

TACTILE ART: THE OPEN-AIR

I like the idea of people kneeling down on or beside the marked rock, not just looking at it but feeling the surface, following the cups and grooves with their fingers. Rock motifs, unlike wall-paintings, are tactile. Rocks can be warm, cold, dry, wet. A light covering of leaves can be gently brushed to one side to reveal a pattern that is becoming obscured. Did people make a wish, did they bring to the spirit of the place a problem, a thank-you? Were they like people who visit churches on rare occasions and light a little candle for a similar reason, without necessarily believing all that the church stands for? Even without the decoration, rocks can be pleasant to sit by, especially when the views from them are stunning. There can be solitude there, detachment from the world, a different perspective

on life. Oh yes, places can indeed have power. We might even feel that when we experience them we have recovered something we thought we might have irrevocably lost – a link with a world of nature that elsewhere is concreted over and swamped with adverts and other lies and cajoleries. We are not like prehistoric people: no way, for we have too much built-in change, but we are not *totally* separate. We can share up to a point the places that they may have visited, and perhaps even share some feelings with them, but it is a mistake to think we can tune in fully to their minds. That is why I am so reluctant to theorise about what I cannot know, yet I can appreciate in basic ways the places where they left their presence and their marks. I can hear someone ask them the question: 'Why do you do this?' Their answer might be, 'Because we've always done it that way'.

ART IN BURIALS

If the rock-art had been only in the open air we would conclude that the positions had been carefully chosen, not only of the site but of the individual rock. It had a purpose being there and nowhere else. Because of its other connections we can go a step further and say that because of its presence on some standing stones and on increasingly more rocks revealed in burial mounds and chambered tombs, perhaps at times very remotely spaced from each other, it had some sort of spiritual/religious meaning, something beyond the ordinary part of life that is concerned with just keeping alive or becoming richer. The way that people were buried suggests that the past was important to them, that ancestors should be treated with respect, and that the dead should be buried in such a way that useful and buried things could be taken with them. Not necessarily for use in another life but perhaps because no one could bear to inherit what these people had owned in this life. Sometimes breaking one of these objects was also a sign that the object as well as the human had to die. Trouble was taken to make sure that the burial spot was remembered and seen too, so a great heap of stones on a well-sited mound would see to that. Some were selected for even more special treatment by having the images made in the past buried with them too: the precious symbols on slabs in the grave where they could only be seen by the dead, and the decorated cobble stones that made up the mound placed there, like wreaths at a funeral, but covered. In the cists the slabs were in some cases broken off other surfaces already decorated, but others were specially made. In either case there was an emphasis on concentric circles, and the occasional spiral found its way into the grave, rather than on simple cup-marks. Even some of the cobbles, showing no erosion after about four thousand years, were marked not only with a single cup, for there were

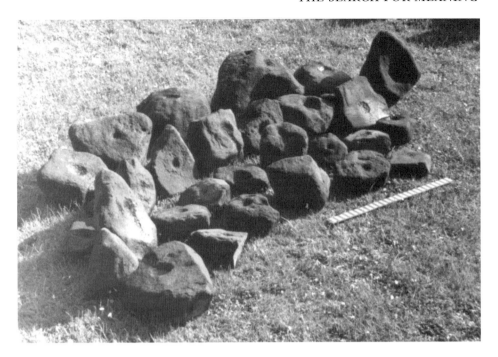

73 Weetwood decorated cobbles

complex designs on even small surfaces. In other cases the larger cobbles, some marked, were used to form a kerb.

On a far greater scale, the art forms were so revered that they were built into the construction of the great passage-graves, creating an extraordinary inward-looking, mysterious and even scary atmosphere, for fear and awe are part of many religions. The dramatic entrances, constricted tunnels leading into the heart of the mound, the burial chambers within carried a variety of symbols that must have marked significant stages to those who were allowed access. In Anglesey, in Ireland and northern Scotland this special group of tombs and images may well have been developed in a separate tradition from those who built the smaller but more prolific cairns, but the concept of marking rocks and even the shared symbolism of some of them, does not divide them irrevocably from each other. Traditions are linked to other traditions, in tombs along the European coast, in places like Brittany. In Ireland the decoration of kerb stones, those slabs open to public view were both elaborate and simple, some unfinished. Here the circle was truly the dominant image, the large circular kerbs holding in the circular mass of thousands of stones, and outside that mound would be more circles of standing stones. The tradition of such construction continued at Clava, but much, much later, without the richer embellishment that the simple rock-art there replaced.

If we leave aside the research into alignments of these tombs, which most people accept are related to important astronomical events in the farmer's calendar, we are faced with attempts to explain rock-art as 'Shamanic'. Almost every new recruit to archaeology seems to think that he or she must accept this. It is significant that Professor Eogan, who has spent more time than anybody, very carefully and valuably, exploring through excavation the great tombs of the Boyne, who feels a thrill at his first entering them and a strong sense of mystery, does not believe that it is all down to 'Shamanism', or whatever we call people working through what is described as an 'altered state of consciousness' brought about in some cases by the use of drugs. One major problem here is that although there are people in the world who do bring on an altered state of consciousness through the rhythmic clapping and dancing of the tribe in a charged atmosphere or who take hallucinogenic drugs to achieve the same state, if we try to transfer this idea to somewhere across the world and to a different time, it is hardly relevant. For me the acid test (forgive the pun) is for people who believe this to demonstrate it with evidence. I have not encountered anything that convinces me that there was anything going on in the rock-art areas that shows this to be true. What on earth am I supposed to be looking for? One reviewer did not like the way I dealt with the issue and thought I ought to explore it further, but how, if none of us knows what he is looking for? There are so many other things to investigate to occupy my time. It is perfectly possible for people over centuries in Britain to adopt symbols that have been passed down to them and to create designs in man-made caves and tunnels to create a sense of awe and wonder, but we do not know that they needed an altered state of consciousness to do this. Are we making further insoluble problems for ourselves by suggesting otherwise?

The transfer of rock-art panels from one monument to another, although rare, does show a reverence for the past that continues. There might have been more instances than we know about, for early archaeologists may well have overlooked them. We are dealing with such a wide time-span that we cannot assume that there were common practices in ritual, but that they meant different things to different people in different times.

I found myself at ease excavating two mounds where there was definitely a link between mound-building and rock-art, but in type these mounds are more recent than those chambered tombs/passage-graves in Ireland. These are two different traditions, both using rock-art, but 'round barrow' burials are far more numerous, with less elaborate construction. In comparison the number of the large tombs is tiny. In the Weetwood/Fowberry area two of the three cairns are built on decorated outcrop, so we may assume the site itself was already important before the cairns were added. Although the unexcavated cairn at Weetwood has signs of a cist at its centre and a possibly displaced decorated cover, the other two

mounds are in an area where the written record shows many to have been dug into, so we cannot be sure what the mounds were covering – if anything. As the Fowberry mound had a worked flint between it and the decorated outcrop in a sterile, very thin soil, it is possible that there was little or no time-gap between the two episodes. In the same county, the Hunterheugh excavation did not establish a definite burial, but there were similarities in choice of site for a possible mound – a sheet of decorated outcrop with a scatter of cobbles on it, some of which had decoration. A major disturbance here was the building of an Iron Age or Romano-British enclosure wall over the outcrop that made sequencing difficult. It is important to note that all these mounds are in areas where there is much decorated outcrop ranging from simple to complex motifs, many of them only effectively recorded in the past 30 years, and some of them the most satisfying decorations in Britain, at least to our eyes. A total of about 60 decorated cobbles and kerb stones is quite a high number for two mounds, but any finds of decorated stone within mounds are important, as they can be seen as offerings, similar to offerings of artefacts.

When we look at similarities of burial practice at sites where rock-art is incorporated, there is a particular link between the chambered-tomb/passage-grave traditions of the west coast of West European countries. Brittany is particularly important. When we look at the distribution of open-air rock-art in places like Galicia and the motifs on the rocks, again we can make links. This is not surprising as seaborne transport was available and there are examples of goods being exchanged in this way. Because links between European countries were possible and can be demonstrated, this does not mean that we can start doing the same further afield, especially when so many different forms of rock-art exist in the world over such an enormous span of time. We can look at aboriginal cultures and try to understand their ways of looking at life and expressing their beliefs and fears, but this does not mean that we can make a case for attempting to explain other cultures by transferring the concepts from one society to another.

OTHER WORLDS

If someone goes into a trance in an African cave, makes a link with 'another world' through magic and is revered for handing it on to the tribe, this should not make us assume that the same happens here. Even supposing that people have got it right about whether this process worked in parts of Africa. I cannot see why it should apply in Britain unless there is some strong piece of evidence. This does not deny that in British prehistoric communities there may have been a group which had the power to impress the tribe with 'insight' or healing powers,

someone thought to be in touch with the gods; the complex way in which monuments are arranged points to an order of doing things, a 'ritual' that must have been led by someone with experience and power over others. Recent excavation and research at Durrington Walls has linked the site to a great congregation of people who feasted there at special times, then processed via the river-bank to Stonehenge for ceremonies which honoured the dead, then returned for feasting and celebration of fertility, possible taking the cremated remains of people with them for scattering on water or land. Whether this is true in detail or not, it does highlight again the importance of ancestors, of fertility and of the intense concern about the return of the sun in the spring. The ritual formalises all that. Rock-art in the open-air, on monuments and in burials is another kind of formalisation of a poignant idea. What state of mind the people were in when they went through their ceremonies or made their marks we cannot know – only guess. At least we know that feasting played a great part on these occasions, to judge by the number of animal bones that have been excavated. Whether mind-altering substances were involved is possible when people want to make the most of the experience, enhancing even further the power of their massing together for exciting, fundamental rites. It still happens among some modern party-goers.

SHAMANS AND TRANCES?

Dr Paul Bahn has given everyone something to think about in his challenges to Shamanism, exposing some of the pseudo-science of 'trance' with the support of Dr Helvenston. Paul's explanatory article appears as an appendix to this book. Their research is a serious challenge to the 'trance-fixed' and I leave the verdict to science.

This idea of people going around in a trance-like state has been a gift to TV companies. We have seen the repeated pictures of vague human shapes moving through mist-covered land to perpetual background music, have been brought in rapidly into caves to focus on red hand-prints on cave walls, shimmering there, drawn in and out of focus. We have even been allowed occasionally to listen to someone explaining something without its being totally drowned out by sound effects.

THEORY AND RAREFIED LANGUAGE

But does this indulgence really help those who formulate the theories or try to convince us? In our language we hear of 'liminal' areas and terms like 'phenomenology' suddenly becoming part of the constant jargon, but

such words can often cause bewilderment. Once terms are current, people often fail to consider what they mean; the Local Government Association has published a list of words and phrases in common use that should be scrapped because they hide meaning (a famous example is 'predictors of beaconicity'). The point is that if people continue to think in these terms, they cease to think! I recently observed this at close hand when I was asked to join a local government committee to establish a development plan, and many of those to whom I spoke confessed that they had ceased to think except through jargon. I was asked to rewrite the documents in plain English, which I was very pleased to do. Some people would not last a minute in a classroom if they were to leave the rarefied atmosphere of specialised language. Of course we need to use terms that define clearly what we want to say, and will coin new terms, but the danger is when language deliberately sets out to exclude all those who are not in the magic circle – a form of protectionism and statement of superiority.

When something is hard to explain, I'm afraid that some people try to cover up what they do not know by using convoluted language by which they attempt to disguise their ignorance, and at the same time make it all sound very profound. Of course we all have to use specialised terms that have developed in an academic discipline, and readers have to make an effort to understand this. Nancy Mitford, in her theory of 'U' and 'Non-U', maintained that the upper classes (U) protected their culture from being accessed by the lower classes (Non-U) by developing a language that only those chosen few, those 'in the know', could understand, and that if anyone from this class came to use it efficiently, the U group would change the language to keep them out. Robert Graves wrote of a 'cool web of language' that protects us from harsh reality. We see this misuse of language particularly in politics, but it is by no means confined to that. Language should be a means of saying what we mean, but it is too often used to fudge issues.

Take one example and try to explain what it means:

> From these observations it seems that much of the superimposed ornament has plastic qualities while the pre-existing ornament lacks such qualities, indicating the plastic ornament on the kerbstones may be part of the superimposed tradition.

I doubt whether we shall be given the answers to all our questions on rock-art, but there is certainly no disgrace in admitting what we don't know. On the contrary, our confession of ignorance is perhaps the beginning of wisdom. And how good it is that we can't know everything! We have learnt much about rock-art, have acquired considerably more information, developed sophisticated methods of studying it, but some

aspects of it still evade us. Why not accept that as we go on trying to learn more, and why not try to say what we mean as simply as possible? Above all, we should share what we know with as many other people as possible, for rock-art belongs to all of us.

A PAUSE FOR THOUGHT

Anyone who thinks that the solution to problems of origins and meanings of rock-art is straightforward and can be solved by the accumulation of data might reflect for a moment on another academic problem that interests me: what do we know about Shakespeare? Here is an extensively and intensively admired playwright who has exasperated researchers who want to know about his life outside his plays. The Vice-Chancellor of Durham University, Bill Bryson, in his slender but potent work on Shakespeare, has pointed out how many eminent academics have tried to fill in some sort of background to his life without any convincing evidence. Surely, with such an icon, there should be plenty known about him? No. There is very little. The database can tell us how many commas, colons and question marks there are in his plays. Some have traced the books and documents that he might have read. But how far does this get us?

> The Library of Congress in Washington contains about seven thousand works on Shakespeare – twenty years' worth of reading if we read at the rate of one a day – and the number keeps growing. *Shakespeare Quarterly*, the most exhaustive of bibliographers, logs about four serious new works – books, monographs, other studies – every year.

Bill Bryson's conclusion when we examine what we don't know about Shakespeare's life is: 'he is a kind of literary equivalent of an electron – forever there and not there'.

That is why I have spent my life enjoying reading, researching and watching his plays and why the details of his life pale into insignificance. With rock-art, the enjoyment of places and designs is what matters most to me. I am not worried about what I don't know, because perhaps I never will.

4

ARTISTIC RESPONSES
TO PREHISTORIC ROCK-ART

Even though modern people cannot be sure what the motifs meant or exactly how they were used in the distant past, they readily react to the designs and to the places where they are found. In a sense the ancient art is recreated by our responses as we react to it in our own ways, with a different background of experience from the people who put it there. People may respond by copying the designs or by considering what symbols are personal to them and then create their own in a similar tradition, not necessarily on stone, but using many media. Others may see nothing and remain unmoved by what they think are doodles cut into rocks. Yet a curiosity to know what they mean and a consideration of how they are affected by them comes through some responses that I will examine.

When the motifs were first being discovered it was realised that they had to be effectively recorded if they were to be shared. One way was through drawings, especially in the days before photography became available and popular. When we look at these efforts today we can see some of them as art forms in their own right.

Lithographs were a popular medium for those able to afford them; appropriately from the Greek *lithos*, meaning 'stone', prints were taken from an inked engraved stone or metal surface. These were not only very attractive, but also were a means of spreading information about them by people who could afford this process. In Northumberland, for example, the Duke of Northumberland paid for this work to be done and employed artists and scholars of competence to do it. His sponsorship of such work included the production of a splendid colour catalogue of his antiquities by Mr Collingwood-Bruce in Alnwick Castle Museum, including artefacts of stone, pottery and metal from all over Britain. In Scotland the same quality of work was achieved in rock-art illustration for Sir James Simpson's discoveries. There were other drawings like those used by George Tate of equal competence but not quite as exotic as those of Collingwood-Bruce. There was a concentration not only on accuracy, but also on artistic presentation, although what we record today shows that much was missed in these early drawings.

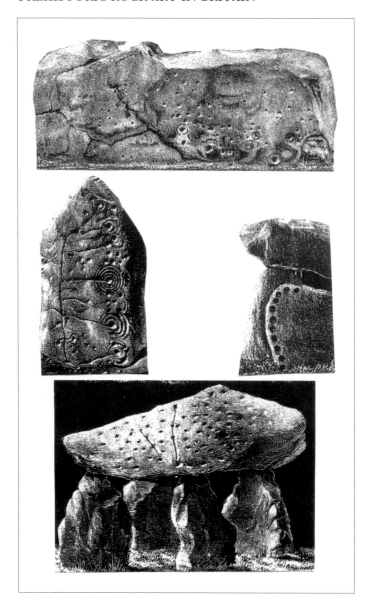

74 Lithographs to illustrate Sir James Simpson's work: Rothiemay Circle (Banffshire), Moonbutts (Perthshire), Lancresse cromlech (Guernsey) and Glynnog-Faw cromlech

Reactions to rock-art went beyond recording to something more individual and freer. My examples are from personal experience.

In the 1970s I had courses of American teachers visit Alnwick Castle when it was a College of Education in the summer holidays, to work there for a few days in specially-chosen localities in Northumberland as part of a more extensive study-tour of Britain. When I shared rock-art sites with them they wanted to do what they did in their work with children – to use the experience to explore further. All chose to express their feelings for it differently, as these examples show:

75a, b & c Modern designs: mathematical, and two fabric prints

1. A mathematician decided to take a large sheet of plywood, mark it out, hammer in nails, and connect strings to them to echo the designs that interested him.

2. Two of the women preferred to take a softer and more colourful approach, by choosing motifs for design on fabric.

No responses were exactly the same. No one, of course, told them what to do and they drew on their skills and experience.

In a different way (and I have written about this elsewhere) a group of 14-year-old fast-track GCSE art students from Greenfield Community School, Newton Aycliffe in County Durham, took part in a project called 'Written In Stone', variously funded and supported, that was aimed at 'exploring their own culture and individual identities and those of the people in the prehistoric North East'. They and their two young teachers knew nothing of rock-art, neither did their support specialists at the Sunderland glass factory, which was a great advantage when they asked me to introduce them to some of the best rock-art in Northumberland. At the beginning of the project they were brought to a field centre at Belford,

after I had been to the school to meet them (very important, this, to reassure them), from where we visited Roughting Linn. This is the largest panel in England, but I did not take them there immediately; instead, we climbed down a little valley to see a hidden waterfall. On the way to the rock-art we walked over the ancient ramparts and ditches of a curving enclosure which meets the small cliff over which the water falls. The sun shone, and when they reached the rock all the motifs were showing in relief. What was so impressive was the stillness that overcame the young people and the sense of awe with which they had their first encounter. It would have killed their reactions to give a lecture about rock-art; it was far better to let them respond in their own ways, not to be told what they were looking at, not to make their minds up for them – and it worked. The adults with them were likewise moved by what they saw, and noted the reactions of the youngsters. Their subsequent work and record of some of their conversation tells its own story (*colour plates 11 & 12*).

The evening at the field centre was spent in discussion and work, when designs began to emerge. On the next day we took them to see outcrop rock-art on Chatton Park Hill and the rock-shelter not far away at Ketley Crag. The site, unlike the shut-in experience of waterfall and rock panel the previous day, is exhilaratingly open, with views from scarp to the Cheviot Hills. There was plenty of talk, with more and more questions asked, more individual responses, but I sensed that we could not keep this up for much longer. They were bursting with energy and restlessness which called for a new direction, so we went off to Bamburgh, one of the finest sandy beaches that I know, with a castle that the young people were later not only to visit but to experience being part of an excavation team. At first, as we expected, they let off steam, then, without a word being said, they began to draw images in the sand. One girl concentrated on making a huge spiral, though none of these appeared on any rock-art she had seen. Some of the boys made a burial chamber decorated with personal motifs and put one of the group in it. Others reproduced some of the motifs they had seen on the rocks, with interesting variations that reminded me of how prehistoric people had done the same thing.

So in two days the whole theme of symbolism had really taken off, producing the varied, individual responses that became the keystone for the whole project. The images show some of this.

I have been teaching all my life, and will anticipate what many will say about the project: that it was well-financed beyond the ordinary school budget, that children were offered facilities and expertise beyond those usually available, and that the children had already proved that they had the ability to cope with this and to contribute something special. That is true, but it was an exploration of what is possible, given the right conditions, and something that can be passed on to others who are looking

for new ways of teaching and learning. There is a detailed report of the project, which continued long after I had played my part, but for me one great moment was when the work done was displayed at the Museum of Antiquities, Newcastle, among all the other pieces of the past there, and it filled the place with light, colour and originality. It obviously had the freshness and vitality of youth. I have seen other work by young people where rock-art is the starting point, but this had a degree of expertise that made it even more special. The impetus, the provoked reaction is the start, but professional guidance that comes from good teaching is also essential to enable the work to reach its highest point, no matter what the budget limitations may be. In contrast to this was a primary school wall that I saw covered with identical ducks, all flying in the same direction, a peripatetic teacher's idea of what art was. If only one had been a different colour or flying in the opposite direction, there might have been hope! In another instance, I had to grit my teeth on a visit to a teacher in training when the Head demonstrated a lesson in 'creative English' by getting children to describe a wooden crocodile and awarding good marks to the pupils who remembered most of what he had elicited from them, in writing. That is very different from responses such as these:

> 'The first time I saw them, I thought that they were like explosions – I'm puzzled.'
> 'They are almost symmetrical, but not quite perfect – like people, nobody is quite the same.'
> 'Bunches of circles on a rock in the middle of nowhere, it does not seem to make any sense. I had never thought about art being in the middle of nowhere.'
> 'Maybe they were a way of communicating.'
> 'I like the mystery of them.'
> 'You can make them what you want them to be.'

From there they moved on to the 'hidden meanings within the urban landscape of Newton Aycliffe', symbols in their home town. They went back to Bamburgh to take part in an excavation, to discover how people learn about what happened in the past, filling notebooks with sketches and ideas that they were able to use in their glass-making course at Sunderland and in their school art room.

If anyone's response to this is 'Let's put rock-art on the curriculum' I shall totally oppose them. The reason why this and other work with young people involving the past works well is because it is not prescribed, is open, and depends on enthusiasm. It is chosen, not imposed, and is relevant. If we allow people to fill up the curriculum with what they feel ought to be there (largely because they have learned it themselves and feel

that everyone else should know it) we end up with subjects that will be timetabled in ten-minute stints!

In teaching we seldom know what impact our efforts have had; people go on to live their own lives, we may never see them again, never hear of them so our assessment of work done is limited.

Of a different kind was another project in which I was involved: 'Northern Rock-Art' at the Durham Art Gallery in September 1996. It was sub-titled 'Prehistoric Carvings and Contemporary Artists'. There were many sponsors and good funding for this. One of the highlights for me was that it brought together carvings on slabs from Jedburgh to Dalton, many that had not been seen for years, and others that had never been exhibited. They included the Witton Gilbert cist-cover, and all were well displayed. The idea of the exhibition was to invite a number of contemporary artists to show how they responded to 'prehistoric landscapes, imagery and values, and to a time when art was integrated with everyday life, universal concerns, and a more spiritual relationship with nature and the land.' The main sponsor was, appropriately, Northern Rock (*colour plate 4*).

Among the artists was Andy Goldsworthy, whose main contribution was the construction of a cairn in the grounds. Although the work was interesting, for me it lacked the immediacy and involvement of the young people from Newton Aycliffe, as many artists seemed to be adding rock-art motifs to the kind of work they were already doing, although it was specially made for the exhibition. However, the display introduced a new audience to ancient rock-art, attracted by the reputation of the artists.

I have mounted three exhibitions in the Queen's Hall, Hexham with photographs, rubbings, drawings and some text that have covered Northumberland and beyond. The University of Durham staged an interactive exhibition in the Fulling Mill Museum including some fine lithographs borrowed from the Duke of Northumberland and paintings by Gordon Highmoor, as well as real decorated rocks.

There are artists who do not prepare for a specific exhibition, and have always been involved in rock-art. Gordon Highmoor is intensely interested in the quality of stone, and has not only illustrated my book covers but also contributed an essay 'Towards a more precise definition of rock-art' in my book on Cumbria (2002). In his conclusion he says:

> I began this essay by confessing my irritation at the use of the term rock-art, but the more I explore the landscape as a painter and sense the atmosphere of the mountains, fells, valleys and moors, the more I feel that this is how Neolithic people saw it. My long-standing interest in, and subsequent realised experience of, archaeology has heightened my knowledge and perceptions, yet, in a curious way, has deepened the mystery. Instinctively

I feel and sincerely hope that it is some form of 'art', but in truth unless someone discovers a Neolithic version of the Rosetta Stone, it is unlikely that we shall ever know.

Gordon has freely given his paintings to me to use in and on my books, and the three that appear here are fine examples of what he feels and how skillfully he says it. His work has also been exhibited in the Museum of Archaeology and Anthropology at Cambridge University (*colour plates 1, 2 & 3*).

Another artist friend of long-standing, Birtley Aris, recently had a retrospective exhibition of his work at the same Durham Museum as above, which showed his tremendous versatility and talent in works as for apart as the New Orleans jazz scene and North East buildings. His particular interest in landscape brought him into contact with Roughting Linn many years ago, when I was beginning my work on rock-art. Since then he has incorporated much of his art work with an intense interest in poetry, including some recent illustrations for Sean O'Brien's poetry. He cooperated with Linda France, a poet, to illustrate 'Acknowledged Land', a collection of reflections on rock-art in the landscape in which imagination and personal identity take pride of place (*colour plate 13a*).

He and I have visited many sites together and share a particular fascination for the Old Bewick landscape, a cooperation which resulted in his illustrating my novel, *Unquiet Grave*. All these examples show that the experience of rock-art can provoke many different reactions from people with varied interests in how to express that interest. I use poetry in my own work, as our reactions to rock-art can be felt rather than thought out at times, and are perhaps best expressed that way.

At Kilmartin there has been an interest in experimenting with methods of pecking out the art, with some impressive results. There is a carved boulder outside Kilmartin House museum pecked out by Andy McFetters which at the time showed the grooves to be lighter than the surface of the rock, but now blending in. His favoured stone used as a hand pick is whinstone, a hard volcanic rock. Martin Murphy, who made the superb wooden table in the Marion Campbell Room at Kilmartin also made an impressive 'copy' of the Ormaig rosettes and others, after experimenting with many different rocks to get the right one suitable for use as a hammer stone.

This practice is important so that we can actually demonstrate how the carving was done and not just theorise about it. One problem with all this is that we do not want people to leave such replicas scattered around the country unless they are clearly marked and recorded. It is possible to make something so well that it can be taken for an original.

The display of a rock-art site is also an artistic exercise, if it is going to be given its due. This means careful planning of an information board,

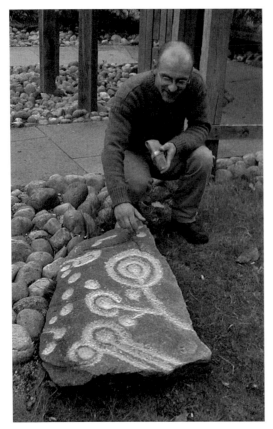

76a & b
Modern stone carving:
Andy McFetters with his work at
Kilmartin, and the stone tool devised
by Martin Murphy to carve an
Ormaig replica

drawings and wording that do justice to the site. We do not want the kind of monstrosity that was left on site for years at Roughting Linn.

The problem with interpretation panels is that they may not be convincing, and they need the combined efforts of archaeologists and good designers to achieve accuracy and acceptable presentation. The boards must also fit in with the environment and be made of material that defies vandalism and weathering. It is as well to avoid the kind of sensational nonsense that we sometimes see of mystical figures prancing around doing odd things!

Museums, as we have seen, play an important part in displaying rock-art when someone in charge accepts it as an important aspect of the past. Too often it lies unnoticed in the vaults and storerooms. Not all of it can be displayed (Newcastle has about 60 panels, for example), but there is a good case for displaying them a few at a time, changing the display as often as necessary. Good, angled artificial or natural lighting is important so that the motifs can be clearly seen. The display must be highly professional, with not too much writing, as a well-captioned visual image has a greater impact. Fortunately museums have got away from

77 Roughting Linn notice board: only recently removed

the static displays that I remember in my youth, and many have become exciting places to visit instead of mausolea.

THE DIGITAL REVOLUTION

Along with the need to display art well, the digital camera and specialised programmes that can manipulate and enhance images have made an extraordinary change in our ways of seeing, our recording and display. I must confess that I do not tamper with my images, partly because I have not adequately managed the technology, but I find other people's efforts fascinating. There is now a large body of people, not professional archaeologists, who are absorbed in the world of rock-art, and strive to share with the public their new-found interests through 'blog sites'. They communicate with other enthusiasts, share the delights, and have opened the gate to yet more enthusiasts.

I have chosen a few examples of the kind of images that they produce (*colour plates 9a* & *9b*).

GARDEN ENHANCEMENT

Of great interest to me is a neighbours' garden; they decided that they would like three standing stones and added to them on the ground spiral motifs and cup-and-ring designs, made of pebbles sunk in gravel (*colour plate 15a*).

5

A HISTORY OF THE STUDY OF ROCK-ART IN BRITAIN

I wrote this chapter for another publication, but as it remains what I want to say about the subject, I am including it here with little change.

> J.C. Langlands discovered some worn and defaced figures incised on a rude sandstone block, near to the great camp on Old Bewick Hill in north Northumberland. Though strange and old-world looking, these figures then presented an isolated fact, and he hesitated to connect them with by-past ages; for they might have been the recent work of an ingenious shepherd, while resting on a hill; but on finding, some years afterwards, another incised stone of a similar character on the same hill, he then formed the opinion, that these sculptures were very ancient. To him belongs the honour of the first discovery of these archaic sculptures...

It was George Tate, the Alnwick historian, who first explained how the discovery of the first rock-art in the 1820s began in Northumberland. No one could have been more outside what we think of as mainstream archaeology than John Charles Langlands, whose family was famous for making fine silverware in Newcastle. What made him give up the idea of being in the family business and move to Old Bewick, a small village north of Alnwick with his wife and children, must have been the lure of farming. At this he excelled to such an extent that he was commended in official reports for the way in which he treated his workers, for they tended to stay with him when others moved periodically during the 'hirings', and he trained and kept his farm managers. He also was one of the first farmers to realise that better conditions of housing would hold itinerant workers.

Langland's interests were many. His daughters helped at the local school, and one of his greatest contributions to the community was his part in the restoration of Old Bewick Church of The Holy Trinity, one of the loveliest in the county. Born on March 27, 1800, John became tenant of Old Bewick in May 1823, and died in 1874. He is commemorated by a cross at the end of the Kirk Burn Lane, on the road to Chillingham, and his sons and wife have plaques in the church. The sons were army officers, one killed in New Zealand and the other in France. The daughters are not

commemorated in the church, but we can read about them in the school log books.

John Langlands was in many ways typical of the kind of curious observer who would have been aware of the landscape around him and what it contained. Old Bewick village lies at the foot of a Fell Sandstone scarp, the kind of formation that has an abundance of prehistoric rock-art sites, burials, and enclosures. At Old Bewick there are two particularly interesting pre-Roman enclosures joined together like a pair of spectacles, poised at the edge of the scarp above the valley of the River Breamish, which here changes its name to Till. There are smaller enclosures on the scarp edge, a disturbed burial cairn which has a cup-marked cobble dislodged from it, and a large quarried cairn in a dominant position. The site brings together many prehistoric monuments, but it is particularly important for its rock-art. The large Mini-sized block of glacially-moved sandstone, with a gently-sloping surface, was chosen for the addition of cup-and-ring marks linked by grooves flowing down its surface, inter-connected and interweaving, and by a row of horizontal cups and others on three vertical surfaces. We now notice that someone had begun to dig in grooves for wedges to split the rock, but had abandoned the idea. We also notice that the surface was weathered in such a way that it already suggested circular designs, and that these irregularities were exploited on the top with cups and cups and rings, and with the enhancement of a large, deep oval basin.

There is another large block of stone close by, decorated less profusely, and in the field sloping down from the hillfort are many cup-and-ring marks, with variations on the theme.

Some are embedded in the enclosure's outer wall; others have survived recent field clearance of heather and stone for pasture. Langlands knew nothing of this profusion, but he would have known the importance of much of this marginal land as an extensive burial-ground, for there is an abundance of cairns. Many show the tell-tale signs of having been dug for treasure: a hole on top, and collections of worked flints, pottery, shale and jet objects, for shepherds with time and acute observation would have sought out possible sources of riches, only to be disappointed, for there was nothing of monetary value – just curiosities. Some cairns, we now know, have rock-art incorporated in them.

In the 1860s interest in the area was directed at the large burial mounds such as that at Blawearie, when the ubiquitous Canon Greenwell paid it a fleeting visit with workmen armed with pick and shovel. He found graves in it, pottery and a jet and shale necklace, but left a considerable amount for me to excavate in more scientific times. Overlooking the site, further along the scarp is Hepburn Moor, aptly named, as it means high ground with burials, some still visible.

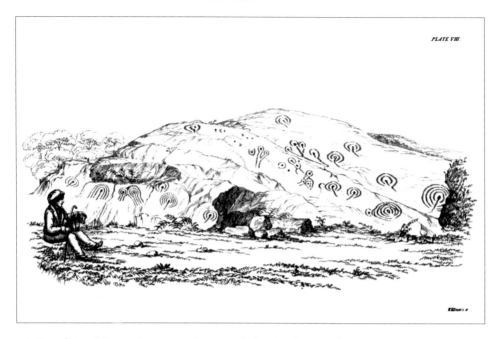

78 Roughting Linn as it appeared to people in the nineteenth century

Prior to that, Greenwell had found a site at Roughting Linn, in 1852, which George Tate visited with him, pulled 'nine inches depth' of turf off it, and exposed several sharp and distinct motifs. Later that year Greenwell read a paper on them at the Archaeological Institute in Newcastle and, 'though two ponderous volumes professing to be a record of its proceedings have been printed, strange it is, that this paper, the most novel communication made to the meeting, found no place in this publication'. It seems then, that rock-art was not everyone's flavour of the month!

Dr Johnson, secretary to the Berwickshire Naturalists' Club, published the Roughting Linn stone in his *Natural History of the Eastern Borders*, so someone was taking an interest.

Tate reckoned that these Northumberland discoveries stimulated interest in other parts of the country through the Society of Antiquaries of Scotland and in the Metropolitan Journal. However, he pointed out that the real work of discovery had been in Northumberland, where 'several members of this club and their friends have been quietly, yet successfully, exploring the district'. It became so detailed that Tate was asked to get everything together and publish it. He took longer than he expected, because it was difficult to get accurate drawings and because he had hoped that some excavation would have thrown more light on what they meant. He did, however, manage to draw all those known, all

but Roughting Linn on the same scale, with the help of an artist, John Storey, based on rubbings and tracings. He acknowledged help from, among others, John Langlands, adding, 'Here, therefore, the geologist, the antiquary, and the artist have united to produce, as far as possible, correct representations of these time-worn sculptures'.

Tate is a man after the field-worker's heart. He says, 'Oftentimes, as I have experienced, days may be spent in wild exposed moors and hills, with no gain save negative results'. He puts his cards on the table with his presentation:

> I wish it to be distinctly understood, that in this paper I shall deal more with facts than fancies; and as I shall give an account, not only of the inscribed stones themselves, but also of the ancient remains with which they are associated, I believe, that a collection of authenticated observations will have their value, even though we may not arrive at a full and satisfactory explanation of the symbolical figures; for such an extensive survey of the subject will of itself dissipate some of the crude notions which have been formed as to the meanings of the figures, and which have been founded on a limited knowledge of the facts bearing on the question.

His survey covered 53 sculptured stones in Northumberland with 350 figures.

When in 1853 George Tate had read a paper to the Berwick Naturalists' Club, Mr J. Collingwood Bruce was impressed with Mr Tate's 'sagacity' and agreed that the carvings had 'a common origin, and indicate a symbolic meaning, representing some popular thought.' The Rev. Greenwell in 1863 took up the theme again, this time with the Tyneside Naturalists' Club, and told them that 'They differ from all other symbolised expressions with which we are acquainted, and seem peculiar to the Celtic tribes which once peopled all Western Europe'.

His work on British Barrows was well-known among the learned, and urged others to investigate further, although his methods did provoke some contemporary criticism. Interest spread; local history societies were inspired to explore and record, they attracted speakers of note, and this interest included rock-art. Leisure, money and a good formal education ensured that their findings were presented to others. High quality lithographs, photographs and drawings were part of this recording.

When Tate read a great landmark paper in 1864 to the Berwick Naturalists' Club at Bamburgh, the President remarked that the subject was 'in its infancy' and 'what we want, and what we have to wait long for, a key, which, like the famous Rosetta stone, will enable us to read and interpret these remarkable inscriptions, engraven so long ago upon the Northumbrian rocks. Whatever may be their import, now so mysterious,

they cannot fail to prove, when their meaning is discovered, of very high interest.'

Mr Collingwood Bruce, who produced splendid lithographs with the help of the Duke of Northumberland, gathered together current research to make his own position clear. He felt that one tribe had made the marks, and that if one discovered many more in Europe it would be possible to trace the movements of these people. He found evidence of the *period* of the rock-art in areas 'abounding in remains of the kind usually styled Ancient British – camps, burials and (rarely) standing stones'.

Bruce found that there was no satisfactory answer to the *intention* behind them. He rejected the idea that they were maps of camps, warned readers of the Druidical sacrifice theory, and was not convinced that they were 'sun symbols'. He said that 'it is highly probable that these incised markings are, in some way or other, connected with the burial of the dead', and was supported in this belief by Canon Greenwell. 'If we connect the circular marked stones with interments, we advance a considerable way towards an explanation of their meaning; for this implies that they have a religious significancy.'

In the Duke of Northumberland's collection of local material at Alnwick Castle are drawings by Mossman that are similar to those produced by Tate.

Tate drew other parallels from Malta, Penrith, Pickering, Dorchester, Ireland and Derbyshire. When he asked what they might mean, he swept aside the argument that they might be plans of camps, preferring to see them as a symbol representing some popular thought, telling of 'the faith and hope of the original inhabitants of Britain'. He added, 'Beyond these general views, I confess we wander into the regions of fancy and conjecture'. After some speculations, he says, 'Those who are not content unless every mystery it fully explained may feel dissatisfied, that after all the labour research bestowed on the inscribed rocks, we cannot read them off as from a lettered book. ... Something, however, has been achieved – materials for aiding in the fuller solution of the problem have been placed on record – an advanced starting point made for future enquiries – and a description and representation preserved of marvellous sculptures which time and the elements will eventually obliterate.'

That sums up the stage that all of us reach in our researches.

The other significant writer and researcher in this field was Sir James Young Simpson, Bart., MD, DCL, Vice President of the Society of Antiquaries of Scotland, and of the Cambrian Archaeological Association, one of Her Majesty's physicians for Scotland, and Professor of Medicine and Midwifery in the University of Edinburgh. That is how he is described as author of *Archaic Sculpturings of Cups, Circles, &c. upon Stones and Rocks in Scotland, England and other Countries*. It was published in

Edinburgh by the Society of Antiquaries in 1867, thus providing another landmark work along with Tate's. As we see, he is a man eminent in disciplines other than archaeology, who became fascinated by rock-art. Like others at the time, he also quotes Sir Thomas Browne's dictum:

> Time, which antiquates antiquities, and hath an art to make dust of all things, hath yet spared these minor monuments.

The book was to provide a learned and solid basis for anyone wishing to know more about cup-and-ring marks. A scientist, he made careful, factual records of all that he encountered, and did not speculate unless there was good reason to.

Scottish antiquarians were already taking a serious interest. As long ago as 1785 an 'incised slab' that covered a cist full of cremated bones at Coilsfield in Ayrshire had been drawn.

In 1830 Archibald Currie published the first brief regional survey of rock-art, the cups and rings of Cairnbaan in *Description of the Antiquities, Etc., of North Knapdale*.

Sir James analysed motifs – how they were made, what they looked like, of what common elements they were made up, and in what contexts they were found, going beyond the bounds of Scotland to do this. One has an insight not only into the man himself, but into the contacts that linked the learned and comfortably off who had the time and inclination to research, including many clergymen in rural parishes. He always acknowledged debts to his scattered friends and acquaintances. He received information from them, and incorporated it into his book in his style. He omitted no detail, including precise measurements. He ensured that his illustrations would not only be informative, but attractive, through 'the artistic skill with which Mr Richie has produced the Lithographic Plates'.

He brought his vast scientific experience and the worlds that it opened up to him to his hobby. It provided a way of seeing and a way of communicating his discoveries by crossing subject boundaries.

His approach was to begin with the main elements in cup-and-ring art, to show some deviations from these, and to describe the way they were produced.

The second section dealt with the locations of rock-art, beginning with those in monuments, for some of the earliest discoveries were made in the previous century, and needed to be included in his corpus. We see them in stone circles (without the popular tendency to attribute them to Druids), in avenues of stone, cromlechs, tumuli, cists and urn covers, and on standing stones.

It is interesting that he should take these locations first, as we tend to go for the wider spread of rock-art within the landscape, but he saw that

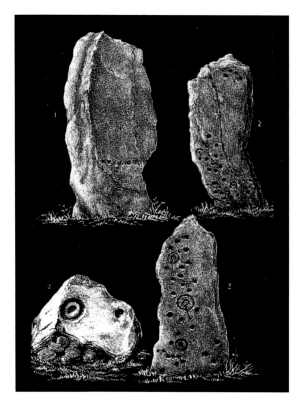

79 Lithographs: Colinton, Largie, Shap and 'Ballymenach'

attributing a function to them could only be explained in this way. Some that he recorded have now gone, but we have his words and pictures. Like us, he was fully aware of how much of our past has been lost through land clearance and ploughing.

He did not confine himself to Scotland, but pursued similarities elsewhere, incorporating Northumberland, Welsh and Yorkshire monuments as he went along.

He pursued the context through 'underground houses', fortified buildings, ancient enclosures and camps. He left the connection of motifs to the dead to follow those connected with people's lives, in round houses and in or near 'ancient towns (*oppida*) and camps'. He moved into Northumberland territory for further examples, drawing on information from 'my friend, Mr Tate, of Alnwick' and the Rev. William Greenwell. He reiterated what he had already seen in Tate's account and praised 'an elaborate series of large and magnificent drawings made by Dr Collingwood Bruce'. He drew attention to the proximity of rock-art to settlement sites, such as Beanley, Old Bewick and Dod Law, and reminded us that the links persisted in Yorkshire, Wales and Cornwall. Throughout, he drew on information sent to him by people he called his friends. It is clear that there was a brotherhood (no sisters mentioned) among the early antiquarians.

Art in the landscape was another category for exploration, especially that with no connection to settlement – the only visible evidence that there had been anyone there. He noted that 1852 was the first publication of Northumberland sites, then said (without point-scoring) that Scotland had produced an account 22 years earlier by Mr Archibald Currie, who was formerly 'a schoolmaster at Rothesay' (what would we have done without these inspired amateurs?), who described the antiquities of North Knapdale, Argyll.

In an interesting aside, Sir James directed us to theories that may be both ridiculous and serious. The innkeeper at Carnbaan, known as 'The doctor', interpreted one rock-art panel as echoing 'astronomical plates for elucidating the revolution of the planets around the sun'. He avoided comment simply by quoting his informant, then got on with the more scientific task of recording what was actually to be found on the stone, in a good drawing.

The largest panel of rock-art in Britain, at Achnabreck ('Auchnabreach') naturally took up space in illustration and description. He also referred to the possible meaning of the place-name, something that always interests me in the sites that I record.

The final part of his study of Scottish stones was of portables.

The emphasis then moved to other countries, beginning with 'Lapidary sculpturings in Ireland'. He was fascinated by the imagery of the chambered tombs, but uneasy about chronology. He visited Newgrange with 'my friend, Sir William Wilde', on whose illustrations he drew for his own. He thought that the elaborate motifs and their skilled execution placed them later than others that he had dealt with in Scotland and England.

His 'lapidary' trail led him to Brittany, to tumuli and cromlechs, which he thought ought to be considered 'a still more advanced type of art than that of Ireland'. The current thinking appeared to be that the more skilful the art, the more sophisticated and later it was. Again, he drew on the help of many friends to help him record all this. When he reached Scandinavia, he wrote, 'I am not aware that the active school of Archaeology in Scandinavia has hitherto paid any special attention to archaic pre-lettered carvings upon stones and rocks.' However, he found many interesting examples in the cromlechs of Denmark; he wrote of boats, crossed circles, cups and human figures, and illustrated the spectacular interior of the Kivik mound in southern Sweden from the work of Professor Nilsson, who saw it as a commemoration of some victory, probably naval, 'by worshippers of the eastern sun-god Baal' in the Bronze age. He added, after lengthy discussion, 'Perhaps, however, in the presentation of his ingenious and elaborate interpretation of the Kivik carvings, Professor Nilsson has wandered too far from home,' as they were more probably native, not foreign, in a very wide-ranging dissertation on this fascinating site.

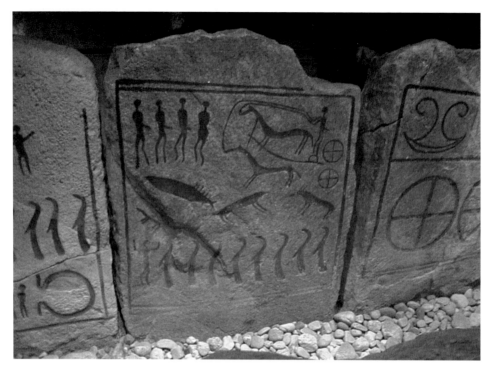

80 Kivik: decorated grave slabs at the centre of a huge mound

His chapter ended:

> I am assured by my friend Professor George Stephens of Copenhagen, that
> examples of stones in Scandinavia, with cup and ring cuttings, are by no
> means so rare as the silence in regard to them of Northern Archaeologists
> would seem to indicate.

He realised that the search in Britain was in its infancy, and this applied
also to the continent of Europe; discoveries all over Europe would 'bring
to light new facts, both as to the sculptures and themselves, and as to the
ethnological relations which may possibly prove among different portions
and locations of the human race'.

The book seems to have grown as he went along, for the last section
covers some of the same ground, showing a reinforcement or modification
of his ideas. He began with high-flown language beloved of that period
and of some of today's writers:

> They are archaeological enigmatica which we have no present power of
> solving; lapidary hieroglyphs and symbols, the key to whose mysterious
> import has been lost, and probably never to be regained.

I will not take you along the path of tracing some proposed hypotheses on how the motifs began and what they might mean, but he had another go at Professor Nilsson's belief in their alleged Phoenician origin, drawing on a vast bibliography to reject the theory. This occupied a whole chapter, with more footnotes than text.

The link with 'religious' monuments was well attested, but he argued that it was impossible to date them accurately because there was insufficient data. He used the rest of his book ('at the risk of some repetition') on their pre-literary appearance, their connection with 'dwellings and sepultures', the character of finds associated with them, and their geographical distribution.

He was doing what many of us have done since: to gather evidence objectively as a basis for understanding, and not look for facts to fit theories. In his thinking Sir James was careful to point out that the discovery of motifs on a portable stone established the *latest* date for its use, but that the carving could be earlier. He also saw that 'the reverence for the sculptures themselves had died out in the minds of the generations who used them as simple building material'. He noted that the freshness or erosion of the carvings must be carefully considered too. As more carvings were left on 'the tombs of the dead than on the dwellings of the living', he saw this as the best way to provide a period for their manufacture, as it was possible that accompanying artefacts could be dated. He warned that the period of use of any ritual monument could be extensive, though, with barrows being used for secondary interments. Pottery sealed in by a cist gave a final date for the use of the motifs. He thought that there was still enough data to show 'the kinds of implements which co-existed and were buried with those men whose sepulchres show the ring and cup carvings'. There was more information in Brittany where 'much more successful enquiries have been made than in our own country'. He was clearly well-informed there, and on work in the Channel Islands, where the 'silting up of cavities' had produced a chronology all of which was characterised by stone implements.

He was convinced that the beginning of cup-and-ring art must be in the Stone Age, and that the practice continued through to the Bronze Age, although at that time no bronze objects had been found in burials connected with cup-and-ring marks.

He noted that it was 'very rare that we ever find early pottery display any of the circular or spiral lines, and then only when it approaches, or comes within, the Bronze Age'. Combinations of circles, spirals and zigzags were the geometric patterns seen on 'the most ancient bronze ornaments and weapons'. He concluded that cup-and-ring marks were earlier than representations of natural or artificial objects.

If such symbols could be of a metal age, were they formed with metal tools? Areas like Northumberland had soft sandstone, but elsewhere surfaces were hard. This did not mean that metal tools had to be used,

however. He used a 'flint celt and wooden mallet' on schist. In Edinburgh Museum the doorkeeper used a three-inch-long flint, one inch wide and ¼ inch thick with a mallet to cut ⅔ of a circle into granite in two hours. It was seven inches in diameter, cut ¼ inch deep and ¾ inch wide. He noted that the sharp tips of the flint broke off from time to time, but by turning the flint round, another sharp edge was formed. He had solved his problem by experiment.

In the British distribution of rock-art he found 'they all evidently indicate wherever found, a common thought of some common origin, belonging to a common people'. But what race or races made them? He delved into literary sources for what was known about Early Britain, but field monuments pointed to a much earlier race. There was enough data to equate them with the building of megalithic monuments, cromlechs and stone circles in Britain, the Channel Isles and Brittany.

> It appears to me not improbable, therefore, that the race of Megalithic Builders, whether Celtic or Pre-Celtic, who had tools of flint and polished stone, first sculptured our rocks and stones with the rude and archaic ring and cup cuttings. But the adoption – and even more extended use – of these forms of ornamental and possibly religious symbols passed down, in all likelihood (with their sepulchral practices, and with other pieces of art and superstition), to the inhabitants of the Bronze age, with its era of cremation and urn-burial – and thence onwards to other and later times; and perhaps they can be still traced in the spirals, circular and concentric figurings upon our ancient Celtic bronze weapons and ornaments; on their stone balls and hatchets; on ancient bone implements and combs.

> It is important, at the same time, to recollect that the *origin* in cup and ring cuttings may still be older than even the age of the earliest Celts or of the Megalithic builders.

Sir James Simpson's contribution to the study of rock-art, with its repetition and emphasis of certainties and problems, is enormous. Everyone who wrote about rock-art referred to him and to others like Tate, but mostly in fragmentary reports of random areas, made piecemeal.

In the 1880s Romilly Allen compiled a list of cup-marks in Scotland. In his general observations he found them free from design in the arrangement of cups and thought that they might have been executed 'one by one, at different times, either by the same or different individuals'. He saw cups and rings as 'a well recognised symbol frequently repeated', connected with burial rites. At Ilkley, in his third paper in 1882, he dismissed suggestions that they were star maps, doodles, picture writing, or games.

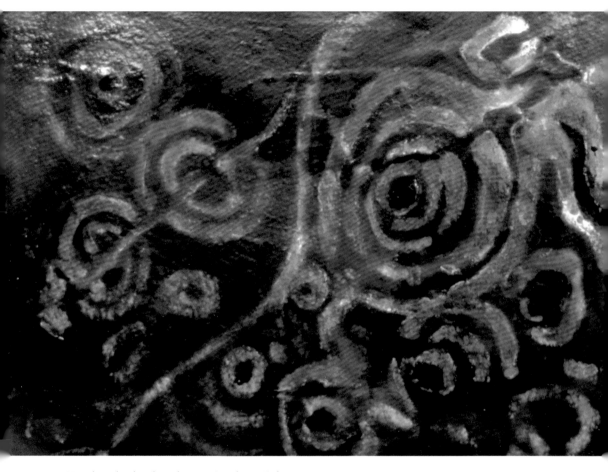

1 Northumberland rock-art (Gordon Highmoor)

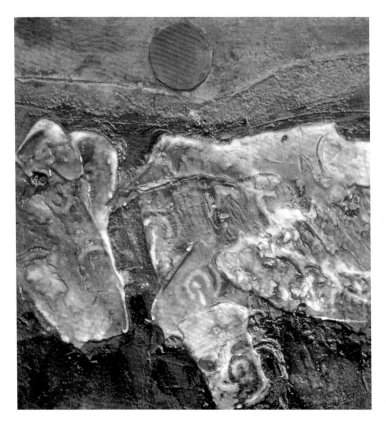

2 Circles in Stone (Gordon Highmoor)

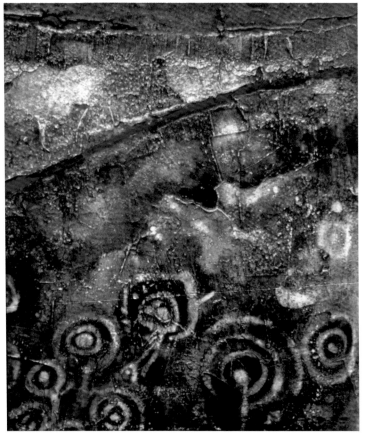

3 British prehistoric rock-art (Gordon Highmoor)

NORTHERN

ROCK Art

Durham Art Gallery

27 July - 1 September 1996

Prehistoric Carvings and Contemporary Artists

4 An exhibition of art inspired by rock-art, held at the Durham Light Infantry Museum

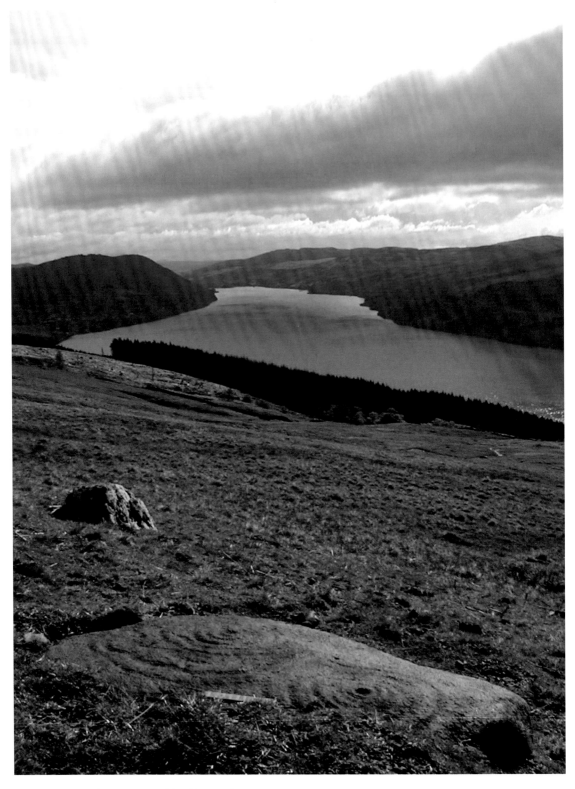

5 Tayside panorama (Paul Brown)

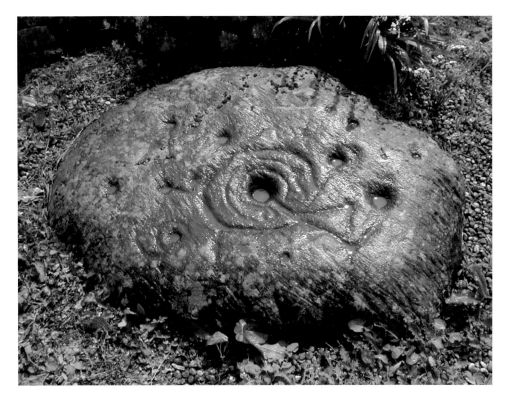

6a Ashover Primary School, Derbyshire (Paul Brown)

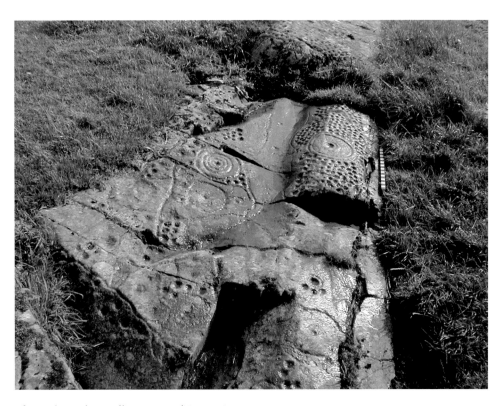

6b High Banks, Galloway (Paul Brown)

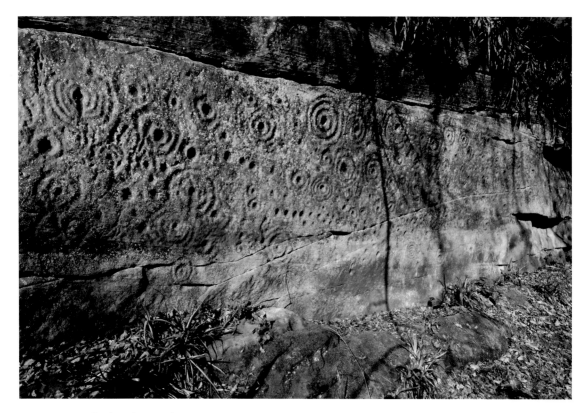

7a Ballochmyle, Ayrshire (Brian Kerr)

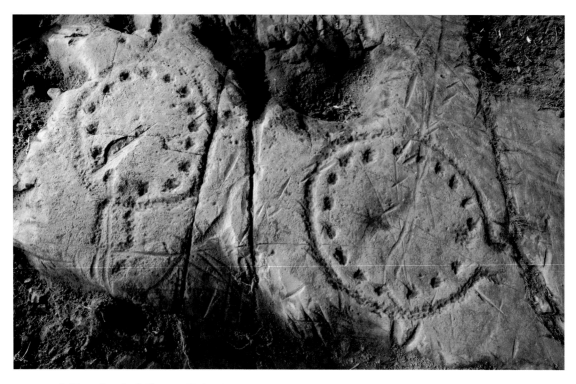

7b Townhead, Galloway (Brian Kerr)

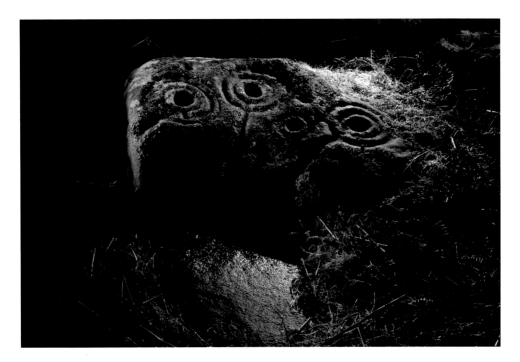

8a Millstone Burn, Northumberland (Ian Hobson)

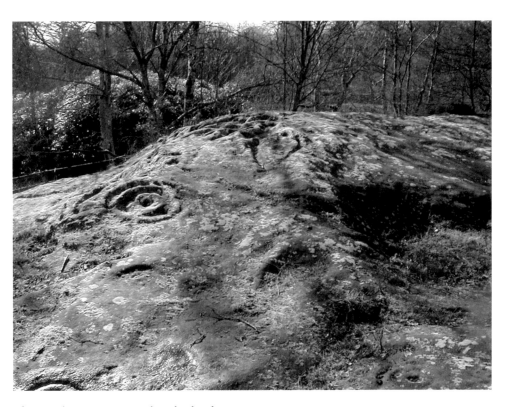

8b Roughting Linn, Northumberland

9a A digital interpretation of the author's drawing of Chatton Park Hill, Northumberland

9b A digital interpretation of a stone on Barningham Moor, County Durham (Ian Hobson)

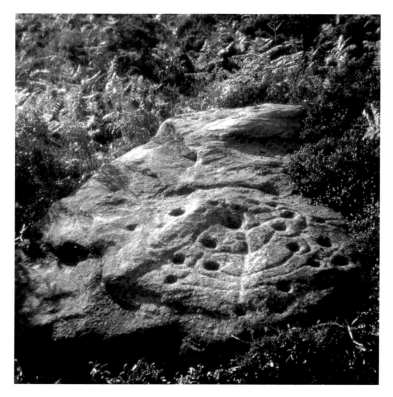

10a The Tree of Life stone, Snowden Moor (Keith Boughey)

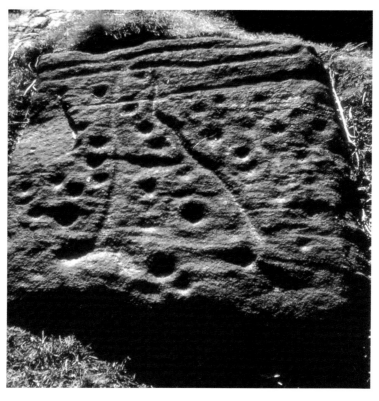

10b Backstone Beck, Ilkley Moor (Keith Boughey)

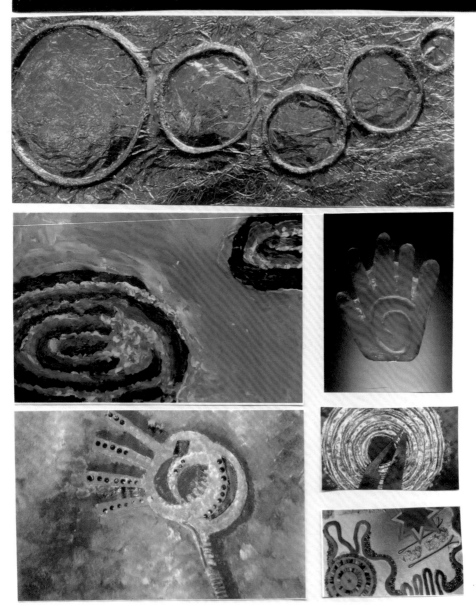

written in stone | a journey of exploration into the past

11 Greenfield Community School, Newton Aycliffe, 'Written in Stone'

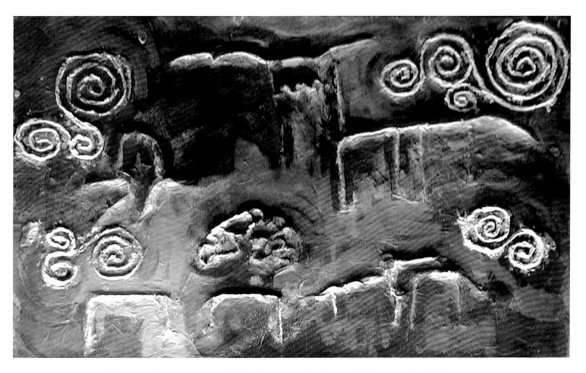

12a & *12b* Artwork from Greenfield Community School, Newton Aycliffe

13a An extract from 'Acknowledged Land' (Birtley Aris)

The following text is visible within the website screenshot:

Rock Art Project / Home

Northumberland Rock Art
Web Access to the Beckensall Archive

Home

Browse Panels

Search Panels

InterACTIVE Zone

Help and FAQ

Links

About Us

Site Map

Welcome!

This website is the celebration of rock carvings made by Neolithic and Early Bronze Age people in Northumberland in the north east of England, between 6000 and 3500 years ago. Over 1000 carved panels are known and most of them are still located in the countryside.

The website is also a celebration of the work of Stan Beckensall who has spent 40 years finding and recording this ancient rock art. For many years Beckensall shared his knowledge and recordings of Northumberland rock art through public talks, conference presentations, and richly illustrated publications. Now we have the World Wide Web!

It is our hope that the information and images presented in this website will encourage greater enjoyment of this cultural resource; inspire the creation of new knowledge and insights into Northumberland and British rock art; and set the basis for the effective management and conservation of this ancient resource for future generations.

If you have the pleasure of visiting Northumberland rock art, please treat it with respect as it cannot be renewed once it has been lost. The responsibility for caring for it rests with each one of us.

The 'Web Access to Rock Art: the Beckensall Archive of Northumberland Rock Art' project was funded by an AHRB Resource Enhancement Grant to the University of Newcastle.

Northumberland (UK)

A·H·R·B
arts and humanities research board

UNIVERSITY OF
NEWCASTLE UPON TYNE

W3C XHTML 1.0

Print Page

Email Us

Bookmark Us

©University of Newcastle Upon Tyne (UK) 2004. Web site design and development by Horacio Ayestaran and Heritage Media.

13b A screenshot from the University of Newcastle rock-art website (Aron Mazel)

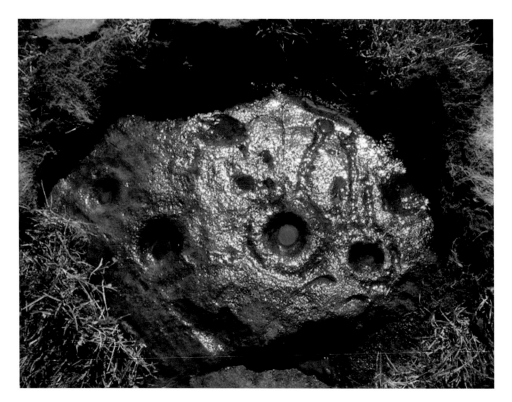

14a Prieston, Tealing (George Currie)

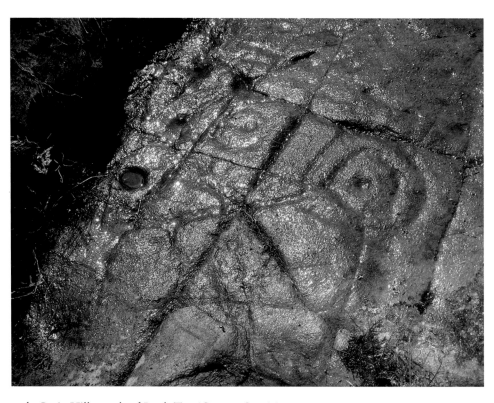

14b Craig Hill, south of Loch Tay (George Currie)

15a The author's neighbour's garden in Hexham

15b International cooperation: Jan Brouwer, Stan Beckensall and Gus van Veen at Ford, at Kilmartin in May 2009 (Paul Brown)

Because they were executed by more than one individual at different times, and by their proximity to tracks across high ground they may have marked routes to sacred high places, like Baildon Hill. He favoured a Bronze Age date for them, rather than their being a continuation of an Early Neolithic tradition.

In West Yorkshire, now with about 700 recorded marked rocks, an early report in 1869 by C. Forrest and W. Grainge was entitled *A Ramble on Rumbold's Moor, among the Rocks, Idols and Altars of the Ancient Druids in the spring of 1869*. This title suggests that they could not have read very deeply, but it included illustrations of carvings. In the same year 'ancient markings' were published in the area of the Cow and Calf rocks on Ilkley Moor. When in 1879 Romilly Allen wrote papers for *The Journal of the British Archaeological Association* on 'The Prehistoric Rock Sculptures of Ilkley', more serious interest began to be shown.

A publication called *Baildon and the Baildons* by W. Paley Baildon, FSA came into my hands recently. It was privately printed for the author and sold to subscribers only – at 6s per part, at the beginning of the twentieth century. Baildon mentions several people who had recorded marked stones, and he visited some of the carvings at Dobridding with the Assistant Architect of the Corporation of Sheffield, Joseph Rycroft, whose drawings are reproduced in the book, and one photograph by W.E. Preston. Mr Rycroft drew clearly, without any shading, and to scale. This brief acquaintance plunged the author into some speculation: 'my knowledge of them is almost entirely derived from the works of others, and I have not made a special study of prehistoric antiquities.' The others were Tate, Simpson and Allen, which he dipped into before laying out his own theory. He thought that any theory had to take into account the widespread distribution of carvings in many parts of the world, and the constant repetition of marks. His conclusion was that they were depictions of 'ghost houses', based on the idea that spirits linger after death and that they required attention from the living – including a house to live in. The house could be real, a miniature copy, or any other representation, such as cup and ring marks, which were used long after their original meaning had been forgotten, and were mere ornamentation. A cup could have been one house, and the rings the stockades. He thinks that such a theory would satisfy the Tates, Simpsons and Allens. So, 'The large rock surfaces covered with carvings, such as Roughtin Linn, I attribute to ghost villages, where a new ghost-hut is made at each death.' He reckons that the unique ladder motif at Ilkley 'could be made by a tribe who cultivated the hill sides in terraces'.

I mention this one theory of many because it illustrates the frustration of people not knowing the answers. Whereas some offer theories with diffidence, others have assurance sitting on them like 'the hat on a

Bradford millionaire'. Ever since these markings were discovered there must have been hundreds of explanations, sadly without factual support. The number of papers multiplied, but there was little interest among professional archaeologists. Then it lay fairly dormant.

Ireland, that home of some of the world's greatest rock-art, had some early references to its passage-grave art, one as early as 1699, when a Welsh antiquarian, Edward Lhwyd, described how workmen had carried off some of the stones from the mound, marked with crude and barbarous sculpture that must have been pre-Roman.

Camden's *Britannia* has a cup-and-ring stone drawing thought to be on a Druidical altar, and a later edition of 1806 described Newgrange as 'a pyramid formed of pebble or coggle stones' covering slabs of cists with spirals and a trellis-work of small lozenge forms, all, of course, put there for Druidical rites. In *Handbook of Irish Antiquities* (1848), William Wakeman illustrated and described a 'great variety of carving, supposed by some to be symbolical.'

The interest in rock-art research left Britain for a while, apart from chance finds, and blossomed in Europe. There an interest grew in the way the art was distributed, its age, and typology. The Abbe Henri Breuil gave an important Presidential address to the Prehistoric Society of East Anglia in 1934, and in 1957 O.G.S. Crawford published *The Eye Goddess*. At this time an emphasis was placed on seeing rock-art as some sort of representation of humans. Breuil in his lecture looked at the relationship between tombs and open-air art, and did not see them as different. He collaborated with Professor R.A.S. Macalister in Ireland, among others.

The 1970s in Britain brought Ronald Morris' work to the fore, and that of the present author. Ronald was a solicitor with a passionate interest in rock-art; he had sufficient means to travel widely and to meet many people on the Continent who were engaged in the study. He published extensively; much of his work does not have the benefit of modern technology, especially the use of computers, but this is no criticism, for his field work was extensive and thorough. He also aimed at writing books for everyone, and many have derived their interests from his regional Scottish studies, where he was the first to open up areas such as Argyll and Galloway to the general public. He published extensive data covering Britain. He was fully aware of the dangers of unprovable theory about the meaning of rock-art, and is famous for his collection of suggestions gleaned from literature and hearsay about them.

No one could have gone forward very quickly without his groundwork, and he followed the best traditions of the Scottish antiquarians not only in his methods but in his personal integrity and consideration for others.

He donated his archive posthumously to me because I was someone he thought would continue the work and because he liked what I wrote. It

was impossible for me to deal with that and my own work, so I donated it appropriately to The Royal Commission on the Ancient and Historical Monuments of Scotland. I still use his camera, which always reminds me that his presence is still with us out in the field.

Evan Hadingham produced his accessible study of rock-art in 1974, *Ancient Carvings in Britain: A Mystery*. What the public wanted at that time was not a learned tome, but a book that showed through its illustrations what rock-art is about, and to express the author's enthusiasm in reasonably simple language. This was a good start.

In 1980 a book by Jean McMann on 'Rock Carvings of Ancient Europe' called *Riddles of the Stone Age* was a collection of very good black and white photographs of sites across Europe covering rock-art in passage-graves, the landscape, and Maltese temples, interspersed with text reflecting on what they might mean.

Because there was little interest shown by professional archaeologists, and because most publications at that time were southern England orientated, research tended to be confined to articles rather than books, and those of us who were determined to present our research both more fully and in a readable form chose the difficult path of publishing it ourselves.

Maarten van Hoek, living in Holland, has contributed much to the recording of sites here, beginning with two slim publications on north Northumberland, and extending his range throughout the British Isles with the speed of someone who has another life and a teaching job. Not only did he re-record known sites, but discovered and recorded new ones. Since then he has extended his range world-wide, through his own website and a stream of articles in international magazines and journals.

Many researchers have been influenced by what was happening in Europe, and many visited the Valcamonica sites in northern Italy, where rock-art study seemed to take on the aura of a mystic crusade. Many have also turned to Scandinavia for inspiration.

Today there is a great deal of cooperation among the major agencies of rock-art research and many personal contacts which enrich everyone.

A brief excursion into rock-art by Colin Burgess looked intelligently at the issue of chronology. Perhaps the most important development for rock-art studies was the arrival on the scene of Professor Richard Bradley, one of the brightest and most approachable of modern archaeologists, and research by a new generation began to place rock-art as a vital part of our development, and not as a fringe activity left to enthusiastic amateurs. Elizabeth Shee in Cork added great expertise in her wide-ranging investigations of megalithic art from Spain to Orkney. Recent work by Ian Hewitt (now at Bournemouth), Paul Frodsham (Northumberland National Park Archaeologist) and Tim Laurie brought interesting new thinking to the study. The work of those mentioned here, and others, is

listed in the Bibliography. What is very gratifying is that we now have so many enthusiasts who discover new marked rocks and report them to us. There has been considerable new data published, not only in books, but also in papers. Apart from the well-known journals, the new *Northern Archaeology* (The Bulletin of the Northumberland Archaeology Group) under the editorship of Paul Frodsham, became one of the most influential in producing new research quickly and well.

Ireland, of course, has its great professional tradition of research, especially in passage-grave art, but hitherto unknown rock-art in the landscape has also appeared. It was astonishing to me to be invited to open the new lecture hall at Castlebar, County Mayo, to give a talk on British rock-art and to present rubbings that I had made of the Boheh stone for hanging in large glass panels on the new library walls. A second panel had been found in the west, recorded admirably, and may be yet another stepping stone to the discovery of more.

I cannot mention all those working in this field, but I do want to draw attention to continued voluntary (i.e. unpaid) contributions. At a time when there is real conflict in England between amateur and professional involvement in archaeology, I have not personally found the relationship at all uneasy. A major book appeared in 2005: *The Prehistoric Rock Art of the North York Moors*. It is the result of years of work by Graeme Chappell, Paul and Barbara Brown, who are brilliant field workers with other jobs. They have found hundreds of rock-art panels and by sheer persistence have pursued references and found lost ones. One area of their discoveries was on Fylingdales Moor, where a large fire later burned many hectares of heather and exposed much of what they had already found, and others. At a meeting of the English Heritage Advisory Group I had established that it was important for such discoveries to remain the literary property of the finders until they were published, and this, after some awkwardness, is now followed as a principle. My own role is to encourage the greatest cooperation between professional and voluntary archaeologists, especially now that so many people are moving into the rock-art domain.

Links between rock-art researchers have always been strong. A strong link between groups for a while was Stuart Feather, based largely in West Yorkshire, but researching with his group into County Durham and the North York Moors. He followed a tradition established by Arthur Raistrick and Eric Cowling, who in turn provided the impetus for the work of a voluntary group based on Ilkley, whose major publication is *Prehistoric Rock Art of the West Riding*. This was through the efforts of Anne Haigh, Sidney Jackson, Bill Godfrey and through the two authors of the work, Dr Keith Boughey and Edward Vickerman – both teachers in their other lives.

There have been other surveys of areas, but the major surveys, except for Cumbria (by the author) have been mentioned above. There is no doubt that there is much more to come. English Heritage's survey, after a lapse in which little happened, has been followed by the funding of a project for Northumberland and Durham County Councils to record all their rock-art. Clearly, most of this has already been done, but hopefully more aspects of it, helped by the training of a new team of volunteers, will come to light.

Meanwhile, a monumental work on rock-art has appeared without its being given the publicity it deserves: Paul and Barbara Brown's *Prehistoric Rock-art in the Northern Dales*. Its 320 pages is a comprehensive record not only of known sites but of many new discoveries by the authors, both of whom are independent of institutions and who have spent years recording at their own expense. It is this kind of work that has extended the record enormously. The gazetteer alone is a lesson to anyone wishing to record rock-art, covering as it does 194 pages out of 320. No matter what re-recording is done on these sites, the credit for finding them is theirs, and it has cost the tax-payer nothing. Their work continues.

Interest has blossomed on a world scale, and in Britain it is interesting to see universities setting up specialised departments of rock-art, and offering post-graduate qualifications in its study.

We must not forget our roots, though.

My own interest in British rock-art owes much to the early scholars. By a fortunate coincidence, unknown to me at the time, the very rock that triggered Langland's interest triggered mine. It was not exactly a road to Damascus, but that huge block of marked rock was a turning point. I was soon to learn that we didn't know much about rock-art, and I set out like these early antiquarians to find out, not as my main occupation, but as a hobby, as a small part of my life. In retirement I have had more leisure to pursue this hobby more thoroughly.

A lack of interest in rock-art among professional archaeologists has probably been due to the fact that the study of rock-art was not the best career move. It involves considerable exploration of the landscape on foot, with not a great deal to show for it, apart from an increase in fitness. Even when sites have been found and recorded, the bewildering questions about how the marks originated, what they mean and why they are where they are, are so open-ended and in some cases unanswerable that many have ignored them. Even now, despite the increase in world interest and the amount of research being done, many find it difficult to incorporate into a thesis on the Neolithic. There are other interesting and safer areas of research that produce more impressive results more quickly. Only recently has this begun to change. When the great panel of rock-art at Chapel Stile in Cumbria was discovered, some people who visited it

thought that it must have been done very recently because no one had found it before.

Since I wrote the above chapter for a collection of essays called *Art as Metaphor* by various authors the picture has changed, as it seems to do rapidly in the new world of rock-art research.

It was unthinkable until recently that rock-art would reach all the daily papers with a full page or two spread, but this has happened, thanks to the project initiated by English Heritage, based on Northumberland and Durham through their county archaeology departments. This shows what a high profile English Heritage has and how it can use this to broadcast its achievements. Its aim was to look at all the records of rock-art in the two areas, to organise a body of volunteers to carry it out under the guidance of specialist technicians largely using laser scanning, photogrammetric techniques and others, and to present their findings not only as a document but also as a website. The latter was based on, and integrated with, the highly successful Newcastle University website, the Beckensall Archive for Northumberland. Not all the volunteers remained in the project, but a core became highly efficient at what they were doing and will continue to be a resource. About 200 more carved rocks were added to the record, which was expected, but little to change the picture of what was already known. The perceived strength of the project was the use of modern 'non-contact' methods of recording, though it must be said that rocks were uncovered for the purpose, for how else would the patterns be seen? Although making wax-rubbings is now apparently frowned upon, even for serious researchers, almost all the panels recorded had been recorded in this way; without that technique there would have been little data for the project to study. Some conclusions of the report were a little odd, especially the one that associated the rock-art with some kind of fire ritual, with not a scrap of evidence.

6

FINDING, RECORDING, PRESERVING AND DISPLAYING ROCK-ART

THE SCANDINAVIAN SCENE

I was very fortunate to be invited recently to Sweden by the English Heritage RAMASES group for its final meeting. The Scandinavian countries have taken a lead in tackling problems of how rock-art should be 'managed' and we were given first-hand experience in the field as well as talks and discussions by those who have done so much to promote it. Although this was not my first visit to Sweden, the experience helped to focus my mind on these issues and to apply what I observed there to Britain. In the same way our colleagues there have been coming to our conferences and making visits, helping each other to think things through. Norway and Sweden have gone much further than we have in many aspects of research, but have also found our websites exceptionally good as models of good practice in recording. It was good to go to a meeting where everything was relevant, after having sat through, or walked out of, quite awful 'presentations' in Britain and in other countries.

WATER ENHANCEMENT FOR GREATER VISIBILITY

One outstanding memory of the visit was the contradiction between what some management in Britain is telling us to do, and the actual practice in the field in a country which has spent infinitely more time and resources on the problems of rock-art management than we have. Take the question of whether it is right to spray water onto a rock to take photographs when the natural light is bad. It has come down on tablets of stone that this must not be done. That is very curious to those of us living in a country where it rains so much of the time. Fellow researchers and I have for years enhanced the rock-art for recording by taking water from streams and ponds to brush or spray. It is also the case that in recent official recording projects, the same practice has been followed. Strong angled sunlight or artificial light does this job well, but lights and sunshine are not always conveniently there. So, a new panel has been discovered miles into the moorland, reached only on foot after a long trek, so what are we to do?

81 Water on the rock: Soletorp, Sweden

People looking at this from a distance don't see the problem because they have not had the experience of making discoveries themselves.

So what happened in Sweden? We were taken to some sites where the images had not been painted in as they are in the main tourist areas, and were almost invisible, so our hosts quite rightly took buckets of water from a stream, emptied them over the rock surface on the upper slope, then brushed it evenly over. It is important that as much as possible the surface should be wet, otherwise it looks uneven. We were then able to see more clearly what had been almost invisible.

RUBBINGS AS A BASE FOR RECORDING

Another 'thou shalt not' comes in the form of forbidding people to take rubbings of rock-art. This is sensible if there is a real problem of the surface being damaged by such an 'intervention' as it is called. Researchers do not make rubbing to use as decorative wall hangings. For years the only way of accurately taking an image of the motifs has been to use strong thin paper such as newsprint, which is cheap when it comes from the ends of rolls used in newspaper production. The rock has to be prepared for rubbings so the surface is cleaned, but this has been done mostly responsibly by avoiding anything which will endanger the surface, such as a wire brush or metal tool. Some rather loose-structured lichens and mosses have been removed in

the process, and those which grow close to the surface were ignored because the cups and grooves can still be felt through the paper. We have not been sure whether the lichens protect the rock surfaces or eat into them, and it is apparent that they soon return. I shall mention this question later. The results of the rubbings vary considerably with the skill and patience of the recorder, and not many manage this satisfactorily, but when it is well done the record is very valuable. For example, in a recent demonstration on a panel in Yorkshire during the English Heritage initial project I was able to reveal all the marks left by the pick used to make the motif. Another revelation is that all the marks and cracks on the surface, no matter whether they are man-made or natural, are revealed and can be transferred as fainter symbols onto the final drawing; this is most important, as those who made the originals took into account all the natural features of the rock to decide on their designs. We are all fallible, no matter what our experience, so it is important to check the drawings we make against photographs and visits to the same rock at many times of the year and in different lights. I have sometimes found that I have missed something or interpreted a natural feature as something artificial and had to do another drawing or more. Another point is that, although it is irritating to see this, someone comes along, removes some more vegetation, reveals a new feature and I have to record this too. The great thing is that any extra visit is a pleasure, that initial mistakes can be put right, and that the places where the rock-art lies have an endless attraction. The one-off recorder misses this. Drawings from rubbings can be faulty, but can also be excellent. The dimension missing is depth, which can be added by inserting measurements, but the new method of recording by laser scanning gives more accuracy, and enables the problems of what is happening over time inside the grooves to be considered. Laser scanning is a very welcome addition, and is regarded as non-interventionist, which is true if the rock is not touched at all, but the surface has to be visible to start with; this can only be seen if the vegetation is removed. There has to be intervention. Another technique being used is photogrammetry, highly favoured by the Northumberland and Durham project.

Appendix V offers an easy and cheap method of digital recording.

However the recording is made, the end-product is usually the drawing. This has varied from the equivalent of pin-men depiction: thin lines, no width, serving only as sketches, to more detailed interpretations. I have filled in the grooves on my drawings with dots. Paul Brown uses a reverse technique like a photographic negative, and shades in the rock artistically to show its structure. Whatever technique is used must be as close to the original as possible, and this is why I am against thick lines which do not show the relationship between one groove and another – where they cross or any other superimpositions. This reduction of a groove to a single line can happen during publication when the drawing is reduced too much,

The antiquarians had some very good artists in their pay and produced lithographs of great quality and attractiveness. We know that many of these are inaccurate, but we should not feel in any way superior; some people seem to delight in decrying past methods because the people who produced them did not use modern technology, which shows a failing in such critics.

So what is the attitude of the Scandinavian researchers and curators to the method of rubbing? Go into any of their museums or research centres, and what do we see on the walls? Rubbings. These also appear on display boards to show the public more clearly what is on the rocks at which they are looking. The same applies to Valcamonica, Italy, where thousands of people visit the rock-art each year. On one of my visits with a UNESCO-sponsored group to southern Sweden I was initiated into other techniques of rubbing by Dr Gerhard Milstreu on a surface quite different from those that I normally worked on. This was like a sheet of glass, glaciated granite, whereas I normally deal with indented sandstones. Following a light brushing of the rock, a small sheet of paper is placed over the area to be rubbed (very different from the long continuous sheets that I used in Britain) and a roll of carbon paper provided the 'ink' instead of wax. The result was made very rapidly. Later these sheets are scanned in a computer now and joined together to give a picture of the whole rock and they can be used like that or a drawing can be made from them. It is as accurate as the skill of the individual allows it to be.

This technique cannot be used effectively on British sandstones because there has to be sufficient flexibility to allow the paper to sag slightly over the grooves and other indentations. My system takes considerably longer as I try to record every single pick-mark on an undulating surface. The obvious conclusion is that a method of recording has to be found which is best for a particular rock.

Another technique favoured in these pre-laser days was to record the motifs in felt pen on a plastic sheet stretched over the marked surface. Although this has been used to good effect in some cases, I rejected it for my own work. When I make a rubbing I do not look at the rock too closely before I cover it with paper, so that I am actually picking out sensitively every indentation on the rock, and then when the paper is removed I compare what I have done with what I see on the rock. The plastic sheet method involves marking out the patterns of cups and grooves on the rock before the sheet is placed over it. This means that we have to trust our eyes to see everything there, and time and time again we miss something. The eye can also anticipate a pattern wrongly. Some people have used this method, then made a rubbing of the problem areas that they are not sure about. Ronald Morris combined these two methods when he took on the enormous task of recording the largest rock-art surface in Britain at Achnabreck.

Whatever methods are used, the outcome should reflect accurately everything that is on the rock, man-made and natural. Unfortunately

82 Sweden: a display in the research centre at Tanums

there are some publications where the quality of drawing is not at all satisfactory, and the drawings should be re-done. At least some modern methods will take away much of the hard grind that I have experienced, especially when one forgets to protect one's knees! Some have avoided the real work by copying photographs – something that I have not done.

John Coles is one of the few professionals involved directly in rock-art recording, having spent over 30 years recording, amongst other places, the rock-art of Bohuslan and Ostfold. His field work was supported by grants from the British Academy and the Royal Swedish Academy of Letters, History and Antiquities. One result of his work has been the publication *Shadows of a Northern Past* (Oxbow, 2005) which for me is an exemplary record of how it should be done. He has commented on how much disagreement there has been among researchers on how to record, and he looks forward to a time when laser scanning and photogrammetry will be the norm. Like mine, his work was done without these aids and he made hundreds of rubbings to produce his pictures. His drawings are similar to mine, and he includes photographs of rocks with wet surfaces. Interestingly, too, his final chapter is headed 'The meaning of it all, or of nothing', and he hates dealing with what he calls 'opinionated opinions'.

DISCOVERY

I have dealt with some aspects of recording first, but without the exposed rock panel there is nothing to record, so how are they found?

A discovery may be accidental such as the disturbance of a cist with rock-art in it, or someone just happens to notice what has been under everyone's noses for years, like the decorated block on Old Bewick Moor. Farming or quarrying have also revealed some, or animals scrape the top cover away. When we started the search in earnest, we found that some were already recorded after a fashion, some still open and others had disappeared either temporarily or permanently. The most common way of adding to the tally of rocks found, as it is with finding sites of flint-working, is to look in the same area where the first is found. It is logical that an extended outcrop of rock traced under grass may have more motifs on it. The area of search widens and more may be found on that 'site' – a general area of rock-art as opposed to a single marked rock. It happens that a single cup-mark may have been showing, and stripping the turf off reveals often quite dramatic designs. We have to face it that rocks were not always stripped using modern archaeological techniques, and people continue to find more this way. We also have to accept that without sites found in this way there would be only a fraction of rock-art for others to study. When an official survey is made how can a rock be re-assessed without removing the cover? How do recent surveys manage to record 'new' rocks when they have to be stripped off to begin with? So the Beckensall Archive survey found over 200 previously unrecorded rocks, mostly small, on Northumberland sites where much art had been already recorded. The English Heritage Northumberland and Durham project found additional rocks too. Some of these had been under vegetation.

Official surveys are therefore finding some, but the work of individual recorders finds even more. I do not know how many hundreds I have recorded in my lifetime, but others are doing just as much. George Currie in Scotland is approaching his 500th and Paul and Barbara Brown, sometimes with Graeme Chappell take credit for hundreds more.

How do people find the new ones? It clearly is not a matter of going out and digging everything up. People develop a sense of where hidden rock-art might be, or even where it *ought* to be. What they are doing is developing a similar sense to those who put it there originally. I have done this myself and been with individual researchers when they survey landscapes. It is a logic that does not come from being in an office, but from sympathy with, and understanding of, a landscape.

There are also voluntary groups of people who have formed themselves into research teams, such as that which produced the work on West Yorkshire based on Ilkley. Hopefully, the English Heritage Project in

Northumberland and Durham may have led to the formation of groups that continue to search and record rock-art in their spare time. In all these cases the voluntary element is crucial, as people who are paid will not undertake a project without 'funding'. It is, after all, the way they earn their living and not a leisure-time activity, so this is not a criticism.

LIFE AFTER EXPOSURE

Let us now assume that we have found a rock and exposed it, and that it has been meticulously re-recorded with every means at our disposal. What next? Do we leave it open or do we cover it over? There is no definite answer to this. On the one hand we may want people to see it, as it was originally meant to be seen. We might take the line that it is up to nature to take its course. There is a big debate taking place all over the world about this. Some countries and regions wish tourism to bring income to needy areas and see rock-art discovery as a boon. Jobs will be created.

But bringing in visitors may cause damage through people walking all over it, scratching their names in a kind of cheap immortality quest or even cutting off panels as souvenirs. There may be hostility from landowners and farmers. The answer to some of these points is that a site must be presented in such a way that it is not damaged. In Scandinavia the building of viewing platforms has occupied local authorities and historians, and they are a solution to the problem of access, for if visitors can easily see the rock-art and take pictures of it, all the better. The walkways and platforms keep them off, and tastefully-erected noticeboards tell them what to look for. They go away feeling that they have had a good deal. Before platforms are erected, the site has to be investigated archaeologically to make sure that what is built will not destroy something else, and there is a built-in clause that the erection of these things should not be irreversible. On no account should the structures be anchored to the decorated rock (83).

The only place in Britain where this has been adopted widely is Kilmartin Glen, where many of the sites are railed, some with platforms, and others have fenced approaches that direct people and keep animals out. Each site too has a noticeboard to inform people not only of what can be seen, but to ask that they share in the business of preserving the site for others to enjoy too (84).

The idea of covering a site with a roof has not been considered in Britain. In Sweden they found that this had not produced 'any unambiguous results'. It is different in the case of some stones which can be moved indoors for their safety and preservation, as, for example, a carved cobble now in Dean church, Cumbria, or large carved slab in St John Lee church, Hexham. Others find their way into museums, where many remain hidden and forgotten.

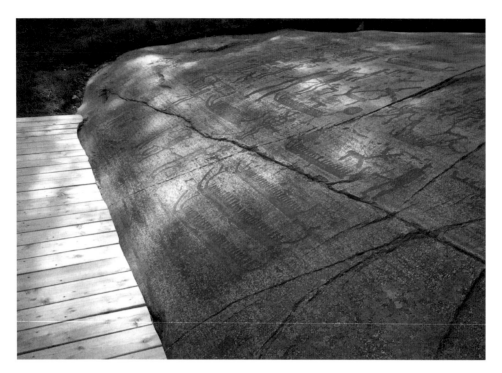

83 Sweden: a viewing platform at Fossum

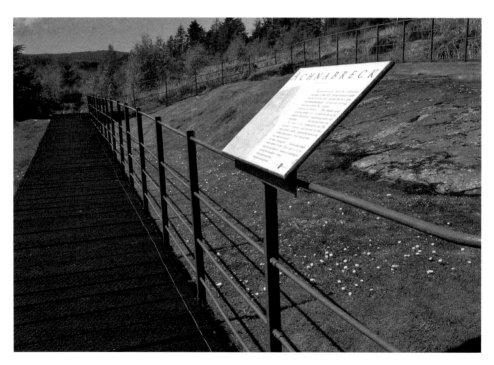

84 Kilmartin: a viewing platform at Achnabreck

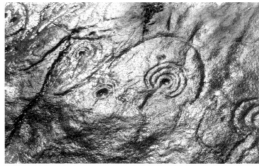

85a, b & c Animals free to roam:
West Horton site with the covered design
(*above left and right*), and Scrainwood
(*below right*)

ANIMALS

At times I feel that I would prefer to pay farmers to protect the rock-art
on their land rather than finance yet another survey of what to do with
it. I say this because there are many places where animals still roam
freely over rock-art panels, scratching them as they go. If the rock-art is
on grazing land there should be an official contract between farmer and
authority that keeps animals off the rock. This may involve compensation
for the farmer, but that is fine because it is his living.

A DEFRA scheme in Northumberland at Chatton Park Hill, one of
the most dramatic rock-art sites in Britain, eventually arranged for the
farmer to move stock off land where it customarily grazed in the autumn
and winter. We had spoken to him often about the problem and he
was sympathetic and cooperative when the scheme was proposed. The
arrangement had a TV fanfare, and hopefully others will get the message
that this is a good thing to do. The land has public access, too.

But, as the photographs in the same county show, there are places where
the rocks are in danger, and in the case of this one at West Horton it is lucky
that the rock has gradually become covered over for most of its surface.
Sadly, it is one of the best patterns in the country, but not many people are
going to be able to see it. If anything needs a management plan, this does.

PAINTING THE MOTIFS RED

In Sweden the major rock-art is painted red, by filling in the grooves and cups. This is almost traditional, though there is little evidence that artificial colour was applied at the time the marks were made. It brought criticism from archaeologists in other countries as unnecessary 'intervention' that would harm the rocks, often from people who had not seen them. Like it or not, the policy is that as the paint fades it is touched up in a lighter tone in the same colour. Originally, when rock motifs were pecked in, the colour of the minerals below the surface was naturally a different colour, so the motifs would have been more visible. Once exposed, this colour change disappears; all becomes uniform again. It would cause outrage if the painting were to be removed because one can imagine lots of children having been brought by coach especially to see the pictures on the rock, would not be able to see much. Rock-art management would hardly be popular then. In some cases the viewing platforms have been fitted with angled, solar-power lights so that this obliquely helps clarity.

In Kilmartin painting has not been necessary as the motifs can be seen generally at many times of the day, and the display panels show people where to look. The kind of rock and the depth of carving make this possible. On the whole the Swedish examples are much shallower. On sandstones it is usually easier to see rock-art.

EROSION

In Britain many people are convinced that the patterns are eroding, but a visit or two at different times can assure that this is not so. To the right (86) is a motif on one of the best-known decorated outcrop rocks in Northumberland, flat on slightly higher ground than its surroundings. In the photograph, taken in autumn 2008 every pick-mark is visible; nothing could be clearer and yet it has been open to the elements and, when I first arrived in Northumberland, there were cattle and sheep roaming freely over it. There had even been fires on the heather that covered its edges. Today there is very little heather there. This rock has been known since the latter part of the nineteenth century; it has been open to the elements, is frequently visited today, so it must be of good quality and, let's face it, lucky. It is now scheduled as an Ancient Monument, there has never been an official plan for its preservation, but those of us who live in the county, visit it, and know the farmers, have had a direct hand in its preservation.

This shows that there is not an immediate problem of erosion there, and on some rocks erosion does not wear away but actually deepens grooves when the rock is on a slope – which many of them are. The pick-

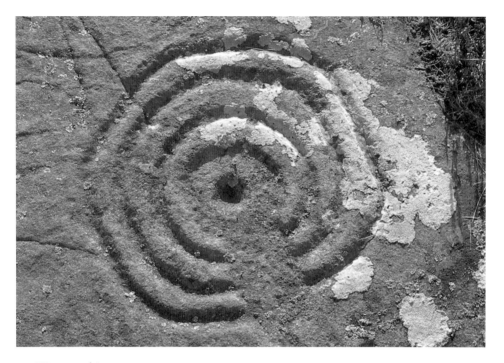

86 Weetwood in 2008

87 Naddro

marks that made the cups and grooves are smoothed out naturally, but this fact should be entered in the archive.

Just using one's eyes is hardly a scientific way of measuring erosion. Within a short time, especially after rain when the sun shines obliquely, the patterns can spring to life in a dramatic way.

This should not make us complacent, though, and every means of measuring change and decay should be employed. 'Monitoring' is important, but it has to be frequent, on a precise programme.

WAYS OF SEEING

No open-air rock-art in Britain is painted. In Sweden many rocks, especially those recently discovered and cleaned, are left like that. When official visitors are taken there, as I was, water is used to bring the designs to life. Some rocks that are on the main tourist trails are the ones that are painted, and this appears to be a sensible compromise. In other areas, selected painting is employed, as at Valcamonica in this example.

In Britain it has not been thought necessary to paint in the motifs, although one important cist slab with decoration in Bristol Museum has been treated this way so that foot-prints and cup-marks on it can be seen in rather low light. It may be that museum interiors could arrange appropriate lighting to display some interesting panels that are almost perpetually in store.

In Irish passage-graves at Loughcrew, where there is no artificial light and access is restricted, some motifs have been painted in white.

LICHEN AND MOSSES

Now comes the question of what to do about lichen and moss growth on rocks, which is shared particularly by northern countries. We have always been unable to say whether lichen 'eats' the rock surface or whether its growth can protect it from further problems such as acid rain or extremes of temperature. Research has been undertaken by university departments to examine the problem outside and in the laboratory. Just as no miraculous substance has yet been found to coat rocks to protect them, it seems that the problem of lichen growth has not been completely solved. However, what is known has led to a policy that has been put into practice in some parts of the world. Again, it is in Scandinavia where much of the research has been done, although at last the need for research has been admitted in Britain; fortunately some of the groundwork has been done for us, and I was impressed at the RAMASES meeting in Sweden to hear the Norwegian Torbjorg Bjelland of the University of Bergen outline her research.

There have been many reasons for removing lichens in Norway and Sweden since the 1930s. Lichens produce acid and this can disintegrate some minerals. Expansion and contraction of lichen hyphae (like a web of little roots that push into the rock) can weaken the rock surface. Questions asked have been these:

Does lichen harm the rock, and how?
Do some species give protection by holding minerals and the weathering surface stable?
Is removing the lichen the most damaging thing to be done?

Projects have now discovered that damage depends upon the species of lichen; some are more 'aggressive' than others and have been identified as such. Other investigations have been into whether some lichens prefer rock that has already been weathered. Before framing a general policy the differences between species had to be carefully considered. If an 'undesirable' lichen was found to be damaging the rock, how should it be removed without further damaging the rock?

A policy has emerged that states quite clearly that lichens should not be removed unless it is absolutely necessary, and that if a decision is made to do this, there should be a carefully worked-out follow-up plan. Lichen should not be removed mechanically but with an ethanol spray. In the past lichen removal with the wrong chemicals has caused problems. Once ethanol has been sprayed the rock must be covered up for two years, and after being re-exposed and examined it has to be sprayed each year, as ethanol does not harm the environment and does not increase weathering.

Incidentally, peat produces humus and grows roots which increase chemical and mechanical weathering, so this is another consideration. Rock-art in the Kilmartin Glen was covered with blanket peat before the peat was removed commercially in the nineteenth century.

What those of us involved in rock-art research have to realise is that we are not capable of making some decisions alone, and that any 'intervention' must be a joint effort of scientific research, environmentalists and archaeologists. Recently a visit to a dramatic rock-art site at Ormaig, Argyll, involving people from Britain and Scandinavia, saw that lichens had spread over the rock that was visible and that some very good rock-art could no longer be seen under a covering of pine needles from trees which had encroached so far over the decorated panel that it had become almost impossible to see it. Public access to the site was difficult, too, through a wood by a steep path; this contrasted with the well-displayed and accessible sites on the floor of the Kilmartin Glen.

Since then, a 'Data Structure Report' was published in October 2007 following excavation of this site. Buried rock-art of high quality was re-

88 Ormaig: the forest

discovered, one part was cleared of moss and grass, but others were not because the roots of the moss cover appeared to penetrate the surface. The aim was to get as much information about the site as possible as a means of directing future plans, including the preservation and presentation of the site to visitors. Recording included 'tracing', photography and laser scanning. During the excavation it was noticed that tree roots had destroyed some of the rock-art, as one would expect.

There was no convincing evidence of human activity around the marked outcrop rocks.

One conclusion that makes interesting reading in the light of the Scandinavian findings was that the lichen cover had protected the rock-art from erosion. However, the cracks in the rock were potentially a weakness when vegetation and algae could penetrate.

Another conclusion was that the coniferous trees around the site should be felled, and that no long-term strategy should be planned until this had been done. There may be more decorated rock in the area, for example.

The replacement of some trees with mixed, open native woodland was thought good because it produces shade and enables rock surfaces to dry rapidly. It was also thought that re-colonisation by lichen would be beneficial. Obviously the felling of the forest in the first place, as at Amerside Law Moor, Northumberland, would have to be done very carefully.

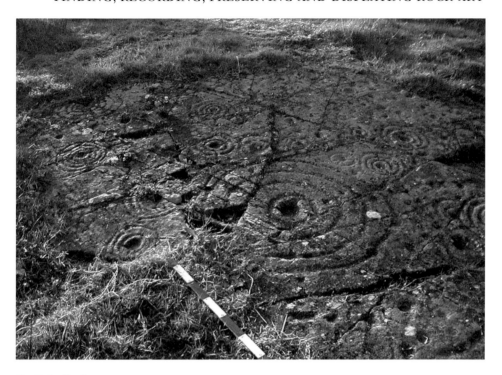

89 Poltalloch

Some sites above the main valley floor had been kept free of growth and some were railed in, whereas others like Poltalloch, once cleaned by the Scottish Royal Commission, had gradually grown over again.

This brings me to what has happened in the past and the need for careful planning.

PAST MISTAKES AND FUTURE POLICIES

The decisions on what steps to take with such sites are important to forestry authorities, landowners and farmers, especially as visitor numbers bring economic benefits as well as additional problems for people living and working there. Kilmartin has done more to promote good practice than most other rock-art areas, and continues to do so, but as we can see from the above, the efforts have to be maintained and based on intelligent research. In Scandinavia the emphasis has been on taking actions which are reversible, but this may be impossible to carry out.

Mistakes have been made in the past. In Sweden, for example, it was once thought that cracks and large gaps in rocks should be filled in with cement. Cracks are an essential part of the way in which natural zoning on the surface was used in the prehistoric design, determining where the

motifs should be placed. They were thought, however, to be allowing water in, which would freeze, expand and crack the rock further. It was decided later that filling in the gaps did more harm than good.

A survey of Norway found that 95 per cent of rocks had been damaged in some way and that the problem was getting worse, that weathering was the biggest factor, the worst damage coming from freezing and thawing, through acid rain, and through the sins of bad management in the past. As their report says, 'there is little we can do with 'past sins' other than acknowledge and learn from them'. The damage from acid rain, largely caused by British industries, had already been done in the 1960s and 1970s.

It is realised that it is not just a question of protecting rocks, but also the whole environment around them, by people working in harmony with nature. This emphasis on context also stresses that when a site is being investigated, it is not a question of giving all the attention to a marked rock surface, but also to consider an archaeological excavation of areas outside the rock. Another point is that if money is in short supply, is it better to spend it on rocks that are already damaged or to ensure that those which are not have a better chance of being saved by being given protection? There are some other issues here, an example being that if water flows over a rock from a spring source and is thought to cause damage, it may be diverted or – because the art is there precisely to mark a spring source – it should be left.

The photograph of the outcrop slab at Cairnbaan (see 5) shows that it lies just below a spring source, that water naturally flows over it, and that the ground just below it is often boggy when all around is dry. Although its companion rock further downslope has been railed off with a stile for access, this one has not, and that is a good thing. The surface has been open for over 200 years, and every mark is still very clear, including the vesicles of its fire-and-pressure changed composition. If there is no problem, don't create one.

A proposal made seriously is that some rocks should be buried for their own good, and others buried to give them a rest. The Swedish report includes the heading 'Here rests a rock carving', a sign set up by a rock panel burial in such a way that it looked like a burial mound. I liked the explanation that 'to give a rock a 'time out' is a type of parking while we wait for new and improved methods of preservation, a better microclimate or just waiting for spring, with less daily varieties in temperature'. How refreshing to have wisdom combined with a sense of humour in a document!

In Derbyshire, one of the region's most satisfying pieces of designed rock-art was 'cleaned' with a wire brush and bleach by a visitor. Such was the threat that the authorities decided to cover it over and mark the spot with a replica. It is one solution to the problem.

In the same county Ashover Primary School adopted two marked boulders unearthed in their grounds and made a feature of them in a

90 'Buried' rock-art in Sweden: Asperberget

planned garden – a splendid way of preserving them and educating children at the same time (see *colour plate 6a*).

Some rocks have been covered with geotextile, mats made out of mineral wool and a tarpaulin. However, it is not clear that covering the rocks in this way is the best practice. Should such a course be considered, it is better to experiment on a surface that has no rock-art so that results can be tested, otherwise new problems may be created.

Whatever actions are taken, everything should be well documented.

In some major tourist sites in Sweden you will see long sections of rock covered with a tarpaulin. A good compromise has been used here: to put a red picture of the carvings on the tarpaulin so that people know what is buried there.

CASTS

There was a time, and this may still happen, when it was thought a good idea to make plaster casts of marked rocks, officially and otherwise. Where this has been done, traces of the plaster still remain long after the event. It was decided that no matter what the material used, this should no longer be done. As far away as Easter Island it has been shown that much of the surface of carvings has come off as a result of this. If there happened to be original painting on the rock being cast, it would remove that valuable evidence. So the answer is not to make any casts, but it is possible that someone is going to propose an alternative by using the results of laser scans rather than the original rock.

VEGETATION, ANIMALS AND PEOPLE

One of the best ways to manage rock-art is to manage vegetation. It is no good relying on a one-off clearance which, rather like patching up a hole in the road, does not do much for long. All the vegetation around the rock has to be controlled. Trees can help to give shade, but if they have acidic needles they do no good at all.

In the Wellhope example which I first recorded a few years ago, the rock jutting out into the grassy forest 'ride' is covered with needles, mosses and lichens. It is one of hundreds in the same county, with inadequate resources to monitor and protect them all, but would it benefit from the trees being cut back around it? It is one of hundreds of decisions to be taken, and the odds are that it will stay like this until the rest of the forest is down. But will the fellers be aware that it is there? What will happen when the forest is re-planted, for this is commercial timber destined for paper or chip-board?

Consider the fate of the next site. It was found by a shepherd on horseback who came to my talk at the Chatton village hall and produced photographs of what he had found. I went with him shortly afterwards to the site, where local TV had already been informed of its discovery to give it coverage. It made a good feature. I was more concerned with the recording of the site, especially (and this is not uncommon) as there was no official archaeologist involved. The site is fully recorded, but in the 1970s forestry moved in to replant the area. Had one of the machine operators not been known to me, I hate to think of what damage the site might have suffered. He ensured that the machines kept away from the rock-art. Gradually the site became covered over. There was nothing I could do about this as I had a full-time job in education and was busy finding other sites in my leisure time. Yes, I am making this personal, because although we do not want to dwell on past mistakes, we must learn from them, as the Scandinavians have said. When a group of us went to look for the site for the Beckensall rock-art website, we could not find it, as it had been naturally buried. It took a persistent and enthusiastic independent rock-art researcher (Ian Hobson) many hours of his spare time, which involves his wife and children too (good for the future, this) to find the site and to confirm what I had found all those years ago. He has a 'blog' site on the internet where he passes on his discoveries, and he is in constant touch with me. Some of his work is in this book.

Just look at what lack of management can do to one of the most interesting sites in Britain and you will see what really needs to be done. If this site could remain buried it would be a reasonable solution, but it is in an active forestry area and could well be destroyed.

No wonder that we find it hard to believe that water on rocks is more important to some than the safeguarding of the site just described! Somewhere the priorities of some managers have gone wrong.

91 Wellhope, Northumberland, 2008

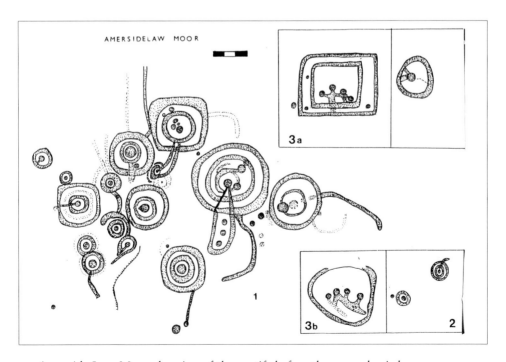

92 Amerside Law Moor, drawing of the motifs before they were buried

93 Amerside today (Ian Hobson)

EXCAVATION

How anyone cannot see the importance of excavation is a mystery to me. We have had a number of crucial excavations in Britain that have revealed more about rock-art. In Scandinavia, excavation is an essential part of the rock-art programme, showing it in its full prehistoric context, but without as yet providing convincing dating evidence.

More excavation is needed in Britain as an attempt to answer some really important research questions, such as what exactly is a rock-art panel the focus of? What activities have taken part around it and for how long? Did the activities precede the rock-art or vice versa? How long ago did these activities go on? Those of us who have worked extensively in the field can pinpoint some possible locations for this. Naturally, we have to think of who is going to pay for it and whether rock-art is a high priority, say, against demands of health or education, but within the archaeology budgets there must be provision. In Norway the Final Report from the Directorate for Cultural Heritage 1996-2005 (Oslo, 2006) concludes that 'not everything can be solved by government funding, and even a yearly amount for this purpose in the national budget is not sufficient'.

Fortunately there have been excavations on British rock-art sites which have pointed the way to a future programme. The most widespread and spectacular have been at the Boyne valley tombs, where dates have been obtained and areas around the mounds have been excavated. The need to rebuild such mounds has led to massive stones having to be moved, one result of which was to allow the backs of such stones to be examined;

some of these were covered with earlier carvings. The use of rock-art is not confined to one period but is extensive on a given site, with evidence of changes in plan. In the same country Blaze O'Connor looked at the question of what was focused on a decorated rock-art panel, when she excavated a site at Drumirril. The area was subject to geophysical survey, producing a kind of x-ray of hidden features, and this showed that there were prehistoric pits close to the marked outcrop. On another site the outcrop was enclosed by a banked enclosure, the outside ditch of which had been re-cut. There was a stone revetment and post-holes dating to numerous periods in prehistory, the earliest being the Neolithic, suggesting as we see elsewhere that the extent of use of rock-art was possibly over one thousand years. This is just a beginning.

In Scandinavia the Scandinavian Society for Prehistoric Art has reported through its journal *Adoranten* some impressive excavations that are beginning to make us see rock-art in a much wider setting, stressing how crucial such methods are. In the prologue to the 2006 edition this statement appears:

> The systematic performance of full-scale excavations at rock-art sites is a relatively new discipline in archaeology. The results are promising and at almost all places where an excavation has been carried out interesting traces of human activity have been revealed.

Management and research have been involved not only to understand why the rock-art has been put there but to protect the material that will be able to tell us more about it. Outside the rocks themselves are areas covered over with turf and other vegetation which hide what other activities were going on at the same time and earlier and later. The archaeologists acknowledge that because rock-art is impossible to date from the rock surfaces themselves they have to find out from what is associated with it to have a chance of working out a time-scale.

Sometimes they found that the traces of settlement may just have been coincidentally close to the decorated rock. In other cases many finds seemed to reflect 'non-practical activities', meaning something 'ritual' or 'religious' going on. For example, if cooking pits are found, it is as well to remember that in prehistoric society and in others the holding of feasts is in itself a ritual, as at a funeral party. At one site where the rock-art is on an almost vertical cliff covered with a line of magnificent ship images, excavation revealed a low stone wall starting at one end of the carvings then curving round to meet the other end, enclosing the vital part of the rock. Many of the stones had been burnt, and a large quantity of burnt clay and pieces of pottery was found. Other sites showed that stones had been placed in front of the rock. When Richard Bradley recently excavated

a site overlooking Loch Tay (some of the rocks being pictured in this book) he found a raised platform against an outcrop decorated with complex art, whereas on a lower slope leading up to this site he excavated a single earthfast boulder where the few motifs were simple and there were no traces of other deposits around that rock. What if more and more of such sites were to be examined? Would there be some marked rocks deliberately singled out to have a viewing platform built against them? If so, why?

An excavation that impressed me when I visited Valcamonica, Italy, was at a rock-art site at Cemmo, near Capo di Ponte.

There were elaborate carvings of lines of animals and blades of different kinds from the Copper Age dated later than our Early Bronze Age, pictures of animal-drawn carts and ploughs and a disc carved on the rock. Around it was a well-built semi-circular wall which ran round the rock face to enclose it, probably of the same date as the carvings. As part of the same complex there were 10 decorated standing stones ('menhirs' or 'stelae') commonly found elsewhere in this area. The wall had been frequently reconstructed and lasted from late Prehistoric to Roman times, so the area had remained special for almost 3000 years. What an incredible record this has provided. Let us hope that we can find a similar site – and why not?

Why not? Because we have not looked, and if we heed the people who think that excavation will destroy the chance of people in future from excavating a site with even better technology, we have a curious sense of time. What we want is the answer to vital questions now so that the future can build on that. We have so many sites that there is no danger of running out in this or the next generation!

I will give one example.

I discovered the rock that you see here just protruding from a low bank on a moorland in Northumberland that had been surveyed many times. It lies inside the rim of a low oval enclosure. The slab seems to be part of a floor of slabs, but I have not investigated this. It lay under a very thin layer of turf. I took photographs, made a rubbing, then a drawing, and it was entered on the Sites and Monuments Record. I covered the rock securely to prevent further disturbance, though people have been to see it since. The site is in no way prominent, lying at ground level, but with extensive views from the decorated rock in all directions. In an area where there is much more rock-art (two fine pieces of it in Alnwick Castle Museum), walls, Iron Age enclosures and Romano-British sites, all unexcavated, but not necessarily undisturbed, it seems to me that here is a superb example of an excavation that would help to answer many questions that I have been asking throughout this book.

I repeat that this is only one of many such sites that are known by those of us who seriously research rock-art and it may help our understanding. We will never know until we do something about it, will we?

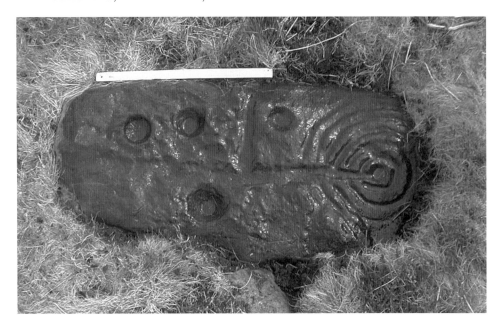

94 Beanley Moor

FUNDING

I remind the readers that almost all the work of locating and recording British rock-art has been done without any grants prior to the English Heritage project. This is certainly true of my work (including photographing sites from the air), and when I think of other discoverers it is so clear where the real work has been done. My experience of official bodies has been generally happy and cooperative but some of my colleagues have been met with ingratitude and even rudeness despite the enormous contribution that they have made. Something is clearly wrong with attitudes here, and this is very worrying.

OWNERSHIP

No one group 'owns' our rock-art. Whether it delights those who go out into the country with their cameras and share their delight with an audience on the web, those who study it in depth in universities, those who love to read or hear about it, the children who have adopted it in their school garden, those from a County Durham New Town who used it as a spring-board for their exploration of symbolism, artists who are inspired to paint it or poets to write about it – all these are the descendants of those who made it originally and who deserve to view it.

APPENDIX I

TERMINOLOGY

Cairn

A mound of stones made to cover a burial or to mark another special spot, often with a kerb of larger stones to hold in the cobbles. Other terms such as 'barrow' and 'tumulus' are used for the same thing. In the areas where stone is scarce, the mound is usually made of earth from a specially-dug circular ditch.

Carving

A not very accurate term in rock-art because it is usually associated with sculpture, but it has become accepted by frequent use in the same way that 'rock-art' has been accepted.

Cist

A large stone-lined box for burial of body or cremation, set in a pit, usually with a capstone for cover.

Earthfast

Rocks of different sizes and shapes moved into position by natural forces such as ice sheets, and rooted in the ground.

Engraving

As all rock-art is made by 'pecking' and some then smoothed out or ground, it is best not to use this specialised term.

Gutter

An unpleasant-sounding word which is used for the groove that leads out of a cup, but it wrongly implies that it was for drainage.

Igneous rock

Fire-formed in volcanic conditions (such as granite).

Incision

This means cutting into the rock without pecking it.

Metamorphic rock

Rock that has been changed by the action of intense heat and pressure.

Motif

A combination of symbols.

Outcrop	Sheets or blocks of immovable naturally-deposited bedrock.
Passage-graves/ chambered-tombs	These are burial mounds, some of them very elaborate and large, with a central structure of corridors and rooms roofed over (some corbelled) before being covered with piles of smaller stones. They vary in complexity, and are particularly prominent in Ireland and on the west coast of Wales, England and Scotland. They are linked to similar structures along the European Atlantic seaboard, and archaeologists believe that the influences are mutual, acting both ways. Not all have rock-art but when they do it is more varied than cup-and-ring art.
Pecking	This is the art of chipping out symbols on the rocks by constant hitting. The marks are clearly visible in hundreds of examples, and it is possibly to gauge the type of tool from these.
Petroglyph (and glyph)	Beloved by classical scholars and those who like high-sounding terms, it simply means marks made on rocks.
Pick	A stone tool shaped to a point or chisel edge, designed to be impacted on a rock when it is hand-held or mounted like a mallet. Experiments have shown that a hard rock like whinstone (dolerite, basalt) is ideal for the purpose. Flint could be used, but because it is rare in many rock-art areas naturally and fractures easily, it may not have been used often. There is surprisingly little evidence of the tools used, though more thorough excavation may help to find the chippings made or the tools themselves.
Portable rocks	Rocks that have been moved by people. This is a term preferable to 'mobiliary', which suggests that the rocks move themselves.
Rock-art	A generally accepted term covering all marks on the rocks.
Sedimentary rock	Rocks formed by material deposited by water, such as limestones, shale, grits, coal and sandstones.
Symbol	A single mark such as a cup or groove.

APPENDIX II

TIMESCALES

Absolute dating depends on modern technology, so when the periods of prehistory were first named for convenience they were general. The periods have been retained, though the more we know, more subtleties have crept in. It is obvious that no one shouted 'all change' and the next period began. Whatever system of naming was adopted, there were bound to be overlaps. Bearing this in mind what follows must be taken as a very rough guide; as it is impossible to think of thousands of years ago, we have to accept what a rough guide it is. The 'periods' or 'ages' all take place before written history; such things as pottery, weapons, tools, bones, ornaments, burial grounds, settlements and defences help to identify the period. Once a particular type has been identified through radiocarbon dating in a secure buried site ('context'), a further discovery of a similar artefact can be assumed to belong to a similar time. As some sites go on being used for hundreds of years, the recording of layers in which finds are made is crucial to when they found their way there. Bearing all that in mind, here is a summary of the periods of prehistory. The 'Stone Ages', named by people keen on classics, contain the Greek *lithos*, which means stone. The earliest was Old (*Palaeo*), the Middle was *Meso*, and the New Stone Age was *Neo*. They cover thousands of years between them, and make it difficult for anyone to think 'chronologically' except by reference to what is found of material use in them.

Palaeolithic
The oldest and longest of all, when for periods most of the country was covered with ice sheets which, when they began to melt, were followed by new vegetation, animal migrations and the appearance of people in pursuit of food and shelter. In the later part of this vast period we have the first appearance of British rock-art at Creswell Caves, animals scratched on the walls of caves by people who lived there.

Mesolithic
The middle period was during a warmer climate when food was more abundant, offered by animals and vegetation. There was no farming,

groups were mobile, probably living by the sea, moving up the river valleys in the summer to camps, where they hunted, gathered and conserved natural resources for the next visit. So far this period is not associated with rock-art, though there have been some recent claims to some possible scratch marks in caves.

Neolithic

Often heralded as a great 'revolution' there is no doubt that managing the land through arable farming and stock-rearing did bring a great change to people's lives. It meant that they were less dependent on hunting and gathering, although these activities still remained essential, as people became more fixed to settlement sites with houses and walled enclosures. We do not know when exactly rock-art appeared in this period; there is difference of opinion largely because we have so little information, but we do know that by the end of this period rock-art was being made. Increased use of ceremonial sites, more elaborate ritual for the burial of the dead coincided with this, and the appearance on rock-art on some of them (*but only some of them*), gives us some sort of period for it.

Metal Ages

The gradual use of the first metal – copper, so difficult to smelt – was followed by bronze (when tin was smelted with copper) and then by iron. We need only be concerned with copper and bronze, which were early luxury items, used alongside stone tools, which made their appearance around 2400 BC. Depictions of metal tools are very important, as we see in the cists at Kilmartin, in this overlap of stone and metal ages.

In the later Bronze Age, rock-art dies out, probably because it lost its power as a symbol and became irrelevant to new values. When it does occasionally appear in a different period, it has perhaps become a curiosity, not understood for what it was, but decorative and quaint. It might have had a life-span of something over 1000 years, which I find very difficult to get my mind around! We can only date it from what is found with it, and that is very little, so we must not become over-confident when we suggest such things.

Until more sites are excavated with a carefully worked out research programme we may not know more, and even if we do, the chances are that we are not going to know much anyway. Above all we must not try to try to get results to fit theories. Our minds must always remain open to many possibilities.

APPENDIX III

REGIONS

ENGLAND AND WALES

The South
The south of England has only a little rock-art, associated mainly with burial/religious sites.

Wales
Not a prolific area for rock-art as yet; all the known examples have been recorded in *The Proceedings of the Prehistoric Society*. The north-west coast, including Anglesey, has some of the best, some associated with passage-graves.

Derbyshire
Decorated outcrop and earthfast rocks begin in significant numbers in Derbyshire, though it is thinly spread. There is no book about it, but the *Derbyshire Archaeological Journal* keeps us up to date with discoveries.

North-west Yorkshire
The rock-art here has been well recorded in a book by Keith Boughey and Edward Vickerman, *Prehistoric Rock Art of the West Riding*. About 700 marked rocks have now been included in a survey undertaken entirely by independent archaeologists working as a voluntary team over many years. The main focus was Ilkley Moor, but the area has been extended well beyond this.

The Isle of Man
There is some rock-art recorded in articles.

North York Moors
The spectacular fires on Fylingdales Moor have revealed this region to the press and public, but rock-art there has been known for many years, thanks to the work of independent archaeologists. The area is greater than Fylingdales itself, and there is a particular interest in associations between rock-art and burials. There has also been some fine professional excavation of monuments

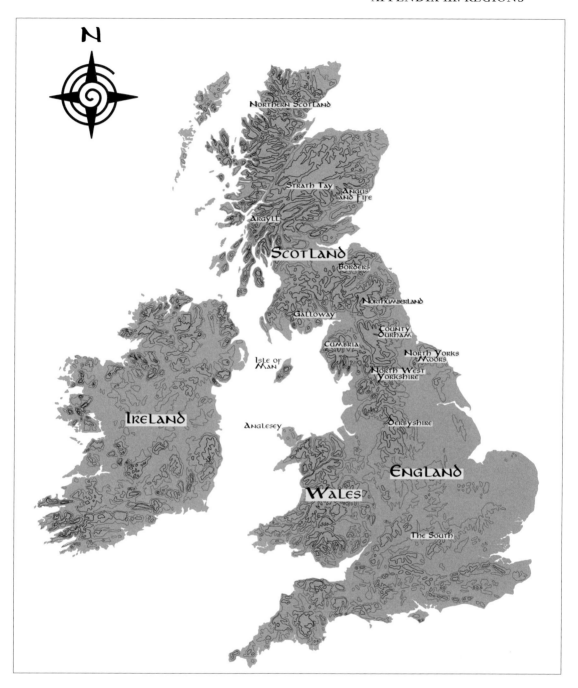

95 Main areas of British rock-art (Marc Johnstone)

to flesh out the picture of less skilled excavation of the past. The key book for this region is by three independent archaeologists, Paul Brown, Barbara Brown and Graeme Chappell, with every rock listed in detail.

County Durham

Until the work of Stewart Feather, Dennis Coggins, Tim Laurie, Barbara, Paul Brown and myself, there was little recorded rock-art in what now covers a wide spread of landscape. Books have been produced, notably by Beckensall and Tim Laurie and by Paul and Barbara Brown. This work provided the basis for further recording by the NADRAP project, which can be accessed on the internet. Further work on the area is included in Paul and Barbara Brown's book on rock-art in the Northern Dales, covering Cumbria, Durham and North Yorkshire, which includes many previously unrecorded sites discovered by the authors.

Cumbria

The first published survey of Cumbrian rock-art was by Paul Frodsham (see Bibliography). Based on this, my first private publication on Cumbria was a slender pamphlet-type book, which, with the help of Paul and Barbara Brown, grew into a much larger one. At first it was thought that Cumbrian rock-art was confined to monuments, but outcrop rock has provided another dimension. There are now many people in the county looking out for more, and it is only a matter of time more will be found.

Northumberland

With well over 1000 marked rocks, Northumberland has always occupied, and still does, a prominent position in the history of rock-art. I have written a book on this, but the strength of recording now lies in the website of Newcastle University, a superb example of complete cooperation between professional and independent work. The website formed the basis for the Northumberland and Durham Rock-Art Project (NADRAP), which could not have happened without that expertise. Decorated outcrop, earthfasts, burials, rock-shelters are all there.

SCOTLAND

Scotland not only has some magnificent rock-art and a tradition of research, but has of late produced 500 more examples, thanks to the work of George Currie, an independent searcher. It was also the starting point of the work of the late Ronald Morris, to whom everyone owes an enormous debt. Scotland has become a research area for Professor Richard Bradley and his team, who developed a method of researching rock-art in Northumberland which can be applied effectively elsewhere. At first this made use of data already known, but now includes some of the excavations that are so essential to any progress that we are to make in understanding it, notably in areas like Loch Tay, the Clava Cairns (Inverness) and selected

recumbent stone circles. There has been significant research by the Scottish Royal Commission, so the future looks bright.

Galloway

Parts of Galloway are further south than parts of Northumberland. Ronald Morris published a book that caught the popular imagination and caused many people to go in search of rock-art. An independent researcher, Maarten van Hoek from Holland spent his holiday time covering much of Britain, and one of his finest works is on Galloway, although unfortunately this is printed privately in a limited edition. The rock-art is largely coastal, varied and exciting. It needs a definitive book, and if Scotland can produce a website similar to those on northern England, it will be a blessing to Scottish archaeology.

Borders to Clyde-Forth

There is so much to include beyond Galloway too, although there are no great concentrations. From the Borders north, rock-art has been documented by Ronald Morris in BRA reports and others, but there is no recent book collecting this together. The Clyde-Forth region is particularly well-served.

Argyll

The area that includes Kilmartin and Knapdale is one of the richest and most concentrated for rock-art, and at Kilmartin it is much better displayed than in any other area of Britain. Ronald Morris produced an easy-to-follow guide to Argyll, which aroused considerable interest at the time. The RCAHMS produced an excellent survey which is a standard for others to follow. My own book on Kilmartin, with its profuse illustrations in full colour, is aimed at a more general audience. More work is being done, centred on the Kilmartin House Trust, including excavation and conservation.

The Isle of Arran may be included here; it has one major panel with mainly 'keyhole' motifs, which I have recorded in detail, and others have been found by local people.

Strath Tay

Rock-art in this region has been published in articles, and reflects increasing ongoing research there. The valley includes Loch Tay with its proliferation of sites to the north and south, thanks to the work of George Currie, Richard Bradley and Alex Hale (RCAHMS), including excavation. Intensive field work has shown just what new sites are awaiting discovery, and there is some deep thought going into an understanding of why it is there.

Angus and Fife

Similar emphasis on new discoveries has been made by independent researcher George Currie and by official bodies, with the name of Alex

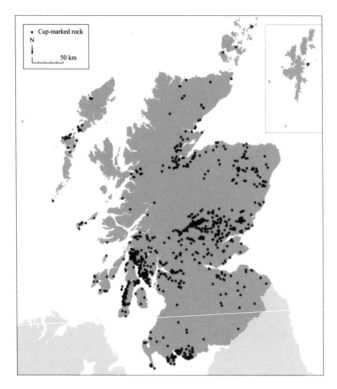

96 Map of Scottish rock-art sites, from 'Circles in Stone' (RCAHMS)

Hale again representing the RCAHMS, and John Sherriff. It is too early for a book to be produced, possibly, but the data is being entered in the Sites and Monuments record. Other reports appear in papers. Sites include outcrop, earthfasts and decorated standing stones.

Northern Scotland
There are no great concentrations of rock-art sites yet, but some important associations on cairns and in the field, including Clava and recumbent stone circles. Aberdeenshire and the north-east coast have a concentration of marked rocks, too.

IRELAND

Although the best-known rock-art is associated with the passage-graves/chambered tombs of the Boyne valley and Loughcrew, thanks to the work of outstanding Irish archaeologists, there has been increased interest in finding and recording 'art in the landscape', some of which has been excavated. The south-west Iveragh Peninsular and Dingle Bay are very important concentrations, researched recently by Avril Purcell, and Maarten Van Hoek has revealed more sites including those in County Donegal.

APPENDIX IV

A WORLD PERSPECTIVE

There has been a considerable amount of work world-wide on rock-art, many theories put forward about its meaning, and a common concern for how this important part of our heritage should be preserved. Although Britain has an enviable record for its skilled archaeology, it has lagged far behind some countries in its research into rock-art. Yet people like John Coles have done a considerable amount of work in other countries that is first-class: he is one of the finest investigators of Scandinavian rock-art, linking up with many other able researchers there. In turn, researchers from abroad have a great interest in British rock-art and frequently visit to record sites and to share expertise. More British people are going to see what, for example, happens in places like Valcamonica, Italy and the Coa valley, Portugal. Christopher Chippindale, Richard Bradley and George Nash have turned their attention to other countries to enhance what they have also researched in Britain, to the benefit of both. Dr Aron Mazel, at Newcastle University, is from South Africa, and has great expertise in not only rock-art, but in curatorship. George Nash and Clive Waddington have made rock-art a priority for themselves, so there is a good, enthusiastic coverage that bodes well for the future when we add their work to that of independent researchers.

At Les Eyzies-de-Tayac world experts in this field representing over 20 countries were invited to share views at the Musée National de Préhistoire and to prepare a document which could be distributed via UNESCO to all governments to explain what rock-art is all about and how the study of it and concern for it should become a national responsibility. Any one member of this group could have written the final report, such was the measure of agreement among them. This conference took place in September 2005. The report has only just been published, but I offer my own contribution when I put what I thought was the British perspective. It is a summary, hopefully clear and concise, that covers some of the points dealt with in my books.

BRITISH PREHISTORIC ROCK-ART: AN OVERVIEW

Background to the study of British Rock-Art

The history can be stated briefly: until very recently it was in the hands of independent/amateur archaeologists. It began with the nineteenth-century leisured, wealthy and scholarly men as an additional interest to their lives. Today it is still largely independent, but has attracted considerable professional attention, largely during the last 15 years. It has always caught the imagination of the general public. There is now an effort to make up for lost time, by making more resources available for its recording that were inconceivable 30 years ago.

World perspective

Apart from the recent Creswell Crags discovery of Palaeolithic cave art, Britain differs from most of the world in that its rock-art is almost all geometrical/abstract. Other countries share some of these motifs, but Britain has virtually no pictures to offer, and its use appears to be limited to a period of about 1000 years, from Neolithic to Early Bronze Age times. Questions about its distribution and use and about how it is to be recorded, conserved and made accessible are shared with all countries that have rock-art.

Recording

Recording has varied considerably in quality and accuracy, and it is now essential to standardise the British approach. A most important step has been the launch of the Beckensall Archive for Northumberland (http://rockart.ncl.ac.uk) by Newcastle University in January 2005, which has now achieved over 6 million hits on the web, an indication of great public interest internationally. This website is capable of being extended to any part of Britain, thus achieving standardisation through proved usefulness and accuracy. It was done with the support of a grant from the Arts and Humanities Research Board with an international team led by Dr Aron Mazel working for two and a half years in the field and office.

Despite standards laid down by the International Federation of Rock-Art Organisations (IFRAO), there are still many different recording procedures and terminologies. The arrival of GPS and other recording devices has simplified the recording of the location of rock-art throughout Britain, but how the motifs are to be drawn and presented needs much more work, as it is patchy, depending on the skill of the recorder. Devices such as digital photography and laser scanning have brought new possibilities, but the latter has not yet been widely used except among specialised professional groups. This work has been accelerating in the past few years and will continue to challenge 'traditional' methods of recording, thought by some to be damaging to the rock surfaces.

A general survey of recording and other related skills was undertaken by English Heritage in a Rock Art Pilot Project (RAPP), reported in January 2000 (in which I took part as an adviser). Its aim was to study the current state of research, conservation, management and presentation of rock-art in England after examining archives and doing a study in depth of two areas in Northumberland and West Yorkshire. To keep this in perspective, the RAPP based its general report on only c.1600 panels; Northumberland alone now has over 1060 recorded rocks. As a result of this report, RAMASES (Rock-Art Management, Assessment, Study, and Education Strategy) was formed as a committee to oversee the implementation of the report; it met infrequently at first, and there was a danger of the initiative fading, but recently the change of focus from South to North for its meetings, and its concentration on bringing in specialists from Scandinavia to share its proceedings with British people who are actively involved in studying rock-art as archaeologists and managers has given it a stronger sense of purpose.

Meanwhile other research, independent and professional, has gone ahead. The project gave rise to one initiative, which has only just been realised in a scheme funded by English Heritage and run by Northumberland and Durham County Councils to re-record everything, using a team of volunteers that the project trains, initially led by Dr Tertia Barnett. This takes part, however, in some of the best-documented areas in Britain (Northumberland and Durham), in which considerable work has been already done and hundreds of rock-art panels have been accurately recorded and published. All this work has been made accessible through national publications, for the general public as well as for academics. Similar work has been done independently for other areas, notably Kilmartin, Galloway, southern Scotland, north-east Scotland, Cumbria, West Yorkshire, and the North York Moors. National independent publications of regional studies have been an important feature of British rock-art research, and continue to be so. That on Kilmartin, Argyll, complements a superb survey produced by The Royal Commission on the Ancient and Historical Monuments of Scotland, providing a colourful and detailed account of all the sites in that area for a more general audience. Ireland has its own special, on-going research, mainly on the chambered tombs of the Boyne valley, but more work is being done on rock-art in the Irish landscape too. Details of these publications are to be found in the Bibliography.

Universities have contributed much new work, especially Reading University with Professor Richard Bradley, who has done more than any other academic to further the study in Britain and its relationship to international sites. Professor John Coles has made a particular link with Scandinavian research by working there, and Christopher Chippindale of Cambridge has contributed his wide range of exploration. Paul Bahn

has added the Creswell Crags sites to his wide expertise. More institutes are now offering degrees and further degrees with a rock-art component, such as the Universities of Durham and Southampton, and there will soon be more reports to synthesise.

There follows a summary of what is to be done about recording:

- The establishment of a national database linked to an international one.
- The use of a universally agreed terminology, already in existence, as clear and simple as possible.
- All recording to be set in a wide archaeological context (all prehistory to be recorded).
- Drawings, photographs and other recordings to be on an agreed scale. This has not been done in the past (*mea culpa*), but there are now well-established standards.
- The 'history' of each rock to be included.
- Each recorded rock to be cross-referenced and mapped (County, Parish, accessibility, condition and threats to it).

The above are essential to further research.

Conservation

It has now become important not only to record accurately what is on the rocks, but to assess the condition of the site and motifs. This has been subjective, as motifs appear faint or bold according to the conditions of natural light. There is still confusion in Britain expressed on the effect of lichen and moss on motifs.

Threats such as visitor numbers, animals and quarrying are fairly obvious. What is to be done is another matter. Help can come from government, but so far this has been an inadequate response to the problem. In the Kilmartin area of Scotland, many sites are fenced off so that they cannot be damaged by animals, and this, together with display boards, also helps to control the behaviour of visitors. This, however, is a patchy exception to the general malaise.

Conservation, access, and farming interests are interrelated problems. Good management of these is essential. It is not enough merely to 'schedule' ancient monuments, as this in itself offers little protection.

Associated research

As rock-art is not just an artefact, but a way of looking at the world and responding to it, there must be an approach that includes other disciplines such as anthropology and art history. The danger here is that people look at it from one point of view, seeking for some artificial link only with their own subject. Already there are too many unsupported theories from

people who think they know all the answers – astronomers, ley-liners and mystics. By all means allow people their responses, but these should not be imposed on others as 'truth'.

Presentation of rock-art and education

As rock-art belongs to everyone, we must not exclude it from the public, but involve them. There are many ways of doing this.

At the sites themselves, there should be excellent design of presentation panels. Few areas have achieved this. There are exceptions, such as the great tourist attraction of Newgrange, Ireland, where the tomb has been reconstructed and lighted for controlled visitor access, and the surroundings explained. To a large extent, Kilmartin has also achieved this, but there are so many sites that can only be termed badly presented or not at all. The largest panel of rock-art in England, Roughting Linn, is a national disgrace, with no finger posts to indicate where it is, no control of tree growth, and a hideously decayed notice board.
(Note: some steps have now been taken to put this right. The awful notice board and fence have been removed, and some of the threatening vegetation cut back).

Not all rock-art sites should be open to the public, and some should be covered over for their safety. The decision on what to do with a site must be made after extensive work to assess the threats to it, and if it is then decided that the site should be available to public visits, rigid standards of presentation and control should be applied. Access to a site and intelligent use of it in a larger educational programme can be of enormous interest to those who go there. (An example is the 'Written in Stone' project, described elsewhere in this book.)

It is unrealistic to expect schools to include rock-art in curriculum, but awareness of its power can be integrated into school disciplines, preferably inspired by site visits, images in museums and internet. The general public has long been interested, and many have bought books, visited sites, and attended talks so we have the opportunity to build on that. However this is done, I think it essential that approaches must be discussed with realistic and experienced teachers.

Archaeologists should work hard to reach the public in their findings, through direct and interesting communication in order to sustain and encourage public interest.

Excavation

Although the current trend is against excavation, it is clear that it is essential if we are to attempt to answer many of our questions. In Britain, people are highlighting specific sites that may help to answer questions of chronology and purpose, as we have pathetically little data on this when we consider

that its use extends well over one thousand years. Those of us with an intimate knowledge can recommend such sites. Excavations up to now are few, but crucially important. One recent example is Professor Bradley's re-excavation of parts of the Clava Cairns, Inverness; this much-visited and well-displayed site was assumed to be multi-period and it was also assumed that the chambered cairns there were of the same date as those in the Boyne valley, Ireland. Radiocarbon dating demonstrated that all the monuments there were of the same period, and all later than the Neolithic. Work of this type extended to the recumbent stone circles, where rock-art plays an equally important part in monumental structures. Another example is from Ireland where Blaze O'Connor's recent excavations (2003) around a marked rock have established a long history of use of the area focused on it.

Excavations must not be limited to the cairn, standing stone or rock-art panel, but should include an examination of its landscape context. There is a particular case for examining the relationship between burial and the use of motifs. It may also help us to understand the environment at the time the markings were made.

Once sites have been excavated, selections may also be used to monitor the erosion of those left open.

Administration

We must continue to make our case for public money to be used to further the study of rock-art. This will be considerably less than is spent, for example, on the restoration of one historic building. The money should be spent wisely and responsibly, and I would suggest on these items:

- Research, including excavation, through universities, with the incorporation of independent groups.
- The encouragement of independent archaeologists to submit and publish their work with financial help, as this is usually done with difficulty at their own expense.
- The involvement of all museums in projects and display.
- Constant inspection of sites, with inspectors who have an extensive knowledge of rock-art.
- Liaison with farmers and landowners to establish which sites can best be accessed by the public, and careful consideration on the quality of display.
- Immediate publication of reports or, at least, a digest.

I really think that government agencies should take a decisive and unwavering lead in all this. Ultimately, that is the only effective way forward. Perceptions of the age, character, fragility, heritage and responsibility for rock-art should be firmly embedded in all societies. That is optimistic, but worth aiming at.

APPENDIX V

RECORDING

Having experienced the technique outlined below in Kilmartin in May 2009, I was impressed not only by the results but also by the cheapness of the method of recording. Paul and Barbara Brown have added this valuable contribution.

RECORDING ROCK-ART USING A DIGITAL CAMERA AND INEXPENSIVE STITCHING SOFTWARE

Since the development of the digital camera numerous photo processing software packages are offered such as Adobe Photoshop, Arc Soft Photo Impression, and Serif Photo Plus all containing numerous tools and processes including a 'panorama' function. This mini programme scans digital codes within a photograph and matches them, providing an automatically 'stitched' image that creates a panoramic photograph. Provided there is concurring overlap of the subject it can cover an area up to 360 degrees. The function is currently inbuilt in many of the latest cameras.

The programme provided the stimulus for an idea to photograph directly above specific sections of the rock-art panel then to stitch all images together. This forms a good template that not only allows the panel to be traced but also offers close and detailed examination of carvings on a computer monitor or projector screen. The main concern was whether the software could stitch vertical, horizontal and angled horizons without distortion. To assess the feasibility of the system a number of trials were undertaken on previously recorded rock-art panels in North Yorkshire that provided positive results.

Since many professional archaeologists advocate non-contact methods of recording rock-art it was decided to test the system as a potential 'non-contact recording technique'. We did this on a visit to Kilmartin, an area that contains numerous elaborately decorated panels of rock-art such as the famous Ormaig panel. The site has recently been excavated and surveyed by archaeologists; it lies in the Ormaig Forest and is generally covered in Sitka Spruce needles that are acidic. Using a soft natural-fibre hand brush we removed the residual needles to expose carvings. Although

in general local stream water can be used in a hand sprayer to cover the whole surface of the rock to highlight both carvings and texture, on this occasion rain-water on the surface produced the same effect. A 10cm scale that indicates north is placed against the rock to give size and orientation.

From tests we found that dull but bright days give a uniform exposure shadow-free with no reflections on the rock surface. Naturally not all rock surfaces are conveniently flat; for example the rock-art at Ormaig is on a slope. The panel was photographed vertically section by section by moving the camera on each section with a slight overlap so that the picture is repeated on the next shot. The camera may be mounted on an expandable monopod pole at maximum length and held horizontally over the section to be photographed. Each picture was checked prior to shooting the next frame. The camera is held parallel and equidistant to the rock surface to follow the contour of the rock surface and the completed sequence of photographs can be downloaded via a card reader to laptop or PC. The camera used was a Fuji FinePic S5500 which was triggered using the inbuilt 10-second timer. Many cameras now have infrared remote triggering for continuous shooting.

The stitched photograph of Ormaig was created using Serif Panorama Plus 3, a separate stitching software programme available at £10 UK freepost via the Internet. The programme is simple to use: each photo is imported from a selected folder and six images stitched in batches providing composite pictures that are automatically stored as separate images that can be stitched to the next processed batch until the full area of selection is covered. Alternatively each stitched section may be stored in a file for closer examination. The final stitched image can be stored in JPEG format and adjusted in Photoshop for best contrast and sharpness.

Some quality may be lost during the stitching process; for example our Fuji Finepic has a 4 Meg CCD sensor and the processed composite image resolution is 150dpi (dots per inch) projection on a 2 x 2m screen which provides an acceptable image that does not pixellate. Resizing using Photoshop can achieve up to 250dpi, which is close to publication standard.

APPENDIX VI

CREATING A WEBSITE

BY DR ARON D. MAZEL

A VIRTUAL APPETITE FOR ROCK-ART: A BRIEF REVIEW OF THE BECKENSALL NORTHUMBERLAND ROCK-ART WEBSITE

The study of rock-art has probably experienced more growth than any other branch of archaeology during the last three decades. This phenomenon is not only evident in the increase in amateur and professional recorders and researchers and the proliferation of academic and popular rock-art publications, but is also reflected in the growth of websites either dedicated entirely to the subject or containing extensive rock-art material. One website which provides evidence of this trend is the *Northumberland Rock Art: Web Access to the Beckensall Archive (colour plate 13b)*. Launched in January 2005, this website was an instant success and showed that there is a substantial local and international virtual appetite for rock-art, including abstract Neolithic and Early Bronze Age cup and ring rock carvings which lack representational figures. This short piece will briefly consider the making of the website and the response to it.

Although Northumberland rock-art was first recognised as being ancient in the 1820s it was only in the 1850s that its study really began with the work of illustrious antiquarians such as Tate and Simpson. This initial phase lasted until the 1880s. Since then there have been two further periods of engagement: the 1930s and from the 1960s until the present, the latter of which has been the most extensive and sustained. Much of the recent work is associated with Stan Beckensall who has developed a large archive of Northumberland rock-art consisting primarily of photographic images (negatives, slides and prints), rubbings, drawings, and detailed written commentary about the rock-art panels and their contexts. This archive, which was donated to Newcastle University and is available for further study, served as the inspiration for the creation of the website.

In the early 2000s Stan had a quandary. He was about to publish a book about Northumberland rock-art (Beckensall 2001) but he was informed by the publishers that there was insufficient space to accommodate his numerous illustrations at the preferred size. To try to get around this dilemma, Stan approached Newcastle University for assistance to produce

a CD with illustrations to support the publication. Instead, however, a plan was hatched to take advantage of the potential of the rapidly developing internet to not only make accessible larger versions of the illustrations, but to place the entire archive on the internet. This appealed greatly to Stan with his strong commitment to sharing his knowledge about rock-art with the largest possible audience. A successful application by Professor Geoff Bailey, Dr Clive Waddington and Glyn Goodrick to the Arts and Humanities Research Board led to the establishment of an internationally groundbreaking project in terms of providing unrestricted access to an extensive rock-art dataset. I was privileged to be offered the position to undertake the project.

The Northumberland rock-art project ran from July 2002 to December 2004. The primary aim of the project was to create a well-structured and user-friendly website, supported by a database, to provide the basis for future research, educational outreach, and the wider public access and understanding of rock-art. Moreover the project was intended to: encourage further recording and research; ensure a comprehensive illustrative record (drawings and photographs); improve our understanding of the vulnerability of, and threats to the carvings by natural and artificial processes; and, develop an appreciation for future management and conservation requirements.

There were several challenges at the outset, these included: developing a complete inventory of the Northumberland rock-art panels, which meant interrogating the archive and Stan!; establishing the nature and extent of the resources available for the website; conceptualising the potential audiences for the website and determining what information they required to ensure that it satisfied their needs; developing a panel reporting form; creating the database (with Horacio Ayestaran); and, planning the field work programme.

With Stan's active and invaluable support close on 90 per cent of the 800 panels known to still be in the countryside were located and recorded. Return visits were made to 560 panels to collect additional data on setting, surface, panel type, art, and management and conservation. The photographic archive was boosted by over 8000 new images; these were mostly digital images, but 1800 colour prints were taken. Stan also managed to add about 100 new illustrations to the database. A particularly rewarding outcome of the field work programme was the increase in the number of known panels from 790 to 1060, mainly due to field discoveries and information supplied by colleagues, farmers, and members of the public. In tandem with the field work, the office work concentrated on updating the records; cataloguing and scanning thousands of Stan's line drawings and photographs (some dating back to the mid-1970s); inputting information and images into the dedicated

interactive database created by Horacio Ayestaran, who also implemented the website; and, creating the Interactive Zone and the graphic design of the website, done by Marc Johnstone and Jess Kemp.

The Beckensall Northumberland rock-art archive turned out to be more extensive than initially anticipated and this also characterised the website. The website included:

- An entry for every carved panel, with data on e.g. location, archaeology, environment and management.
- Six thousand images including 360° Bubbleworld photos of 46 panels in their settings.
- Browse facilities to access all panels according to parish, map, type, location, access (with suitability for wheelchairs), image type and art motifs.
- An interactive search facility for a combination of criteria.
- An Interactive Zone with e.g. learning journeys about rock-art, a tribute to Beckensall, video and audio clips, recommended visits, games, photo galleries and bibliography.

The website was launched at the Lordenshaw rock-art area, supported by local, national, and international media coverage. The response to the website exceeded all our expectations. In the first five days it received over 15,000 unique visitors, 370,000 pages were viewed, and there were more than two million hits! It was astonishing, and at one point Horacio thought that the website might crash because of the large amount of traffic! People from all over the world were visiting Northumberland rock-art virtually; for many, I am certain, it was their first time to learn about this wonderful heritage resource in the north of England. Predictably, the very high level of visitation was not going to be sustained, but the website has continued to attract attention. By the middle of 2008, and therefore three and a half years after its launch, the website had received over 115,000 unique visitors, more than 500,000 pages had been visited, and there have been greater than 17 million hits. The visitors have hailed from over 100 countries. Of course, statistics can be deceptive, but these figures tell a compelling story: that the website has been a great success and that it has substantially increased global knowledge and interest in Northumberland rock-art. We believe that this is, in part, due to the huge virtual appetite internationally for rock-art.

As the Beckensall Northumberland rock-art project was drawing to an end, English Heritage announced that it was going to fund a project on Northumberland and Durham rock-art, which would be overseen by archaeologists from these two County Councils. Started in mid-2004, some of the distinctive features of the new Northumberland and Durham

Rock Art project (NADRAP) was that it trained up volunteers to do the field work and data capturing, and explored new recording techniques (e.g. photogrammetry). In order to avoid duplication of effort, the Beckensall project shared information with the NADRAP project team (e.g. panel data, panel reporting sheet, database system) and members of the Beckensall team became members of the NADRAP Steering Committee. It was agreed that it would be counterproductive to have two comprehensive websites covering the same rock-art and that the new website, called England's Rock Art (ERA), would build on and incorporate the Newcastle University's Beckensall Northumberland rock-art website. This was largely achieved through close cooperation between representatives of the completed Beckensall project and Dr Kate Sharpe, who succeeded Dr Tertia Barnett as the NADRAP project manager in 2007, to finalise the structure of the ERA database and to generally ensure a smooth transition between the two websites. Many of the interactive media features from the Beckensall website can now be enjoyed on the ERA website. The ERA website was launched in July 2008.

At the time of writing this short piece both websites are up and running; however, the Beckensall Northumberland rock-art website will be taken down in the near future. Its legacy will live on in the ERA website. It will be remembered as a pioneer in using the internet to freely share large bodies of information about rock-art with a widespread global audience. By giving unrestricted access to the archive, the website broke new ground internationally by showing how the finer details of the rock-art of one part of the world can be fully appreciated and enjoyed by enthusiasts in another part of the world without their having to actually visit it.

Reference Beckensall, S. (2001) *Prehistoric Rock Art in Northumberland.* Stroud: Tempus

APPENDIX VII

THE CRESWELL CAVES ROCK-ART

BY DR PAUL BAHN

Finding Britain's oldest art – engravings made about 13,000 years ago in a Nottinghamshire cave – was an incredible thrill, and the fulfilment of a 30-year ambition. Ever since my days as a graduate student in archaeology at Cambridge I had been fascinated by the cave art of France and Spain, the wonderful paintings and engravings of animals such as horses and bison which our ancestors produced in hundreds of caves and shelters during the last Ice Age, from about 30,000 to 10,000 years ago.

All the textbooks claimed that this was a purely continental phenomenon, and that there was no cave art in Britain, but I could never see the logic in this. Britain was still joined to Europe at the time, because of lower sea levels; there are numerous caves in Britain which were occupied in the late Ice Age, and some of them had even produced a few specimens of portable art, i.e. small engravings on bone. So there seemed to be no good reason why art on cave walls should not have existed here too.

Finding it, however, would probably be tricky. Paintings are usually easy to see, and somebody would certainly have spotted them in a British cave by now if they had survived the ravages of time. But engravings (which greatly outnumber paintings in the continental caves) can be extremely difficult to see, and need to be lit from the side – if lit from the front they often disappear completely, so it takes trained eyes to detect them. I knew that nobody with expert eyes had ever searched the British caves for engravings, so this is what I decided to do.

The first task was to acquire such expertise myself, and this was done over decades of visiting and studying the art in the caves of France and Spain. In the mid-1990s I met Dr Sergio Ripoll, a Spanish cave art specialist, and we determined that one day we would jointly mount a search for Ice Age engravings in Britain.

The final step came in November 2002 when I invited Dr Paul Pettitt, then of Oxford University, to join the venture. Paul is a specialist in British Ice Age archaeology, and unlike Sergio and myself he knew how to go about obtaining permission to see the caves here. By some miracle we were able to find a few days in April 2003 when all three of us were free to make a preliminary search, at our own expense, of a few caves.

Circumstances and fate led us to begin in the north at Creswell Crags, on

the Derbyshire/Nottinghamshire border. In this beautiful little limestone valley, there are a number of caves, such as Robin Hood cave, and Mother Grundy's Parlour, which were occupied at the end of the last Ice Age, in what has become known to archaeologists as the Creswellian period. Some of them had yielded portable engravings of the period. We started on 14 April by visiting the caves on the Derbyshire side, which faced south; and in Mother Grundy's Parlour we spotted what appeared to be an ancient engraving, although we still don't know what it represents.

We were just about to leave when Brian Chambers, at that time senior ranger and curator at Creswell Crags, suggested that we should also look in Church Hole cave, on the other side of the little valley. This seemed less promising, since it faced north, but it had contained some Creswellian occupation, so we gave it a try – and immediately 'hit the jackpot.' What were the chances that a 30-year dream would be fulfilled on the first morning of the search, and with a cave that has proved to be of international importance?

That morning we only spotted a handful of engravings in Church Hole, but they included a major find – an animal outline, about half a metre across, which we first thought to be an ibex. In the 1870s, Victorian enthusiasts had emptied this cave, like the others, of its sediments, in a fruitful search for bones of extinct animals, stone tools and other objects. In doing so, they lowered the floor level by about six feet, so that all the engraved images made by Ice Age people were left high up on the walls, invisible to the observer below. One ledge of Ice Age floor was left at the side, however, and it is easy to climb up onto this. Generations of visitors to Church Hole, until it was closed in the 1970s, had clambered onto the ledge, and celebrated their triumph by scratching initials and dates on the wall here, on top of the 'ibex' figure which they did not see – except for one person who not only saw it but thought it was a male goat, and scratched a long beard under its chin!

It was Sergio who first climbed onto the ledge as he had looked up and seen a vertical line which looked like a possible engraving (it proved to be part of the front leg); when he first saw the animal's head, there was a torrent of Spanish expletives. The three of us agreed later that we had not really expected to find very much – perhaps a small horse-head, but certainly not a world-class figure like this 'ibex'. At the moment of discovery we were hit by a mixture of incredulity, exhilaration and shock. At a stroke, the prehistory of Britain had been changed. This country had cave art too!

What happened next was an amusing illustration of how archaeology works, and shows that one tends to find what one is expecting. We were seeking engravings, with artificial light shone from the side, and that is what we found. In our next campaign, in July 2003, our efforts were funded by English Heritage who installed a temporary scaffolding in the cave to give us access to the upper walls. Thanks to this, we increased the total of engravings detected in Church Hole to 13, two of them on the

ceiling. We now thought we had seen everything the cave had to offer.

But far from it! In 2003 the weather was often dull and rainy, and the figures – which are almost all in the entrance chamber of the cave – were hard to see in natural light. But when we returned to Church Hole in April 2004, the weather was sunny, and the natural morning light illuminated the entrance chamber beautifully. Not only did the engravings show up far more clearly than with artificial light, but we began to see other things, totally unexpected things, which we had missed before.

The previous year, we had seen strange bumps, hollows and small 'sausages' on the ceiling, and assumed they were all natural erosion and fossils. But in April 2004, while leaning on our scaffolding, I saw one of the 'sausages' from a different angle, and with perfect daylight, and I realised with a sudden jolt that it was a beautiful bas-relief carving of a bird with a long curved bill – something like an ibis. In addition our first big 'ibex' turned out to be a stag, after we detected the point of one of its antler tines.

Decorated ceilings are rare in cave art – everybody knows the famous painted ceilings of Altamira and Lascaux, but there are only a couple of others. And bas-reliefs on ceilings are even rarer – only two examples are known, in two Dordogne rock-shelters, an ibex in the Cave Pataud, and a salmon in the Abri du Poisson. So Church Hole has changed from being simply a regional anomaly – cave art much farther north in western Europe than had hitherto been known – to becoming an important cave with about 23 engraved figures, including a few that are truly unique and important, notably the bas-relief bird (Bahn & Pettitt, 2009).

How can we know these figures date to the Ice Age? Radiocarbon dates had already been obtained from the archaeological layers in Church Hole, which showed that the Creswellian occupation here dated to about 13,000 years ago. The style of the animal figures we have encountered is well known on the continent and fits such a date perfectly. And we have independent evidence from calcite covering some of the figures – dating of this by the Uranium-Thorium method has proved that it began to form around 11,000 years ago, so the engravings beneath must be older.

So our first efforts have been more successful than we ever imagined, and produced a discovery of international importance. Is it likely that we found the only decorated cave in Britain on that first morning in April 2003? We doubt it, and since then we have extended our search to other parts of England with caves that were occupied in that period. So far we have only found animal clawmarks in several caves – most caves, unlike Church Hole, are extremely wet and filled with calcite, while others have very eroded and poorly preserved walls and ceilings. We may not find a British Lascaux with glorious paintings, but who knows? That would need a previously unknown cave or an unknown chamber in a known cave, but there is no longer any reason why we should not find some more major pieces of Britain's earliest art.

APPENDIX VIII

SHAMANISM:
A DEAD END IN ROCK-ART STUDIES

by Dr Paul Bahn

In the past 25 years the world of rock-art studies, and of cave art studies in particular, has been enduring an epidemic of what has been called 'shamania', in that virtually every corpus of rock-art, from any period or region, has had the label 'shamanic' or 'shamanist' slapped onto it for no good reason; and an obsession with linking rock-art with so-called 'entoptics' and 'altered states of consciousness' and 'trance imagery' has been substituted for objective and original thought. This distressing trend has, in my opinion, done untold damage to the field of rock- and cave art studies which it will take years to repair. I have written at length elsewhere about this, (Bahn, 2001) and would like to direct interested readers' attention to a book (Francfort & Hamayon, 2001) in which a large number of rock-art specialists from all round the world have explained why this is all nonsense, and why it is simply impossible to identify rock-art imagery that can plausibly be linked to something like 'shamanism' – even in Siberia, the heartland of true shamanism.

The vast majority of Ice Age art specialists find this entire approach a waste of time, a great leap backward to the 1920s when the ethnography of so called 'primitive' societies was simply transferred en mass to Ice Age data. The difference this time is that the 'new' approach was – apparently solidly – based on two platforms: the interpretation of ethnographic testimony from south Africa; and the concept of 'entoptics' and the universal '3 stages of trance' model, derived from neuropsychology. Unfortunately, both of these platforms are riddled with woodworm.

Anne Solomon has already argued repeatedly (e.g. 2008) that the sparse testimony from Bushmen in the late nineteenth century should be interpreted literally, rather than through the tortuous metaphors of the 'shamaniacs', and that it relates their rock-art to mythology. She shows clearly and convincingly that the very limited recorded statements by the Southern San, which have been subjected to highly complex and metaphorical interpretation by Lewis-Williams and his followers, are amenable to other, perhaps more faithful and accurate interpretations, with substantial ethnographic evidence for mythological ancestors,

spirits of the dead, and so forth, being strongly represented in rock-art, as was also suggested by the great Harald Pager and others. Wilhelm Bleek himself, the man responsible for obtaining most of the written testimony of the Southern San, linked their art primarily to myth, rather than to anything like 'shamanism' or ritual. His voluminous records and transcripts make absolutely no mention of 'trance dances' and so forth. Solomon's work constitutes a far more respectful and literal acceptance of the words of the original San informants than the tortuous metaphorical readings which the 'shamanic theory' imposes on them.

Moreover, the shamaniacs have always claimed that the southern Bushmen are extinct, and so they take their ethnography about 'trance dances' and so forth from the remote Kalahari Bushmen who never had any rock-art. But now, several scholars have tracked down numerous descendants of the southern Bushmen, who still visit the decorated shelters and can tell us things about them – needless to say, what they tell us bears absolutely no resemblance to this 'trance imagery' nonsense.

And second, the neuropsychological data that have been presented to validate the model were already erroneous, distorted or hopelessly outdated when first put forward in 1988. Unfortunately, rock-art specialists have no contact with that domain, and so we all – myself included – simply accepted what we were told, trusting that the authors knew what they were talking about. It certainly sounded convincing, and well-researched, and scientific enough, with quotations from impressive sources. Had we bothered to check the facts with neuropsychologists at the time, we would have learned the truth so much more quickly.

In fact it was only in late 2001 that I was contacted by Dr Patricia Helvenston, an eminent American psychiatrist and neuropsychologist, who was absolutely incensed at the travesty of her discipline's data that was being promulgated by the shamaniacs. She and I therefore published a booklet (Helvenston & Bahn, 2005) – anyone interested can obtain a copy from me – which, for the first time, exposed the utterly bogus nature of the model: none of the numerous kinds of natural 'trance' produces the '3 stages', and the only drug which does so is LSD. So we presented the first test of this unverified and unverifiable model – i.e. if you want to argue that the cave artists underwent 3 stages of trance, and that these show up in their imagery, you have to prove that they had access to, and used, LSD – which of course they did not. It's rubbish.

Here are just a few of the basic facts to bear in mind:

- The '3-stage model' of trance imagery has no basis in fact, and is not to be found in standard works on neurology.
- Hallucination is totally unnecessary to account for any imagery in rock-art, whether simple geometrics or more complex figures.

- Even if hallucination or trance were sometimes the ultimate source of the imagery, there are many different kinds of trance and hallucinations, and most do not involve any kind of 'shamanic practices'.
- If the word 'hallucination' is used loosely and somewhat indiscriminately, the same is even more true of the term 'trance'. Very few researchers ever define what they mean by 'trance', and the word has thus become so all-embracing, like 'shaman', as to be meaningless, and in the vast majority of cases is simply assumed or taken for granted.
- 'Trance' does not equal shamanism – shamanism is a complex system of beliefs; it cannot and must not be reduced to facile simplifications such as 'trance' or visionary experiences, let alone to entoptic motifs.
- We have no present means of determining states of consciousness of prehistoric humans.
- And in the absence of the artists we simply cannot differentiate possible shamanic imagery from non-shamanic.

If we cannot do this in Siberia, the heartland of true shamanism, then how can we possibly do so elsewhere? Yet proponents of the 'shamanic reading' of rock-art have claimed to see it all over the world; naturally, this is because their definitions of shaman, shamanism, trance, and so forth are so vague and all-inclusive that practically anything can be and is ascribed to this category.

What is so exasperating is that nobody checks the facts – and I was as much to blame for this as others at first. I am willing to bet that the publishers of Lewis-Williams' *The Mind in the Cave*, and other such books, did not get a neuropsychologist to take a look at it, let alone an objective cave art specialist – despite the crucial importance of doing so. So the bandwagon has rolled on, and the uninformed and the uncritical believe what they are told, even though it is completely erroneous. It's really 'pashmina prehistory', a fad which is now on its last legs, fortunately, as word gets around – it is a common phenomenon that many people start following a trend just as it goes out of fashion! But this one is particularly unfortunate – it's easy-listening, and media-friendly, of course – the media love to be told that we know what cave art or rock-art means, and of course anything that smacks of drugs, magic, hallucinations and so forth is bound to appeal to them. Basically it's McArchaeology – all additive and no substance.

There may certainly be instances where 'shamanism', or something like it, can provide a plausible and appropriate interpretation for some rock-art; but it is not, and must not be seen as, a universal, lumping together

anything and everything under a blanket explanation. Yet that is what we have been presented with, despite frequent protestations to the contrary. Rarely has so much been assumed by so many on the basis of so little. The proponents of the theory see the rock and cave walls as veils or windows – but instead they are mirrors which simply reflect the imagination and wishes of the interpreters. The sum total of the theory, I'm afraid, is that it tells us that prehistoric rock-art was produced by human beings – not exactly a great step forward.

In short, during the past 25 years, the resurrection of 'shamanism', coupled with 'trance' phenomena, as an explanation for most, if not all, of the world's rock-art, has led to a 'bandwagon' effect, with rock imagery from all periods and parts of the world being roped in. The new guise of the explanation was based on fundamental errors, and its application to so much rock-art led to a temporary stagnation in interpretation, which told one little about the artists but much about the interpreters who were wasting their time pursuing a mirage, instead of doing serious and worthwhile research in the field of rock-art. It is sad that the public has been fed such baseless stuff, and I fear it will take years to repair the false image that this bogus approach has produced in gullible or uncritical minds. As I have said elsewhere (2001), it is posterity which will have the last word on this theory, and I am confident what that word will be.

Bahn, P.G. 2001. Save the Last Trance for Me: an assessment of the misuse of shamanism in rock-art studies, pp. 51-93 in (Francfort, H-P. & Hamayon, R.N., eds. in collaboration with P. Bahn), *The Concept of Shamanism. Uses and abuse.* (Bibliotheca Shamanistica, vol. 10), Akadémiai Kiadó: Budapest

Francfort, H-P. & Hamayon, R.N., (eds. in collaboration with P. Bahn) 2001. *The Concept of Shamanism. Uses and abuses.* (Bibliotheca Shamanistica, vol. 10), Akadémiai Kiadó: Budapest

Helvenston, P.A. & Bahn, P.G. 2005. *Waking the Trance Fixed.* Wasteland Press: Kentucky, USA

Solomon, A. 2008. Myths, making and consciousness. *Current Anthropology* 49 (1): 59-86

BIBLIOGRAPHY

Dr Keith Boughey has produced what is probably the most extensive bibliography of British rock-art in existence. In lists that he sent to me he has gone to great trouble to distinguish the different authorship involved, such as 'independent' and 'professional'.

What follows is a pared-down version of this suited to the prospective readership of this book.

Some short articles, for example, which have appeared in various journals, are omitted because they have been incorporated in larger works or are repeated in part or as a whole elsewhere. Reviews of books have also been omitted.

Readers are reminded that Keith still holds these extensive bibliographies should more detail be required.

Some authors, notably the late Stuart Feather, whose work ranged widely and involves many other people, have not produced books, but have left as a legacy a great number of articles too numerous to list here. Such work does find itself listed in other works, which the serious student will pursue.

The list excludes many websites, which are increasingly important sources of information and speculation.

* Indicates works by independent archaeologists, the star appearing only on their first entry.

Adoranten is published by the Scandinavian Society for Prehistoric Rock-Art, Tanums Hallristingmeuseum Underslos

Bahn, P. and Rosenfeld, A. (eds) 1991. *Rock-Art in Prehistory*. Oxford, Oxbow

Bahn, P.G. 1998. *Prehistoric Art*. Cambridge Illustrated History. Cambridge: Cambridge University Press

Bahn, P. G. 2006. Rock Art: World Heritage, pp.3-8 in American Indian Rock Art 21. (P. Whitehead, ed.), Proceedings of International Rock Art Congress, Flagstaff, Arizona, 1994 (on CD-Rom)

Bahn, P. & Pettitt, P. 2009. *Britain's Oldest Art: The Ice Age Cave Art of Creswell Crags*. English Heritage: London

Barnatt, J. and Reader, P. 1982. Prehistoric rock art in the Peak District. *Derbyshire Archaeological Journal* 102, 33-44

Barnett, T.F. and Sharpe, K.E. (eds). 2009. *Carving a Future for British Rock Art: New Directions for Research, Management and Presentation*. Oxford: Oxbow Books

*Beckensall, S. 1974. *The Prehistoric Carved Rocks of Northumberland*. Newcastle-upon-Tyne: Frank Graham

Beckensall, S. 1983. *Northumberland's Prehistoric Rock Carvings: A Mystery Explained.* Rothbury: Pendulum Publications

Beckensall, S. 1986. *Rock Carvings of Northern Britain.* Princes Risborough: Shire

Beckensall, S. 1991. *Prehistoric Rock Motifs of Northumberland, vol.1: Ford to Old Bewick.* Hexham: privately published

Beckensall, S. 1992. *Prehistoric Rock Motifs of Northumberland, vol.2: Beanley to the Tyne.* Hexham: privately published

Beckensall, S. 1992. *Cumbrian Prehistoric Rock Art. Symbols, Monuments and Landscape.* Hexham: privately published

Beckensall, S. 1996. Symbols on stone: the state of the art. In P. Frodsham (ed.), *Neolithic Studies in No-Man's Land (Northern Archaeology)* 13/14, 139-46

Beckensall, S. 1999. *British Prehistoric Rock Art.* Stroud: Tempus

Beckensall, S. 2001. *Prehistoric Rock Art in Northumberland.* Stroud: Tempus

Beckensall, S. 2002. *Prehistoric Rock Art in Cumbria: Landscapes and Monuments.* Stroud: Tempus

Beckensall, S. 2002. British prehistoric rock art in the landscape. In G. Nash and C. Chippindale (eds), *European Landscapes of Rock Art,* 39-70. London: Routledge

Beckensall, S. 2003. *Prehistoric Northumberland.* Stroud: Tempus

Beckensall, S. 2004. British Prehistoric Rock Art. *The Future of Rock Art – a World Review,* 40-49. National Heritage Board of Sweden.

Beckensall, S. 2004. The significance of the distribution of rock art in Britain. *XXI Valcomonica Symposium: new discoveries, new interpretations, new research methods,* 78-90. Capo di Ponte : Edizione Del Centro

Beckensall, S. 2004. British Rock Art. *The Valcomonica Symposiums 2001 and 2002,* 90-9. National Heritage Board of Sweden

Beckensall, S. 2005. *The Prehistoric Rock Art of Kilmartin.* Lochgilphead: Kilmartin House Trust

Beckensall, S. 2006. *Circles in Stone: a British Prehistoric Mystery.* Stroud: Tempus

Beckensall, S. 2009. *Northumberland's Hidden History.* Stroud: Amberley Publishing

Beckensall, S., Hewitt, I. and Hewitt, I. 1987. Rock art of prehistoric Britain. *Archaeology Today* 8(3), 48-53

Beckensall, S., Hewitt, I. and Hewitt, I. 1991. Prehistoric rock motifs recently recorded in Northumberland. *Archaeologia Aeliana* (5) 19, 1-5

Beckensall, S. and Laurie, T. 1998. *Prehistoric Rock Art of County Durham, Swaledale and Wensleydale.* Durham: County Durham Books

Bjelland, T. and Elberg, B.H. 2006. *Rock Art: A Guide to the Documentation, Management, Presentation and Management of Norwegian Rock-Art.* Norwegian Working Group for Rock Art Conservation, Directorate for Cultural heritage

*Boughey, K. 2005. Prehistoric Rock Art of the West Riding. *Yorkshire Dales Review* 90, 3-6

Boughey, K. 2007. Prehistoric Rock Art: Four New Discoveries in Nidderdale. *Prehistory Research Section Bulletin of the Yorkshire Archaeological Society* 44, 39-48

Boughey, K. 2009. The Stanbury Hill Project: Archaeological Investigation of a Rock Art Site. *Prehistory Research Section Bulletin of the Yorkshire Archaeological Society* 46, 45-6

Boughey, K. and Vickerman, E. 2003. *Prehistoric Rock Art of the West Riding. Cup-and-Ring-Marked Rocks of the valleys of the Aire, Wharfe, Washburn and Nidd.* Wakefield: West Yorkshire Archaeology Service

Bradley, R. 1991. Rock art and the perception of landscape. *Cambridge Archaeological Journal* (1) 1, 77-101

Bradley, R. 1996. Learning from places – topographical analysis of Northern British Rock Art. In P. Frodsham (ed.), *Neolithic Studies in No-man's Land, (Northern Archaeology)*, 87-99. Newcastle. Northumberland Archaeological Group, 13/14

Bradley, R. 1997. *Rock Art and the Prehistory of Atlantic Europe. Signing the Land*. London: Routledge

Bradley, R. 1998. *The Significance of Monuments*. London: Routledge

Bradley, R. 2000. *An Archaeology of Natural Places*. London: Routledge

Bradley, R. 2009. *Image and Audience: Prehistoric Art*. Oxford: Oxford University Press

Bradley, R., Harding, J. and Mathews, M. 1993. The siting of prehistoric rock art in Galloway, south west Scotland. *Proceedings of the Prehistoric Society* 59, 269-83

Bradley, R., Harding, J., Mathews, M. and Rippon, S. 1993. A field method for analysing the distribution of rock art. *Oxford Journal of Archaeology* 12 (2), 129-43

*Brown, B. and Brown, P.M. 1999. Previously unrecorded prehistoric rock carvings at Copt Howe, Chapel Stile, Great Langdale, Cumbria. *CBA Archaeology North* Winter 1999, 16-18

Brown, P.M. and Brown, B. 2008. *Prehistoric Rock Art in the Northern Dales*. Stroud: Tempus

Brown, P.M. and Chappell, G. 2005. *Prehistoric Rock Art in the North York Moors*. Stroud: Tempus

Brown, P.M. and Brown B. 2009. Recording Prehistoric Rock Art in North Yorkshire. *Prehistory Research Section Bulletin of the Yorkshire Archaeological Society* 46, 29-37

Burgess, C. 1990. The chronology of cup and ring marks in Britain and Ireland. *Northern Archaeology* 10, 21-6

Burgess, C. 1990. The chronology of cup and cup and ring marks in Atlantic Europe. *Revue Archéologique de l'Ouest. supplément* 2, 157-71

Carr, D. 2003. Geology and the Distribution of Rock Art: A Study of Derbyshire. *Archaeology Durham*, 54

Chippindale, C. and Tacon, S.C. (Eds.) 1988. *The Archaeology of Rock-Art*. Cambridge.

Coles, J. 2005. *Shadows of a Northern Past*. Oxbow

Cooney, G. 2000. *Landscapes of Neolithic Ireland*. Routledge.

Darvill, T. and O'Connor, B. 2005. The Crook yn How stone and the rock art of the Isle of Man. *Proceedings of the Prehistoric Society* 71, 283-331

Díaz-Andreu, M. (ed.) 2002. *Art on the Rocks: an exhibition in the Fulling Mill Museum of Archaeology, Durham, July-September 2002*

Díaz-Andreu, M., Hobbs, R., Rosser, N., Sharpe, K. and Trinks, I. 2005. Long Meg: Rock art recording using 3D laser scanning. *Past: The Newsletter of the Prehistoric Society* number 50, 2-6

Ellis, C. and Webb, S. 2007. *Excavations at Ormaig Cup and Ring Marked Rock Art Site in Argyll*. Kilmartin House Museum

English Heritage 2000. *Rock Art Pilot Project: Main Report. A report on the results of a pilot project to investigate the current state of research, conservation, management and presentation of prehistoric rock art in England*. Bournemouth and London: English Heritage

Frodsham, P. 1989. Two Newly Discovered Cup and Ring Marked Stones from Penrith and Hallbankgate, with a gazetteer of all known Megalithic Carvings in Cumbria. *TCWAAS (2)*, 1-19

Frodsham, P. 1993a. Prehistoric Rock Art in Northumberland. *Archaeology in Northumberland 1992-1993*, 26-7. Morpeth: Northumberland County Council

Frodsham, P. 1996. Spirals in Time: Morwick Mill and the Spiral Motif in the British Neolithic. *Northern Archaeology* 13/14, 101-38

Frodsham, P. 2007. 'The Phallic Explanation.' A late Nineteenth Century Solution to the Cup-and-Ring conundrum. In C. Burgess, P. Topping and F. Lynch (eds). *Beyond Stonehenge. Essays on the Bronze Age in Honour of Colin Burgess*. Oxbow. 31-37

Hadingham, E. 1974. *Ancient Carvings in Britain*. London: Garnstone Press

Hale, A. 2003. Prehistoric Rock Carvings in Strath Tay. *Tayside & Fife Archaeological Journal* 9, 7-14

Helvenston, P.A. and Bahn, P. 2005. *Waking the Trance Fixed*. Wasteland Press, USA

Hewitt, I. 1991. Prehistoric rock motifs in Great Britain: an appraisal of their place in the archaeological record with specific reference to Northumberland. Unpublished thesis. Bournemouth University

Ilkley Archaeology Group, 1986. *The Carved Rocks on Rombalds Moor. A Gazetteer of the Prehistoric Rock Carvings on Rombalds Moor, West Yorkshire*. Wakefield: West Yorkshire Archaeology

Hygen, Anne-Sophie, 2006. *Protection of Rock Art*. The Rock Art Project 1996-2005. Oslo

Johnston, S.A. 1993. The relationship between prehistoric Irish rock art and Irish passage tomb art. *Oxford Journal of Archaeology* 12(3), 257-79

Mathews, M. 1996. Mental maps and maps of stone: interpretation of prehistoric rock art sites in Galloway. Unpublished MA thesis, University of Reading

Mazel, A.D. 2005. http://rockart.ncl.ac.uk. *Archaeology in Northumberland* 15, 48-9. Morpeth: Northumberland County Council

Mazel, A.D. 2005. Virtual access to the Beckensall Northumberland rock art archive. *International Newsletter on Rock Art*. 42, 24-7

Mazel, A., Nash, G. and Waddington, C. (eds.). 2007. *Art as Metaphor: The Prehistoric Rock Art of Britain*. Oxford: Archaeopress

*McMann, J. 1980. *Riddles of the Stone Age. Rock Carvings of Ancient Europe*. London: Thames and Hudson

*Morris, R.W.B. 1968. The cup-and-ring marks and similar sculptures of Scotland: a survey of the southern counties, Part II. *Proceedings of the Society of Antiquaries of Scotland* 100, 47-78

Morris, R.W.B. 1969. The cup-and-ring marks and similar early sculptures of Scotland. Part 2. The rest of southern Scotland, except Kintyre. *Transactions of the Ancient Monuments Society* 16, 37-76

Morris, R.W.B. 1977. *The Prehistoric Rock Art of Argyll*. Poole: Dolphin Press

Morris, R.W.B. 1979. *The Prehistoric Rock Art of Galloway and the Isle of Man*. Poole: Blandford Press

Morris, R.W.B. 1981. The prehistoric rock art of Southern Scotland (except Argyll and Galloway). *British Archaeological Report Series* 86. Oxford

Morris, R.W.B. 1989. The prehistoric rock art of Great Britain: a survey of all sites bearing motifs more complex than simple cup-marks. *Proceedings of the Prehistory Society* 55, 45-88

Morris, R.W.B. and Bailey, D.C. 1967. The cup-and-ring marks and similar sculptures of south-western Scotland: a survey. *Proceedings of the Society of Antiquaries of Scotland* 98, 150-72

Nash, G.H. and Chippindale, C. (eds.), 2002. *European Landscapes of Rock art*. London: Routledge

O'Connor, B.V. 2003. Recent excavations in a rock art landscape. *Archaeology Ireland*.17 (4), 14-16

O'Connor, B.V. 2006. Inscribed Landscapes: Contextualising Prehistoric Rock Art in Ireland. PhD Thesis, University College Dublin

O'Kelly, M. 1982. *Newgrange: Archaeology, Art and Legend*. Routledge

Eogan, G. 1986. *Knowth and the Passage Tombs of Ireland*. Thames and Hudson

RCAHMS. 1971. *Argyll* vol. 1. Edinburgh: HMSO

RCAHMS. 1988. *Argyll* vol. 6. Edinburgh: HMSO

Sharpe, K.E. 2003. Rock Art and Rough Outs – An exploration of the sacred and social landscape in a prehistoric Lakeland valley. Unpublished MA Thesis, Department of Archaeology, University of Durham

Sharpe, K.E. 2007. Motifs, Monuments & Mountains: Prehistoric Rock Art in the Cumbrian Landscape. Unpublished PhD Thesis, Department of Archaeology, University of Durham

Shee Twohig, E.A. 1981. *The Megalithic Art of Western Europe*. Oxford: Clarendon Press

Shee Twohig, E.A. 1988. The rock carvings at Roughting Linn, Northumberland. *Archaeologia Aeliana* 16, 37-46

Shee Twohig, E.A. and Ronane, M. (eds) 1993. *Past perceptions; the prehistoric archaeology of south-west Ireland*. University of Cork Press

Shepherd, D. and Jolley, F. 2008. An interim account of rock markings in the South Pennines. *Prehistory Research Section Bulletin of the Yorkshire Archaeological Society* 45, 54-9

Simpson, J. 1867. *Archaic Sculpturings of Cups, Circles, etc upon stones and rocks in Scotland, England and other Countries*. Edinburgh: Edmonston and Douglas

Simpson, D. and Thawley, J. 1972. Single grave art in Britain. *Scottish Archaeological Forum* 4, 81-104

Trinks, I., Díaz-Andreu, M., Hobbs, R. and Sharpe, K.E. 2005. Digital Rock Art Recording: visualizing petroglyphs using 3D laser scanner data. *Rock Art Research* 22(2), 131-9

*Van Hoek, M.A.M. 1987. The prehistoric rock art of County Donegal (Part I). *Ulster Journal of Archaeology* (3) 50, 23-46

Van Hoek, M.A.M. 1988. The prehistoric rock art of County Donegal (Part II). *Ulster Journal of Archaeology* (3) 51, 21-47

Van Hoek, M.A.M. 1995. *Morris' Prehistoric Rock Art of Galloway*, Oisterwijk: privately published

Waddington, C. 1995. An exploration of the role of cup and ring marks with particular reference to the Milfield Basin. Unpublished MA thesis, University of Newcastle upon Tyne

Waddington. C. 1996. Putting Rock Art to Use. A model of Early Neolithic Transhumance in North Northumberland. *Northern Archaeology* 13/14, 147-8

Waddington, C. 1998. Cup and ring marks in context. *Cambridge Archaeological Journal* 8(1), 29-54

Waddington, C. 2007. Cup-and-rings and passage grave art: insular and imported traditions? In C. Burgess, P. Topping and F. Lynch (eds), *Beyond Stonehenge: Essays on the Bronze Age in Honour of Colin Burgess*, 11-19

Waddington, C., Mazel, A.D. and Johnson, B. 2005. Excavation of a rock art site at Hunterheugh Crag, Northumberland. *Archaeologia Aeliana* [5] 34, 29-54

Watson, A. and Bradley, R. 2004. In the image of Ireland? Monuments and landscape in Neolithic Cumbria. *Archaeology North* number 22, 11-13

INDEX

C=Cumbria, D=Derbyshire, Dr=Durham, S=Scotland
N=Northumberland NYM=North York Moors
P and K=Perth and Kinross

Achnabreck (NR855906) 20-1, 29, 30, 93, 106, 110
Allan Tofts, Goathland (NYM) 18
Amerside Law Moor NU075276 (N) 24-5, 116, 121
Argyll 11, 93, 98, 115, 133, 137
Arran 24, 133
Ashford Primary School SK347632 118, *colour plate 6a*
Asperberget (Sweden) 119

Backstone Beck SE12774625 *colour plate 10b*
Balkemback NO382384 (S) 66
Ballochraggan NN56137 019827 20, 23
Ballochmyle S512254 (Ayrshire) 40-1, 64, *colour plate 7a*
Ballymeanoch NR033964 (Kilmartin) 47
Barningham Moor NZ052076 (Dr) 30, 43
Beanley Moor (N) 92, 125
Blairbuie 1 NR883890 (Kilmartin) 22, 23
Boyne valley (Ireland) 52, 122, 134, 137, 140
Brittany 71, 73, 93, 95, 96
Buttony NU017310 (N) 20-1, 23

Cairnbaan NR838910 (Kilmartin) 11-12, 14, 91, 118
Cemmo (Valcamonica, Italy) 124
Channel Islands 45

Chapel Stile/Copt Howe NY314058 (C) 21, 41, 104
Chatton Park Hill NU075290 (N) 18, 20, 43, 80, 111
Clava Cairns NH757445 (Inverness) 55-6, 71, 132, 134, 140
Coa Valley (Portugal) 135
Coilsfield cist NS446264 (Ayrshire) 91
Copt Howe/Chapel Stile NY314058 (C) 21, 41, 104
Corrody Burn NN954 385 (P and K) 18
Coldmartin NU0992278 (N) 37-8
Corby's Crag NU128096 (N) 39
Craig Hill (Tayside) *colour plate 14b*
Creagantairbh NM843012 (Kilmartin) 19
Creswell Crags caves 39, 136, 147-9
Croft Moraig circle NN797472 (Tayside) 46
Crummock Water (C) 42-3

Dean (C) 109
Dod Law NU007316 (N) 24-5, 92
Drumirril (Ireland) 123
Durrington Walls 74

Eel Hill (Dr) 16, 43
Eggleston (Dr) 17

Finduie Wood NN74097 47827 (Fortingal) 17, 42
Fossum (Sweden) 110

Fowberry NU098278 (N) 16, 49, 72-3
Fulforth Farm cist (Dr) 30
Fylingdales NZ955015 (NYM) 44, 51,
 100, 130

Gayles Moor NZ115062 (Dr) 34
Gayles Moor NZ116058
Galicia 61, 71
Gallow Hill NO395406 (Tealing) 43
Galloway 21, 25-6, 98, 133, 137
Gallows Outon NX448420 (Galloway)
 28
Glassonby NY572393 (C) 53
Gled Law NU010306 (N) 21
Glentarf NN808 19497 (Perth and
 Kinross) 16, 21
Gleann Da Eigg 39
Goathland, Allan Tofts (NYM) 18
Goatstones four-poster NT829747 (N) 56
Greenrigg, Patterdale (C) 17, 42

Hanging Stones SE128467 (Ilkley) 26, 42
Hare Law NU013354 (N) 24
Hawthornden NT280632 27, 29, 40, 64
High Banks NX709489 (Galloway)
 colour plate 6b
Honeypots Farm stone NY552299 (C) 27
Houxty NY951791 (N) 57

Ilkley 26, 42, 61, 96-7, 100, 108, 130
Idol Stone SE132459 (Ilkley) 44

Ketley Crag NU074298 (N) 11, 12, 20,
 38, 80
Kilmartin 11, 19, 20, 24, 35, 47, 49, 63,
 66-8, 83-4, 109-112, 115 117, 129,
 133, 137-141
Kivik (Sweden) 93-4
Knowth tomb (Ireland) 52, 54

Lamp Hill, Lemmington NU138112 (N)
 18
Little Meg NY576374 (C) 29, 30, 55
Loch Tay 12-3, 124, 132-3
Long Meg stoneNY571372 (C) 40, 45-6,
 64-6
Lordenshaw NZ056991 (N) 33-4, 36,
 145

Loughcrew (Ireland) 51-2, 55, 114. 134

Malta (Tarxien temple spirals) 58-9, 90
Millstone Burn NU118052 (N) colour
 plate 8a
Moonbutts standing stone (Perthshire) 46,
 78

Newlaw Hill NX735489 rear cover

Old Bewick (NU078216) 20, 22, 40, 58,
 60, 83, 86-7, 92, 108
Ormaig MM822027 (S) 24, 83, 84, `115-
 6, 141-2

Poltalloch NR812963 (S) 117
Prieston (Tealing) NO390396 colour plate
 14a

Ri Cruin cist NR825871 (Kilmartin) 48
Ringses NU016328 (N) 23
Roughting Linn NT983367 (N) 23, 80,
 83-5, 88-9, 139

Scrainwood NT998 098 (N) 111
Shap Avenue (C) 46
Snowden Moor SE180511 (NW
 Yorkshire) colour plate 10a
Stonehenge 45, 63, 67, 74
Stronach Ridge NS003364 (Arran) 24
Soletorp (Sweden) 104

Tayside 15, 46, colour plate 5
Tealing (Dundee) 43, 57
Temple Wood NR826978 (Kilmartin) 67
Townhead (Galloway) colour plate 7b
Turrerich NN 85374 39824 (Perth and
 Kinross) 42

Weetwood cairn NU021281 (N)
 Weetwood 49, 71-2, 113
Wellhope NU115061 (N) 121
Wester Glen, Tarken NN66410 24773
 (Perth and Kinross) 43
West Horton 1NU022316 (N) 44
West Horton 2NU021314 (N) 111
Whitehill Head NU099272 (N) 20
Witton Gilbert (Dr) 19, 82